MW00710144

The Streamline Era
Greyhound Terminals

The Streamline Era Greyhound Terminals

The Architecture of W.S. Arrasmith

FRANK E. WRENICK
with the editorial assistance of Elaine V. Wrenick

FOREWORD BY RICHARD LONGSTRETH

McFarland & Company, Inc., Publishers
Jefferson, North Carolina, and London

LIBRARY OF CONGRESS CATALOGUING-IN-PUBLICATION DATA

Wrenick, Frank E., 1939–
The streamline era Greyhound terminals : the architecture of W.S.
Arrasmith / Frank E. Wrenick ; with the editorial assistance of
Elaine V. Wrenick ; foreword by Richard Longstreth.
p. cm.
Includes bibliographical references and index.

ISBN-13: 978-0-7864-2550-1
ISBN-10: 0-7864-2550-4
(illustrated case binding : 50# alkaline paper) ∞

1. Arrasmith, W.S. (William Strudwick)
2. Architecture—United States—20th century.
3. Bus terminals—United States—History—20th century.
4. Greyhound Corporation—Buildings. I. Title.
NA737.A78W74 2007 720.92—dc22 2006030384

British Library cataloguing data are available

On the cover: 1937 Louisville, Kentucky, Greyhound
Terminal, W.S. Arrasmith rendering; W. S. Arrasmith (1959)

Manufactured in the United States of America

McFarland & Company, Inc., Publishers
Box 611, Jefferson, North Carolina 28640
www.mcfarlandpub.com

To the memory of Elizabeth "Betty" Arrasmith (1901–1999)
and to Anne Arrasmith-Lewis

Acknowledgments

The author wishes to thank those people who provided assistance and support for this book.

Elizabeth "Betty" Arrasmith, wife of W.S. Arrasmith, and daughter Anne Arrasmith-Lewis, two of the most delightful ladies I have had the privilege of meeting, and whose infectious enthusiasm, encouragement, and vivid recollections are at the heart of this book.

Ed W. Baldwin, structural engineer associated with W.S. Arrasmith for 15 years, whose retentive mind, entertaining stories and precision drawings were indispensable to this project.

Stratton Hammon, who shed light on many fascinating aspects of the architectural community in Louisville, Kentucky.

Arnold M. Judd, partner in the firm of Arrasmith, Judd, Rapp, Inc.

Graham Rapp, partner in the firm of Arrasmith, Judd, Rapp, Inc., for providing unlimited access to the firm's archive of renderings, photographs, drawings, drafts, and proposals.

Milton Cooper, staff architect with Arrasmith, Judd, Rapp, Inc., and a relative of Will Tyler, one of Arrasmith's partners, whose answer to my advertisement in *Architecture* magazine requesting information about Arrasmith and his Streamline Moderne bus terminals, was the first step along the path that led to the realization of this book.

Stanley Arthur, draftsman for W.S. Arrasmith, for his recollections.

William Morris, summer intern with W.S. Arrasmith, for his recollections.

Cornelius Hubbuch, interior designer, for his engaging recollections about his work with W.S. Arrasmith.

William B. Scott, Jr., whose archive on Kentucky architects and particularly on W.S. Arrasmith et al., filled many gaps and helped add texture and depth to the story.

Dial Corporation, Dallas, Texas, owner of the Greyhound Lines Company, for providing access to the company's architectural archives.

Richard Longstreth, professor, American Studies Department, The George Washington University, for his review of the manuscript and many constructive and helpful suggestions.

Daniel Vieyra, professor of architecture and environmental studies, Kent State University, for his advice.

Kathleen H. Crowther, executive director, Cleveland Restoration Society, and the society for their support and encouragement.

Chester Liebs, author and professor, University of Vermont; Mark Taflinger, librarian, *Courier-Journal*, Louisville; Mary Jean Kinsman, curator, The Filson Club; Margaret Vollmer, New York Public Library; Eve Bronson, National Register of Historic Places; Beth Savage, National Register of Historic Places; Cynthia Van Ness, Special Collections Department, Buffalo and Erie County Library; Ellenore Krell, Enoch Pratt Free Library, Baltimore, Maryland; Alice Larkin, Evansville-Vanderburgh County Public Library, Indiana; Judy Haven, Onondaga Historical Association, Syracuse, New York; Charles Browne, Broome County Historical Society; Buffalo and Erie County Library, New York; Jo Staggs, Hunter M. Adams Architecture Library, University of Kentucky; William D. Morgan, University of Louisville, Kentucky; James Anderson, Photographic Archives, University of Louisville, Kentucky; Ron Bryant, Kentucky Historical Society, Frankfort, Kentucky; Don Smith, Kentucky Fair Board, Louisville, Kentucky; Gail Golbert, librarian, University of Louisville; Bob Brown and Paul Able, Bowman Field Airport, Louisville, Kentucky; Maureen Krauss, Alumni Relations, University of Illinois; Jack Robertson, University of Virginia; Charles Wotring, president, Royal Coach Corp. Diane Lynch, *Akron Beacon Journal*, Akron, Ohio; Chris Wiljer, Allen County Public Library, Ft. Wayne, Indiana; John Carroll University Library, University Heights, Ohio; Linda Hawk, architectural librarian, Kent State University; Philip A. Esocoff, principal, Keyes Condon Florance Eichbaum Esocoff King, Architects; Ellie Damm, The Old House Guild of Sandusky, Ohio; Robert Bann, Cleveland Fine Arts Advisory Committee; Art Falco, vice president of finance, Playhouse Square Foundation, Cleveland, Ohio; Wilma Salisbury, architecture writer, *Cleveland Plain Dealer*; Paul Westlake, Jr., partner van Dijk, Johnson & Partners; Steve McQuillan, restoration consultant, Cleveland, Ohio; James Casto, associate editor, The *Herald Dispatch*, Huntington, West Virginia; Ms. Olson, Kentucky Library, WKU, Bowling Green; Robert B. Hitchings, Norfolk Public Library, Norfolk, Virginia; Marilyn Gannon, The Hackley Public Library, Muskegon, Michigan; Norwood A. Kerr, Archival Reference Department, State of Alabama Department of Archives and History; Sethen Bronaugh, Louisville Free Public Library; George Livingston, Willard Library, Battle Creek, Michigan; Debora Pfeiffer, University Library, University of Illinois; Cleveland Public Library, Cleveland, Ohio; Rebecca Chandler for her manuscript review; and, Eckhart's Printing, Cleveland, Ohio for computer and imaging work.

Table of Contents

PART III: THE GREYHOUND TERMINALS OF W.S. ARRASMITH

Foreword

BY RICHARD LONGSTRETH

Before his death in 1965 at the age of 67, William Arrasmith could look back with pride on a long career of accomplishment. His professional practice spanned some four decades, most of the time spent in his adopted home of Louisville, Kentucky. He had ascended to and maintained prominence through four partnerships as well as by operating on his own. He had secured over two hundred commissions for work of all types. Commercial, institutional, and governmental buildings were a mainstay, but the business was also sustained by producing plans for a large number of residences. The vast majority of this output was concentrated in Louisville and nearby jurisdictions. Some designs, such as the immense 800 Building apartment house (1959–60) helped define the shape and character of their place, but Arrasmith's legacy foremost consisted of more modest buildings whose impact was as part of a larger whole. While not exceptional, the record was an eminently respectable one.

Beyond the local realm, Arrasmith never gained great prominence in his field while practicing, nor has he acquired that reputation since. Few specialists in, or even aficionados of, twentieth-century American architecture have ever heard of him. Why, then, produce a book devoted to this career, unless it is for a small, local audience or, perhaps, as a case study of one of hundreds of such individuals nationwide whose work represented the mainstream? The answer lies in Arrasmith's extra-territorial legacy—that which he created for Greyhound Lines bus company. Between 1937 and 1960, Arrasmith designed at least fifty terminals and other facilities for Greyhound in almost as many cities and towns, from Jackson, Mississippi, to Erie, Pennsylvania, from Battle Creek, Michigan, to Richmond, Virginia. Arguably, the most interesting of these buildings were created before the 1950s when Arrasmith was able to capture, indeed concretize, the essence of his client's still emerging transportation business.

Today, few people are likely to associate regularly scheduled commercial bus service with an exciting, let alone glamorous, experience. Yet seventy years ago perceptions were quite different. Greyhound was in the forefront of making bus transportation not just acceptable but appealing to a large clientele. At a time when long-distance travel by automobile often could be arduous, the bus provided a desirable alternative. Before and after World War II, Greyhound introduced a steady succession of new models that not only seemed the *ne plus ultra* in modern, streamlined styling, but offered amenities that could be substantially greater than the family car, even for people lucky enough to have a new model. Bus passengers could

recline; take in the view from a lofty position, read, sleep, or chat; forget about traffic, nar-
row and winding roads, poor roadside facilities and they could do so in a then all-too-rare
air-conditioned environment. Buses generally cost less than trains and they served thousands
of places not accessed by the railroads. For many people in small towns and rural areas of
the nation, the bus became the principal means to reach destinations far afield. Bus travel
was never in high fashion, but it was an attractive mode for millions of Americans. Grey-
hound set the industry standard in bus design; in building a comprehensive, national net-
work of routes; and in having its terminals embody the system they served. The terminal
stood as a tangible, permanent signifier of what its owner sought to make a revolutionary
way to address the needs of mass travel. The modernity, the comfort, the efficiency of bus
transportation should be just as evident in the buildings as in the vehicles themselves. Like
railroad stations before them, bus terminals were in effect portals to the city, the places where
many passengers arrived at their destination for the first time and made their initial impres-
sions. The terminal was also intended as an urban landmark, a conspicuous emblem of its
business to local residents and visitors alike, and in its sleek, streamlined elegance a marked
contrast to the staid, largely classically-inspired railroad stations of previous decades.
Arrasmith was not the first architect to address this integrative symbolic program and the
many technical challenges involved in making bus terminals efficient and cost-effective as
well. He did, however, quickly become one of the leaders in this nascent field and probably
did more than any other architect over the ensuing years to enhance Greyhound's public
identity. Bus transportation has changed significantly since the 1950s. Multiple improvements
in automobile and highway design as well as in air travel have been among the most obvi-
ous contributors to the decline in stature of the motor bus. Bus terminals, too, have lost
their emblematic meaning. Most terminals of Arrasmith's time have faded from the scene.
Many have been demolished. Many others have been unsympathetically altered for new uses.
Yet over the last fifteen years, a number have been preserved, even partially restored, in
the course of adaptation. Baltimore; Washington; Columbia, South Carolina; Savannah,
Georgia; and Jackson, Mississippi are among the success stories. In a few cases such as
at Evansville, Indiana, and Binghamton, New York, the terminals still serve their original
function with scant physical changes. The challenges of preserving the legacy of bus trans-
portation remain formidable nevertheless. Part of the problem is that this legacy is
still largely unknown. Greyhound's efforts to the contrary, buses never assumed the aura
of trains in the popular imagination and bus terminals have never gained a following
anything like that which has fostered the preservation of railroad stations in recent
decades. Even in specialized circles, the published record on bus terminals is slim.* These
are among the reasons we should be grateful for Frank Wrenick's monograph. More than
anyone before him, he has brought a major part of the story to light in a well-documented
and engaging way. Through these pages we can see Arrasmith's remarkable contribution to

*Basic studies include Albert E. Meier and John P. Hoschek, Over the Road: A History of Intercity Bus Transporta-
tion in the United States (Upper Montclair, N.J.: Motor Bus Society, 1975) and Oscar Schisgall, The Greyhound Story,
From Hibbing to Everywhere (Chicago: J. G. Ferguson, 1985). Alex Roggero, with Tony Beadle, Greyhound: A Picto-
rial Tribute to an American Icon (London: Osprey, 1995) is a recent popular account. I briefly delineated key develop-
ments in bus terminal design as well as Greyhound's pivotal role in the phenomenon in testimony presented for landmarking
the Washington terminal; see Richard Longstreth, History on the Line: Testimony in the Cause of Preservation (Wash-
ington: National Park Service, and Ithaca, N.Y.: National Council for Preservation Education, 1998), chap. 1. Two useful
period books on terminal design are Manfred Burleigh and Charles M. Adams, eds., Modern Bus Terminals and Post
Houses (Ypsilanti, Mich.: University Lithographers, 1941) and Railroad and Bus Terminal and Station Layout (Boston:
American Locker Co., n.d. [ca. 1945]). The richest published period resource is the industry's principal organ, Bus Trans-
portation magazine.

this routinely ignored building type. Besides the architect's immediate legacy is the standard he helped set for many other bus terminals across the continent. Many remain from the postwar years especially. From Jacksonville, Florida, to Medford, Oregon, they languish, begging our attention and care.

Richard Longstreth
George Washington University

Preface

From the mid-1930s until the end of the 1950s, W.S. Arrasmith defined the application of streamline design to architecture. During this time he cemented the Greyhound bus company's commitment to streamline styling for its terminals throughout the eastern half of the country. In doing so, he played a major role in establishing Greyhound's architectural corporate image, as streamline buildings bearing the Greyhound name appeared throughout cities large and small. In most of these locations the Greyhound bus terminal proved to be the only manifestation of the style. No other architect and no other company utilized streamline styling to the extent Arrasmith and Greyhound did.

By examining the evolution of Arrasmith's Greyhound streamline terminals from 1937 to 1948, and thereafter we can experience the steady progression along a trajectory from its birth, evolution and eventual absorption into a new more modern style.

Architecture was the last bastion to yield to streamline design. When the country was struggling to free itself from the plague of the Great Depression of the 1930s, industrial designers showed the way to a new utopia, waiting just out of reach. Streamline design and styling was utilized to define the future in the tangible immediacy of consumer products and goods of all kinds and descriptions.

When streamline design first began to be applied to architectural design in the early half of the 1930s it was to a very limited degree. By the time the style had firmly taken hold in the form of Greyhound bus terminals in 1937, it had only five years in which to develop before the onset of World War II. When the war was over, Streamline Moderne—the ultimate expression of architectural streamline design—was quickly replaced by an avant-garde style in which streamline themes assumed a crisper and more sharply defined appearance. By the mid–1950s, streamline design had all but disappeared from the landscape of new construction.

This book was inspired by the lack of material on the subject of streamline architecture. In fact, there are very few books that focus on the subject of streamline design at all, the most notable exceptions being *The Streamline Decade* by Donald J. Bush (published in 1975) and *Twentieth Century Limited, Industrial Design in America, 1925-1939* by Jeffrey L. Meikle (published in 1979). Although streamline design is touched upon in a variety of other books on design and art, the treatment is usually tangential. Not surprisingly then, there is no published material on the life and works of the streamline era's most prolific architect, William Strudwick Arrasmith.

This lack of information, combined with the author's abiding interest in all things of

the industrial design and streamline era, led to the book now in your hands. The quest for this information, which began in 1988, resulted in what became an eighteen year adventure.

The Streamline Era Greyhound Terminals: The Architecture of W.S. Arrasmith explores the life and achievements of architecture's most prolific expositor of streamline design. This book is organized in three parts: Part I examines Arrasmith's life and career, particularly his development as an architect; Part II explores the history of Greyhound and the evolution of bus terminals, focusing on the streamline period of architectural design during which Arrasmith's influence was at its strongest; and Part III describes twenty-eight of the Greyhound terminals designed by W.S. Arrasmith, many of which were in the Streamline Moderne style at which Arrasmith was so proficient. A chronology follows, providing a history of Arrasmith's employment and architectural commissions.

Hopefully this book will encourage others to investigate more deeply the field of streamline architectural design, to expand on what is contained in this work, and to shed new light on this long overlooked arena of the streamline era.

Frank Wrenick
Cleveland Heights, Ohio
Fall 2006

Introduction

Almost everyone is familiar with the sleek buses that ply our nation's highways and byways bearing the name Greyhound and its companion symbol of a dashing greyhound dog. Many others are also familiar with the Greyhound bus company terminals that serve their own, or nearby, communities. Some of these terminals are small storefront offices, others are contemporary free standing buildings, and some—the very rare ones—are streamline style buildings that have been in service for a half century or more.

If you have ever chanced upon one of these early Greyhound streamline terminals and been struck by its unique style and contours, you might have wondered about this unusual building and how it came to be. It may be surprising to learn that most of these streamline buildings were the creation of a man who instead of becoming a major league baseball pitcher became an architect admired for his design of buildings in more traditional styles. His earlier buildings were beautiful, balanced and impressive, typical of the architectural genre of the first half of the twentieth century. What was it that turned this seemingly conservative architect and aspiring baseball player into a practitioner of the most modernistic style of his time? How did he come to create what became the architectural identity of the country's largest public transportation company? This is a tale well worth telling.

William S. Arrasmith was engaged in the practice of architecture for forty-four years, beginning in Louisville, Kentucky, six

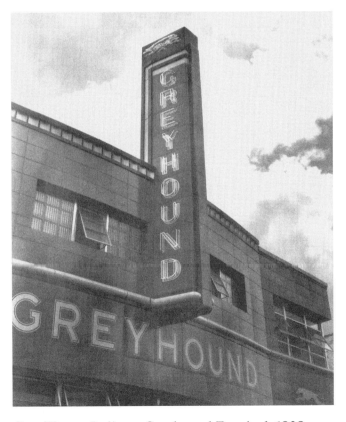

Fort Wayne, Indiana, Greyhound Terminal, 1938.

7

months after his graduation from the University of Illinois, and ending there in 1965. Arrasmith produced a wide variety of architectural work during these years, which can be conveniently separated into three different categories: his Greyhound bus terminal work (both pre–World War II and post–World War II), the construction of the U.S. Army's Camp Atterbury during World War II, and all other civilian work.

Arrasmith demonstrated a high degree of architectural skill and imagination early on in his career and quickly became a respected architect with a reputation for innovative and creative solutions to complex architectural problems.

Architectural commissions in addition to his work for Greyhound ranged from simple residential designs to massive commercial projects including hotels, high rise apartment buildings, factory complexes, hospitals, stores, shopping centers, prisons, university buildings—and even a pontoon bridge built with empty whiskey barrels.

Notwithstanding the wide variety of his many commissions, time has proven Arrasmith's streamline Greyhound bus terminals to be the most distinctive, enduring and memorable examples of his work. Although some of these bus terminals are historical and architectural landmarks, the architect who created them is much less well known or recognized. The following pages will endeavor to tell the story of William Strudwick Arrasmith and the streamline architecture that lay at the center of his commissions for the Greyhound Bus Company.

PART I

W.S. Arrasmith, 1898–1965

The Early Years

William Strudwick Arrasmith entered the School of General Engineering at the University of Illinois to study architecture in the fall of 1917. At the time, Woodrow Wilson was serving his second term as president, America's population stood at one hundred million people, and the country had only recently become a combatant in the war in Europe, better known as World War I.

With world events shifting rapidly and the nation's involvement in the war growing, Arrasmith had many things to consider when he selected the University of Illinois for his higher education. The university's excellent reputation in the field of architecture and engineering was paramount among these considerations, but it was not the only thing that influenced his decision.

Two other aspects of the school's curriculum attracted Arrasmith. One was the university's Reserve Officers Training Corps program, which had the advantage of a new armory building in addition to other recently improved facilities in which to conduct its training program. Arrasmith had always intended to become involved in the military and the program at U of I would provide him an excellent opportunity to achieve that goal at this important time in the nation's war effort.

Another consideration, and perhaps the most persuasive, was the fact that interscholastic athletics had long been recognized as a major part of the university's overall curriculum. Arrasmith had a passion for baseball, and his abilities in the sport were such that he seriously considered becoming a professional baseball player. The school was a member of the prestigious Big Ten Conference which pitted the Midwest's most respected and biggest universities against one another on the athletic field, and baseball enjoyed at least as much popularity as football on the Illini campus. The challenge of such a high level of competition was irresistible and presented a more attractive opportunity than existed at the University of North Carolina, where Arrasmith was then a student.

When Arra, as he was known to his friends, arrived on the campus of the University of Illinois in Urbana, he stood six foot five inches tall, weighed 156 pounds, had a youthful face, intense blue eyes, and wavy brown hair. These physical characteristics were enhanced by a resonant voice and gregarious outgoing personality that conveyed a friendly nature and lively sense of humor, as well as the clear impression that he was an intelligent and self-confident young man.

Born on July 15, 1898, in Hillsboro, North Carolina, Arra came from a devoutly religious Presbyterian family and was one of four siblings who were all brought up to be obedient, industrious, and polite, which helped grace him with an inquisitive mind, an artistry

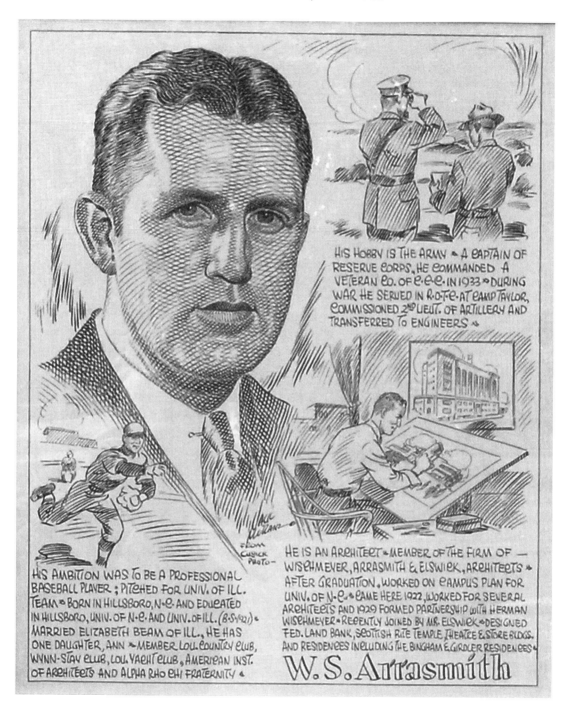

Graphic editorial of Arrasmith's life, circa 1938.

of expression, a deep sense of responsibility, and an encyclopedic familiarity with the Scriptures. Leavened with extemporaneous conversational skills and quick wit, these characteristics were to serve Arra well in both his professional and personal life, where he often used his ability to fluently quote lengthy passages from the Bible to add levity or sobriety to many a situation. He became known during his professional years as a generous and considerate man who would readily assist friends or employees in need of help of any kind.

Arrasmith's parents, Thomas and Mary, placed a high value on education. Each was the product of a long line of early American settlers and pioneers, and each inherited a deep sense of duty and obligation to be productive, morally upright members of their community. As devoted parents they did their best to guide their children along this same path.

These characteristics are not surprising to find in a family who could boast such luminaries among its ancestors as William Bradford, governor of the Plymouth Company for thirty years and second in command to Miles Standish at the Plymouth colony in 1676; Frederick Jones, a member of the North Carolina Assembly and chief justice of the Superior Court of New York in the mid–1700s; Frederick Nash, who sat on the state bench as chief justice; Abner Nash, one of the early governors of North Carolina; Shepperd Strudwick, a famous actor; and Edward Strudwick, a painter who is known for his portrait of Eleanor Roosevelt.[1]

Arra was first attracted to architecture when his family experienced a major tragedy. A fire of unknown origin burned the Arrasmith's family home to the ground when Arra was a young boy. To the surprise of many of their friends, his mother took it upon herself to design their new home.[2]

Mary Arrasmith was a person of exceptional artistic talent and she shared her training in painting, sketching, and drawing with her children. Arra inherited this talent from his mother, and by the age of seven completed a technically accurate rendering of a Roman building and had drawn several very creditable portraits. As Mary worked on the plans for the family's new home, she shared her work with Arra. The project captivated Arra as he watched his mother's drawings and sketches grow into the finished plans for their new home, and finally, into the structure itself. This early experience fanned Arra's nascent interest in architecture and he became almost as enthralled with drawing buildings as he had been with his childhood passion of playing baseball.

Although Arra was the first of his family to actually attend college, learning had always been a priority in the Arrasmith family and educational goals were strongly encouraged at home. Arra began his formal study of architecture in 1916 at the University of North Carolina in Chapel Hill.[3] Although his desire to attend the University of Illinois would mean that he would be leaving his childhood environs, his parents supported his decision and assisted him with the cost of his education.

As patriotic as any young man, Arra felt a genuine obligation to serve his country. The Selective Service had begun drafting men immediately after the declaration of war. If Arra's draft number had come up in the Selective Service draft lottery, he would have been eligible for a student deferment until the end of his first year of studies. Although under no obligation to do anything but wait, Arra joined the Reserve Officers Training Corps upon enrollment and subsequently volunteered along with many members of his R.O.T.C. unit for active duty overseas.[4] Under the circumstances, his sense of patriotism superseded both his desire to obtain an education and his hopes of playing baseball.

Negotiations to end the war had been underway for some time, but Arra fully expected— and actually hoped—that he would see military action. After receiving brief preparatory

training for being sent overseas at Camp Zachary Taylor in Louisville, orders were cut in November 1918 to ship him directly to Europe. He was transported, along with hundreds of other volunteers, to New York City for immediate deployment overseas. As he stood on a dock waiting to board a troop transport to Europe on a November day in 1918, news reached the nation that an armistice had been declared. World War I ended on the eleventh hour of the eleventh day of the eleventh month and Arra's services were no longer needed. He would be going back to school.

This turn of events left Arra with mixed feelings. He was being deprived of an opportunity to help fight for his country, but, clearly his country had managed well enough without his help, and he would now return to school to continue his pursuit of architecture and baseball uninterrupted. He had missed his chance to participate in the epic "War to end all wars," but as fate would have it, other opportunities to serve his country would present themselves.

Upon his return to school, Arra immersed himself in his studies, and baseball.

During his four years in the College of Engineering, Arra carried a full class load in addition to the many credit hours transferred from the University of North Carolina. For students in the College of Engineering, the four year curriculum which focused on architecture required one hundred thirty-five semester hours of coursework. Another seven hours were required for military drill, theory and physical education.

When he graduated from the University of Illinois in 1921, Arra had accumulated one hundred fifty-three semester hours of course work, eleven more than required for graduation.[5] He had done this while pitching for the university's varsity baseball team.[5]

Arra's freshman studies included German, history of architecture, architectural and engineering design, chemistry, business writing, hygiene, military tactics, drill and theory. German was a required course in the College of Engineering because much of the most important engineering work at the time had been done in Germany and a working knowledge of the language was essential. Other courses included analytical geometry and gym. In his second year, he took on more military courses including military law and practical sanitation, drill, national ideas in government, and war issues. He also took general physics, architectural design, working drawing, and freehand drawing. In his third year, with the threat of war now a memory, Arra moved away from military courses as he began to concentrate more heavily on architecture. In addition to architectural design and drawing he now took elementary mechanics and physics, lighting, and strengths of materials. Courses in his final year included advanced studies in areas already covered, as well as courses in building sanitation, theory of architecture, town improvement, statistics, specifications, heating and ventilation.[6]

Even while Arra pursued the study of architecture, another career path was beckoning him. Interwoven into his days in class and his extracurricular activities, Arra vigorously pursued his lifelong love of baseball. Baseball was the sport he enjoyed most, and one at which he excelled. And it was a sport that seriously challenged architecture as Arra tried to determine which profession he would choose to pursue upon graduation from the University of Illinois.

Arra had a natural talent as a pitcher, but as a young player in high school he still had much to learn. While playing on the Hillsboro High School baseball team at the age of fourteen, Arra was taught the best pitch he was to have in his repertoire by a black man who had been watching him on the pitching mound.[7] It was apparent to this man's trained eye that Arra had many fine pitches, but that he lacked a really good curveball. Arra drew on

the man's advice which helped him master the curveball, the pitch that made him a formidable pitcher. It was this curveball that helped to get him on the varsity team at both the University of North Carolina and the University of Illinois. And it was this same signature pitch that had the potential to make him a professional quality player. The pitch was a fast-breaking curve which made most batters feel that the bottom dropped out of it just when they took a swing. It was Arra's favorite pitch, and the one he used most often to get himself out of a tight spot.

And, it was the pitch that he had honed to perfection when he arrived at U of I where he was to have some remarkable experiences as a member of one of the school's all-time great baseball teams. The team traditionally played against the Chicago White Sox during that team's last three spring training sessions. This exposure to major league baseball was a highly coveted experience for U of I's baseball team and one especially looked forward to by the team members who were considering baseball as a career, as Arra was. Two of his varsity teammates signed up with major league teams. Richard Wendell Reichle joined the Boston Red Sox in 1922 and Otto Henry Vogle joined the Chicago Cubs in 1923.[8] Vogel was famous for his ability to hit home runs and was known as the Babe Ruth of the Big Ten Conference when he was a member of the 1921 conference Illini team. Reichle was on Arrasmith's 1920 team where he was an outstanding left fielder.

During 1919 and 1920, Arra pitched regularly for the varsity baseball team.[9] As Arra related the story years later to Ed Baldwin, one of his associates, when Arra walked out onto the mound to pitch his first baseball game he was scared to death. There were four thousand howling students in the stands. The plate umpire tossed him a nice new ball and the batter stepped up with a bat that appeared to be half a foot in diameter and five feet long. Arra looked around behind him to see if just maybe there was someone there to throw the first pitch for him but all he could see was the center fielder way out by the fence, apparently waiting for a home run hit. So, he knew he had to do it himself. Throwing the first pitch was the hardest one of the day. After that he was able to settle down and managed to retire the side, an auspicious beginning for a successful college baseball career.

When Arra was on the pitching staff of the Illini varsity baseball team, the University of Chicago was in the Big Ten Conference. One day when Illinois was playing at the University of Chicago, Arra was warming up behind the grandstand and he noticed an ill-kempt man who was watching him throw practice pitches. "That's a pretty good curve you got there son," the old man said. "Yes," Arra replied, "it'll do." "Say," said the man, "do you mind if I throw a few?" Arra was usually game for most anything so he said, "Sure. Go ahead," and he handed the man his glove and ball. When the old man stood up on the pitcher's mound, his rags just seemed to melt away and Arra knew right away that he was in the presence of an old master.[10]

Arra discovered that the man was Joseph "Iron Man" McGinnity who had been the mainstay of the New York Giants pitching staff from 1903 through 1908. During his ten year major league career he pitched 32 shutouts, one of which was in the 1905 World Series, completed 314 of 381 games started, won 247 games, struck out 1,068 batters, and occasionally pitched double-headers. In his 1904 season with the Giants, McGinnity recorded 35 wins and had a 1.63 earned run average.[11] Thanks to his encounter with McGinnity, Arra picked up some tips that helped further hone his already well developed skills.

In 1921 Arra's team took the Big Ten Conference championship but he was not its star pitcher. The baseball scouts had been watching him closely and the rumor was that he had a good chance of joining the Chicago White Sox. But just when his future as a professional baseball player was looking its brightest, Arra's best pitch, his curveball, did him in. Arra

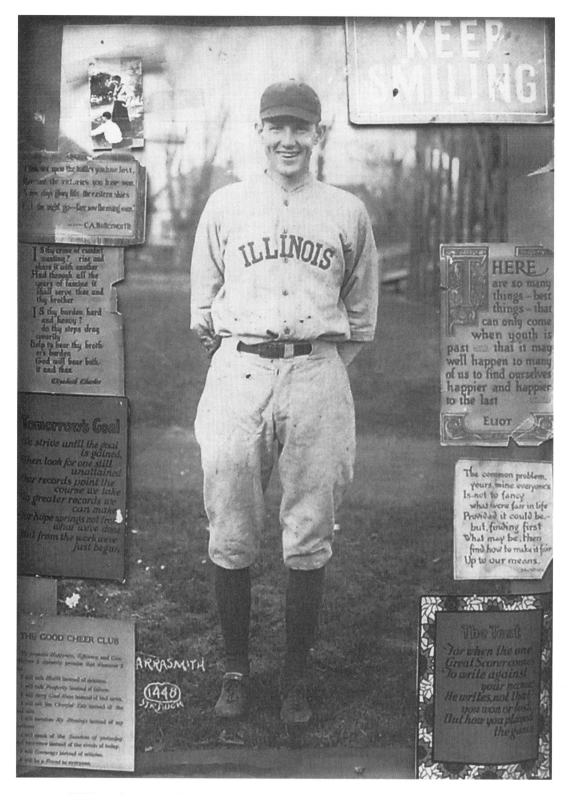

William S. Arrasmith during his baseball days at the University of Illinois.

had always pitched hard, probably too hard. He was played as the leadoff pitcher more than he should have been and, because he did not want to disappoint the crowd, the team, or himself, he often did not give his shoulder adequate time to recover between games.[12]

He also pitched more innings in more games than he reasonably should have, sometimes ignoring pain that told him it was time to stop. All of this intense pitching finally took its toll on his arm and especially on his right shoulder. Even with this injury, the Chicago White Sox thought enough of Arra's pitching abilities to call him up to Chicago for a tryout in his senior year. But the young pitcher threw his arm out trying to send his pitches past the White Sox hitters. In the hopes of being able to have his shoulder operated on, his coach referred him to the White Sox team doctor, "Bone Setter" Rees, who, after careful examination of Arra's shoulder, told him that the tendons in his shoulder were permanently damaged and that there would be no more baseball.[13]

Arra's hopes that he might become a pitcher for a major league team were dashed. He would now be only a spectator in the sport he loved best. Luckily, he had not staked his entire future on baseball as he still had a natural talent for, and a lifelong interest in, architecture. The long delayed decision between a career in baseball and architecture had been made for him. Although the national pastime lost a potentially great pitcher, the architectural profession had won a uniquely gifted and prolific talent.

The years Arra spent studying architecture at Illinois went by swiftly. He had been able to transfer a number of college credits when he moved to Illinois so that his year spent at the University of North Carolina was not lost. His coursework was absorbing and the curriculum very progressive for the day.

From the time the College of Engineering had been established in 1868, the Department of Architecture and Fine Arts had seen itself as a pioneer department and developed a strong attachment to the practicum of general engineering courses and hands-on experience. Architecture students faced the challenges of mechanical drawing, the elements of drafting, structural design, and gained first hand knowledge from inspection trips to selected sites of special architectural interest. They also participated in studio exercises involving the application of what they were learning to specific architecture problems.

The curriculum concentrated on engineering and no courses were included from other colleges, such as liberal arts. The study of engineering and architecture was technical and demanding and the University of Illinois had achieved a reputation for having an engineering program of the highest caliber, due in no small part to its practice of self-evaluation and comparative analysis of competing universities. The university regularly surveyed its alumni to learn if the curriculum had proven to be adequate when applied in the real world of business and commerce. Programs were adjusted or new ones added in response to these surveys to keep the College of Engineering at the forefront.

The most challenging of these exercises was the *charrette*, in which a class was assigned a problem that the students were required to solve within a very limited time frame, usually one week. The term for this type of assignment originated at the Ecole des Beaux Arts and refers to a type of project in which the students drop everything else and work flat out against the clock, almost without sleep for several days. They would have to produce complete mechanical drawings, elevations, and specifications for a building and submit the finished product to their professor for a grade. These charrettes took priority over everything else that might have been going on including other course studies, social activities, extracurricular obligations, and for Arra, varsity baseball.

The charrettes helped prepare student architects for the rigors of practice in their chosen field once they left school. But there was nothing that could be substituted for the experience of what life in the office of a practicing architect was actually like. In the summer of 1918, Arra secured an internship with T. Charles Atwood of Chapel Hill, North Carolina, an architectural engineer with whom he had become acquainted while at the University of North Carolina.[14] Mr. Atwood was a nationally recognized engineer and, some said, the best in North Carolina. His reputation was such that in 1921 he was selected by the University of North Carolina's building committee as supervising engineer for the school's $10 million, ten building campus expansion program. Atwood worked side by side with Arthur C. Nash of McKim, Mead and White of New York, supervising architect for the project. Mr. Atwood developed a close working relationship with Nash and the McKim, Mead and White firm during the university expansion project, which would accrue to Arra's benefit upon his graduation from the University of Illinois.

Mr. Atwood had been impressed by Arra while he was at the University of North Carolina, which led to Atwood's invitation for the intelligent young student to work with him during the summers. It was an excellent opportunity that any aspiring architect would wish to have, and it was Arra's first exposure to real life architectural work. It also allowed him to be near his home town of Hillsboro which was just north of Durham, North Carolina. Arra spent three summers as an intern with Mr. Atwood,[15] during which time he was able to apply what he had learned at school to real world problems in a working office.

Through Mr. Atwood's guidance Arra developed an appreciation for classical architecture

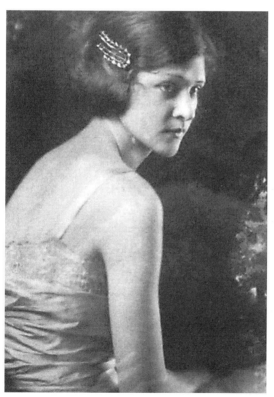

Betty and William Arrasmith at the time of their graduation from the University of Illinois.

and burnished his facility for designing in that style. Arra worked on a variety of commissions during these summers with Mr. Atwood, and it was through this experience that he learned what it was like to be a practicing architect. One of the things he soon discovered was that he was much more comfortable in the role of creative artist than in that of exacting draftsman. Throughout his career Arra was to find the design aspect of architecture much more to his liking than work involving specification, engineering and mechanical considerations. He developed competency in these areas, but his nature was such that he preferred to let someone else handle those aspects of a job whenever possible. One of his closest associates, Ed Baldwin, who did the engineering work for Arrasmith's firm after World War II, said that Arra would design the building and then hand the plans to Ed and kiddingly say, "Here's the plan, now you hold it up with something."[16]

Another thing Arra learned from the summer internships was where his tastes in architectural design lay: he found that he was developing a preference for the work of certain outstanding architects of the early 1900s.

Of particular importance to him were Louis Sullivan and others of the Chicago School of Architecture who had played an important role in the development of skyscraper design and construction, which had become an economic necessity because of the ever rising cost of scarce land in large metropolitan centers. The use of a structural steel skeleton in place of masonry had permitted wide glass windows and other new design innovations which captured Arra's imagination.

Although a trend toward more modern architectural design was beginning to develop in the early 1900s, Arra preferred the more imposing and embellished Chicago style to the relatively featureless newer style. As Arra developed his own personal style, he would reach back to the Chicago School and its practitioners for inspiration. A combination of modern structural designs with more traditional and richly expressive styles, such as Roman, Greek, and Italian, increasingly attracted Arra as his studies continued. He was also developing a preference for large commercial architectural projects, as opposed to residential architecture, as a result of his attraction to Sullivan's work. All of these things, and more, would influence his professional career.

In addition to his summer internships with Atwood, Arra's participation in college sports, and carrying a full load of classes, Arra enjoyed many other aspects of college life. He pledged the architectural fraternity Alpha Rho Chi and as a fraternity member enjoyed many social and fraternal events. Arra was well above average scholastically which left him with plenty of extra energy to devote to fraternity activities, campus social life and of course baseball, where he distinguished himself by being the only architecture student to have been on a varsity team during his years at the University of Illinois.[17] Arra also found time to meet, court and marry a bright young coed named Elizabeth "Betty" Beam whom he had met at a local dance. Betty's family was from Illinois, and therefore a Northerner in the eyes of anyone from North Carolina. This fact could have caused some difficulty in view of Arra's southern origins but the situation was amusingly resolved when his parents, who were very impressed with Betty, decided she was really a western girl. With the approval of both families, the way was cleared for Arra and Betty to get married.

When Arra graduated from the College of Engineering with a bachelor of science degree in 1921[18] he left behind his dreams of becoming a professional baseball player to focus on a career in architecture that now lay before him and he took with him a lasting commitment to the military service that would play at least as important a role in his life as the profession of architecture.

Wischmeyer & Arrasmith Forms in Louisville

Arra's decision to transfer to the University of Illinois had been influenced by a number of factors which have already been discussed but there was one additional reason for his choice. His best childhood friend and fellow aspiring architect, Girdler Webb, who was a year ahead of Arra in school, had chosen Illinois for his formal training in architecture.

When Arra's mother began working to design a new house to replace the one lost in a fire, Girdler shared Arra's enthusiasm for the project, and it subsequently developed that this tragedy piqued their mutual interest in architecture and cemented their resolve to become architects themselves and one day open an office together. It was this longtime boyhood dream that began to reach fruition while the two were studying architecture at the U of I.

Upon his graduation from Illinois in 1920, Girdler moved to Louisville, Kentucky, to begin his professional career in the employ of a prominent architect and old family friend, Brinton B. Davis. Mr. Davis was one of many influential people with whom Girdler's family and relatives were acquainted, and Girdler promised Arra that he would work to make it possible for Arra to join him at Mr. Davis's firm.[1]

When Arra graduated from the University of Illinois he accepted a position with McKim, Mead and White in New York City.[2] After working there for six months he moved to Louisville in anticipation of joining Girdler at Mr. Davis's offices. In the meantime he accepted a position with local architect E.T. Hutchings[3] who had an office in the Heyburn Building in downtown Louisville. Arra spent a year with Hutchings honing his drafting skills and becoming familiar with the architectural community and the professional customs of this important Kentucky city.

In 1923 Arra received the good news he had awaited when Girdler Webb told him that the long anticipated moment had finally arrived. Brinton Davis had agreed to take Arra on as a draftsman and, with two years of professional experience behind him, Arra joined his friend at Mr. Davis's firm.[4]

Brinton Beauregard Davis was born in Natchez, Mississippi, in 1862[5] and, as architects of some years ago would say, he was "born with a pencil and a rule in his hands." Very early on in his life he demonstrated an ability to draw and an aptitude for the artistic expression of his creative talents. His father was an architect of note in Natchez, and as a boy and a young man, Brinton spent seven years under his father's tutelage studying architecture.

His formal education included attendance at the Eustace Academy and the Natchez Institute. Upon receiving diplomas from these schools, he left his home town and moved to New York where he spent two years, 1884 and 1885, as a general draftsman under S.A. Stratton of the architectural firm of Stratton & Elsworth. He then spent four years working in Chicago followed by seventeen months with J.B. Legg of St. Louis, Missouri, during the years 1890 and 1891. In 1891 he settled in Louisville, Kentucky, and in 1902 opened his own office as a sole practitioner where he worked for the balance of his seventy year career as an architect.[6]

Although Davis never had any formal academic training in the field of architecture he was admitted to the American Institute of Architects as a Fellow in 1897, one of a limited number of architects so elected. He was also a member of the Society of Art in London, England, as well as being one of Kentucky's oldest members of the Knights Templar. Having been a captain in the Spanish-American War, he enjoyed the privilege of using the titles captain or honorable before his name when suitable. When Kentucky passed a law requiring the registration of architects in 1930, Brinton received certificate No. 12.

Mr. Davis was one of Kentucky's foremost architects and his commissions were for the largest and most complex of buildings. Among the many impressive buildings bearing his name were the Hopkinsville High School, the Jefferson County Armory, the Kentucky and Watterson Hotels, and the Kentucky Home Life Building. He also designed most of the buildings on the Western Kentucky State College campus at Bowling Green and completed many out-of-state commissions in Illinois, Georgia, Tennessee, Mississippi, and Florida. Davis never liked designing houses. Although the father of two daughters he was often quoted as saying, "If you build houses you have to work for the fair sex, and durn 'em, you can't please 'em."[7]

When William Arrasmith went to work for the sixty-one-year-old Mr. Davis he was well aware of the gentleman's stature within the profession and the community. It was a privilege to work for such a man, and Brinton would play an important part in influencing Arra's appreciation for classical and traditional architecture.

Mr. Davis held very firm beliefs about the modernist movement, a movement that Arra would ultimately play such a large part in developing. Davis didn't like it. He felt it was based on illogical methods and that practitioners of modernistic architecture were using ornamentation simply to make a change. He said in a speech before the American Institute of Architects that "an unrestrained use of thin veneers of glass and other synthetic materials, and the utter disregard of the laws of gravity, tend to give the modernistic structure a flimsy, temporary appearance," and that these structures lacked "dignity, repose, and endurance."[8]

Davis preferred traditional building materials such as brick and stone resting solidly on the ground. He believed that architecture was, of all the arts, the one most continually before our eyes. To Davis, good architecture was frozen music, because it was a harmonizing of every part with every other part. For him Greek architecture was the pinnacle of the art. Davis felt a special duty to the community and the country to produce the very best expression of the nation's highest ideals in his architecture—because they would speak for the age when viewed by those who came after.[9]

Arra was to absorb much of this philosophy while working for Mr. Davis and it would deeply influence his work into the early 1930s. After that, his work would take an entirely new course, one of which Brinton Beauregard Davis undoubtedly would not have approved.

Arra threw himself into his new responsibilities at Davis's firm with abandon. He found every assignment an exhilarating opportunity to apply what he had learned in all the years he spent studying, reading, drawing, and working in architectural offices. Being able to discuss ideas and compare design approaches on real architectural questions with his boyhood friend was a bonus—and a fulfillment of a dream of many years.

The new job was demanding but Arra and Betty nevertheless found time to meet new people and make friends in Louisville. Although they had come as strangers to their new town, they did not remain so for long. They soon became active in the community's social life, and it was during these first few years that they met many of their lifelong friends and business associates. Among these were several who were to play an important part in Arra's future professional life—Louisville architects Stratton Hammon, Hermann Wischmeyer and Frederick Elswick.

While Arra was working hard at his professional assignments, Betty was equally hard at work overseeing their new home and making sure that the "salad days" of their new life would be as comfortable as possible. Managing to get by on the salary of an architect only two years out of college was a challenge, but Betty's careful management of the family finances allowed them a pleasant enough life on Slaughter Avenue.

When Arra began working for Mr. Davis, the firm was occupied with a commission for the design and construction of the Kentucky Hotel to be erected at Fifth and Walnut in the center of downtown Louisville. This was a challenging job, and Arra played an important part in the design of the building. But of course, the name of a junior like Arra would not appear on the plans or any of the other work he did for his employer. Mr. Davis would relay to Arra what the client had told him was wanted and, under the guidance of Mr. Davis, it would be up to Arra to interpret these specifications and express them on paper. When the renderings were completed, Mr. Davis would present them to the client under the firm name, Brinton B. Davis, Architect.[10]

Neither Arra's nor Girdler's names appeared on the drawings. While this may not seem particularly fair, it was the accepted practice and had been expected by both Arra and Girdler. The recognition they received for their efforts, beyond their paychecks, was in their growing stature in the architectural community. Louisville was a young city with a close professional community and word of the work they were doing for Davis had currency and recognition among their peers.

Arra became fully absorbed in the Kentucky Hotel project. It was destined to become one of Louisville's most enduring downtown landmarks and one that would enhance the reputation of Mr. Davis's firm, and Arra as well. The hotel, in the neoclassical genre, perfectly fit Arra's ability to translate traditional design themes into contemporary applications. From the date of its completion up to the present, it stands as an excellent example of the traditional architectural style for which William Strudwick Arrasmith would become most identified during the subsequent thirteen years of his career. It would not, however, be the style for which Arra would ultimately be best remembered.

That style was to develop later and would emerge with a flourish. Meanwhile, other commissions requiring Arra's maturing abilities continued to flow through Mr. Davis's office, keeping Arra busy.

As the first few years slipped by, the blush of Arra's new job with Mr. Davis began to pale. It became apparent to Arra and to his friend Girdler that Mr. Davis, although a highly regarded architect of long standing in the community, was a very hard taskmaster—hard to work for and hard to please. The two young men began to feel that he had a tendency to

be arbitrary and demanding. But Arra did his best to overlook this aspect of the job and concentrated all of his efforts on his projects. His work was of unusually high quality for someone his age and his talents and contributions were beginning to be recognized by more and more people in the business and professional community in Louisville. But, the less-than-comfortable situation with Davis galvanized the resolve of the two friends to act on the plans they had laid down for a partnership in their own firm, and to act to realize this goal as soon as possible.[11]

By 1925 (Arra's second and Girdler's third year of working for Mr. Davis) it was apparent to both that the sooner they could manage to open their own office the better. They made and postponed a number of deadlines, but finally set a date to

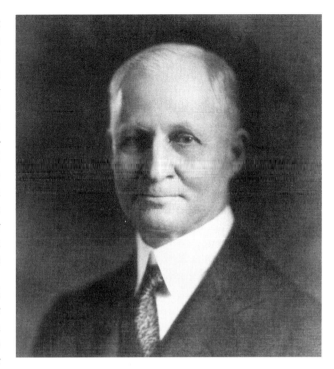

Louisville architect Brinton B. Davis.

leave Davis's employ, obtain their own commissions, and begin to take full credit and responsibility for their work. They agreed to delay telling Davis about their plans long enough to give Girdler time to marry his childhood sweetheart and take a honeymoon trip.

Girdler's wedding day was set and it was not long before the happy day arrived. With the church full of friends and relatives, and Arra acting as best man, the couple was wed. Arra saw to it that Girdler and his new bride departed on their honeymoon in the traditional manner, their car appropriately decorated and trailing a string of clattering tin cans. The only unusual thing about this traditional picture was that the couple was not departing on their honeymoon alone. Girdler's parents were accompanying the newlyweds during the first few weeks of their marriage. Meanwhile, Arra stayed behind marking time, doing Davis's bidding, and awaiting Girdler's return so they could make their break from Davis.[12]

But tragedy overtook these plans. On the couple's return trip to Louisville, their car was hit by a train as they crossed the tracks at a grade crossing. Girdler, his bride, and his parents were all killed instantly. Arra had lost his colleague, his intended business partner, and his closest friend. He also lost another of his long cherished dreams. Injury had prevented him from becoming a professional baseball pitcher and now he had been deprived of working side by side with his best friend in their own architectural firm.

It was a severe blow for Arra, but even as he and Betty struggled to reformulate their plans, fate dealt him one more reversal. He lost his job with Brinton B. Davis. This was totally unexpected, but with Girdler Webb gone from the office and the senior Webbs no longer alive, Davis may have felt that he did not need to honor a promise to his late friends and keep William Arrasmith in his employ since Arra had ridden into the office on the coattails of his friend. Besides Mr. Davis may have felt that the number of commissions coming into the office was not sufficient to retain Arra. At sixty-three, Davis had perhaps

passed the apogee of his career as an active Louisville architect, and he may even have been aware that Arra was thinking of leaving. Whatever his reasons, he fired Arra in 1925.[13] His timing could not have been much worse. Betty had just delivered their first child, a daughter named Anne, and the Arrasmith family income was reduced to zero just when it was needed the most. Arra's immediate need was to find employment as quickly as possible.

When Arra graduated from the University of Illinois in 1921, the dean of the School of General Engineering, Harvey H. Jordan, delivered a commencement address that contained some advice Arra found he could never afford to forget. Dean Jordan, who had taught engineering drawing since 1911 and who was a fixture of the U of I scene until 1953, was a man of intelligence and foresight. He was highly regarded by his colleagues and students and his words were well worth listening to. The dean advised Arra's graduating class that there were three basic principles that would lead to success in the architectural profession. In order of importance, these rules were: get the job, Get The Job, and GET THE JOB. Luckily, Arra had a natural ability to sell himself and it was fairly easy for him to follow the good dean's advice—which he now had to apply to the fullest.

With his family responsibilities escalating, Arra set out to get a new job, and the faster the better. Fortunately his professional reputation had grown substantially during the time he was with Brinton Davis's firm and it did not take long for opportunities to present themselves. Arra accepted the first offer that came his way, a position with Helm Bruce, a Louisville residential real estate developer, contractor, and friend.[14] Shortly after joining Bruce, E.T. Hutchings, with whom Arra had worked when he first came to Louisville, asked Arra to come to work for him again, or at least until he found a more permanent situation. The position with Mr. Hutchings would involve designing commercial structures, and solving commercial architectural problems, which was much more to Arra's liking, and, with Bruce's blessings, Arra accepted Hutchings' offer.

Meanwhile, word of Arra's abrupt dismissal by Mr. Davis continued to spread through the Louisville architectural community, which resulted in yet another offer coming his way in 1926. Clarence J. Stinson, one of Louisville's senior architects, had known Arra since he came to Louisville in 1922 and their relationship had grown during their mutual association in local professional organizations.

Mr. Stinson, a sole practitioner, was among the first one hundred registered Kentucky architects. He had been impressed with Arra and his abilities, and he felt that the two of them could work profitably together. Thus, Mr. Stinson now approached Arra with an offer to become associated with his firm. After relatively brief discussion it was agreed that Arra and Mr. Stinson would join forces and form the new architectural firm of Stinson & Arrasmith, with offices in the McDowell Building in downtown Louisville.[15] Mr. Hutchings and Arra parted on good terms and the new firm opened it doors with the stated purpose of engaging in the general practice of architecture.

Now that Arra was a partner with Clarence J. Stinson, he and Betty once again felt the assurance of a permanent job that presented a good future. The Arrasmiths' earlier concerns were laid to rest and they could now feel comfortable in the knowledge that their home and hearth were safe.

Over the following two years Clarence and Arra worked diligently to build the new firm's reputation and develop its clientele. Mr. Stinson had already established a respectable client base and Arra was able to build on it thanks to his gregarious personality and talents as a salesman. Although he had never before been in a position to secure commissions for himself it came to him quite naturally. For Arra, one of the best things about the Stinson

& Arrasmith commissions was that they were largely commercial rather than residential. Arra had a strong preference for commercial work and, although he could execute a residential commission with skill, he found the world of commercial architecture much more suited to his professional interests.

As a partner in an architectural firm, Arra's stature among his colleagues continued to rise. He became a more prominent member of the Louisville architectural community and architects of high standing were taking notice.

In 1928 an opportunity that would ultimately develop into a long-term relationship came Arra's way. He was approached by one of Louisville's most highly regarded architects, Hermann Wischmeyer, to become his associate. Wischmeyer planned to end his association with the firm which bore his name, Nevin, Morgan & Wischmeyer, and establish his own practice. He was certain that there would be enough work for two architects in the new firm. Nevin, Morgan & Wischmeyer was well known in Louisville at the time, and to have Mr. Wischmeyer ask Arra to be his associate was both a stroke of extreme good fortune and the highest of compliments. An association with Mr. Wischmeyer held the potential for being even more lucrative than his partnership with Mr. Stinson, successful as it had been.

Mr. Wischmeyer had been practicing architecture for thirty years. Although he was a native-born American citizen, his parents had immigrated to the United States from Germany in the mid–1800s, settling in Boston, Massachusetts, where Hermann was born in 1875. The family moved to Louisville the next year and when Hermann reached his teen years, he attended Louisville Male High School, graduating in 1893.[16] His parents encouraged their son to travel to Germany for his higher education, and he received his architectural training at the Polytechnic Institutes of Hannover and Munich. Graduating in 1897 he returned to Louisville to pursue his career in architecture.

His first job was with the heating and engineering firm of Joseph McWilliams & Co. In 1899 he left McWilliams & Co. to become general draftsman and superintendent in the office of D.X. Murphy & Bro. in Louisville. In 1905, Mr. Wischmeyer left Murphy & Bro. to return to Germany where he attended the Polytechnic Institute at Dresden. Upon his completion of studies there he traveled briefly in Italy returning to Louisville in 1906 to open his own office as an independent architect in the Kenyon Building.

Mr. Wischmeyer continued his independent practice until 1912 when he formed the partnership of Gray & Wischmeyer with George H. Gray and

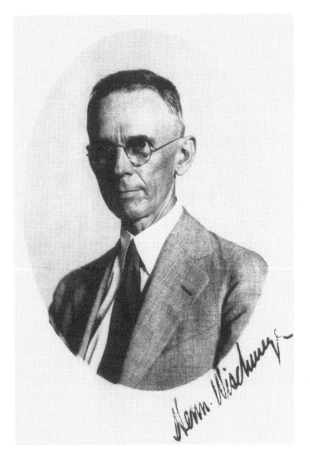

Hermann Wischmeyer.

opened an office in the Starks Building. The firm was dissolved in 1917 when George Gray entered military service and Hermann was once again an independent architect. In 1920 he became a partner in the firm of Nevin, Morgan & Wischmeyer, also in the Starks Building. This relationship terminated in 1928 when Wischmeyer and Arrasmith established their firm in the Heyburn Building under the name Hermann Wischmeyer, Architect, W.S. Arrasmith, Associate.[17] Wischmeyer was fifty-four years old and Arra was thirty-one.

Mr. Wischmeyer's position as a partner with a larger Louisville firm, and the prospects for important commissions that this might provide, was a factor in Arra's decision to join with Wischmeyer. The new arrangements proved to be ideal. Wischmeyer was a pleasant sort of fellow to be with, and he possessed that very important ability for any successful architect: he could "get the job." His forte was his ability to secure important commissions on a regular basis, and he was able to keep himself and his firm reliably busy.

Hermann's wry sense of humor and engaging personality made him a very approachable co-worker. The fact that he sometimes reminded people of a forgetful professor led family and close friends to call him Wishy. Arra had developed an ability to obtain commissions while working as partner with Clarence Stinson, and the new architectural firm began building an impressive list of clients. (Hermann and Arra would remain in the Heyburn Building until Mr. Wischmeyer's death in 1945.) Arra could now look back on Brinton Davis's decision to fire him without warning the year before and reflect that "Brinton had kicked me right upstairs"[18] at just the right time.

The firm of Wischmeyer & Arrasmith was busy from the very beginning and often had more work than it could manage. One of Arra's earliest friends in Louisville, and a fellow architect practicing on his own, Stratton Hammon, was asked to work with the firm from time to time drafting and performing various assignments on an as-needed basis. This method of obtaining timely assistance was a common practice among the architects in Louisville and the arrangement worked out nicely for all concerned. Help was available when needed, individual architects retained some autonomy, and everyone had some share in the work that was available. Wischmeyer & Arrasmith rapidly joined the world of well-established Louisville architectural associations, a position of distinction that it would enjoy throughout its existence.

Notwithstanding Arra's newly elevated position as Mr. Wischmeyer's associate, Betty and Arra did not feel comfortable about purchasing a new home or otherwise adopting a lifestyle that reflected Arra's new position in the professional world. They continued to live modestly, as they would throughout their lives even when experiencing considerable professional and social success.

However, as time went on, Arrasmith could afford to indulge in small luxuries that reflected his professional stature both publicly and privately. Soon a Homburg hat and well-tailored suits became the trademark of this prominent Louisville architect. He indulged his enjoyment of good food in pleasant surroundings by always having an old-fashioned Southern breakfast at home that usually consisted of ham, eggs, home fried potatoes and grits. Southern style evening meals were equally relaxed, with the family never dining until after the sun went down. Both Betty's and Arra's families adhered to the social conventions of the day and dinner at home was a semiformal occasion. Arra's Southern upbringing, which emphasized gracious living, was consistent with his practice of being well dressed at all times. Although Betty was a "western" girl, as Arra's family called her, she had been brought up

to be a cultured woman and the formal dinner practices suited her. Besides, both Betty and Arra relished this opportunity to relax at dinner time and appreciated the chance to wind down after their busy days.

Another luxury the Arrasmith family could now afford was household help. Daughter Anne was growing up and Betty decided to break with the tradition of staying at home full time to manage the household. Her duties as a homemaker no longer demanded the time they had when the Arrasmiths were first setting up housekeeping, and now that their daughter Anne was going to school, Betty had more free time during the day. She took employment as a social worker, a profession she had prepared for while attending the University of Illinois. The additional income made it both possible and desirable to secure household help, and the Arrasmiths looked for someone who would make it possible to maintain the patterns of gracious living they had established. Household help was very inexpensive. A fair wage for a housekeeper was nine dollars a week, and for this wage a housekeeper would come at seven in the morning and not leave until nine o'clock at night.

As the family prospered, Arra and Betty continued to resist any impulse to move to a larger house or a more fashionable neighborhood, but Arra did develop a love of large luxury cars, and the family garage usually contained either a Chrysler or a Lincoln for him and a Chevrolet for Betty. Arra also liked his cars new, and the family would keep cars for only three or four years before trading them in, even during the worst years of the Depression. Arra would never special order a car just as he never got involved with the designing of his own home. Most of these cars, as well as other major purchases, were instead acquired from what was available at the time of the decision to make a purchase.

When it came to leisure time and sports, Arra liked to go fishing, and he took trips to Florida and Lake Michigan. Fishing trips were camping trips and Arra enjoyed the experience. He seldom brought any of his catches home, preferring to cook and eat fresh fish on the spot. He did save a few of his most impressive catches, some of which he had mounted and used to decorate the walls of his living room and his office.

Arra would also escape the daily routine when work permitted. He especially liked to be with friends who shared his interest in outdoor life. Despite a demanding schedule and a rather orderly approach to living, Arra was on occasion known to do things on the spur of the moment when the opportunity presented itself. One of these moments occurred when a friend who was a pilot induced Arra to take an afternoon off. They flew around the Kentucky countryside, returning just in time for Arra to dash home, get dressed and attend a previously scheduled social function with Betty.

Arra also played golf regularly and enjoyed playing squash. He kept baseball in his life both by playing occasionally and by sponsoring Little League baseball teams in Louisville.[19] He had an interest in coaching, and made himself available to team managers. When Arra was a young boy he had not had the advantage of Little League training, and he viewed it as a valuable experience in learning how to play the game properly. He followed Little League baseball closely and attended games whenever his work schedule allowed.

In his free time, at home and on the road, Arra always liked to read and was seldom without a book, his favorite being *The Fountainhead* by Ayn Rand, the well known story of an aspiring architect who valued professional principles above monetary rewards. He also enjoyed anything by Hemingway, especially *The Old Man and the Sea*. As for the rest of his free time, Arra preferred to spend it listening to a baseball game on the radio. Not surprisingly, the

W.S. Arrasmith proudly displays a fishing trophy.

Chicago White Sox games were his favorite. He had played against the White Sox with his U of I baseball team during summer training and now enjoyed following their exploits every season, although he was seldom able to attend a White Sox game. When there were no baseball games on the radio, he liked to tune in *Amos 'n' Andy*, one of the country's most popular radio shows of the day.

Wischmeyer & Arrasmith
During the Depression

Shortly after the newly minted firm of Wischmeyer & Arrasmith opened its doors, it received a commission for one of the earliest airport terminals and administrative buildings in the country. A very forward-looking group of city planners decided that Louisville could become an important point along the rapidly multiplying air routes that were beginning to crisscross the country in the late 1920s. With its central location and a population approaching 300,000, Louisville was uniquely positioned to become a significant air link for the nation's major population centers.

Kentucky had become the first state to enact legislation establishing an airport authority. Following the state's lead, Louisville took steps in early 1927 to create a municipal airport by proposing a bond issue to purchase the privately owned and operated Bowman Airfield which was situated on the city's outskirts. The bond issue passed and the Louisville and Jefferson County Air Board was formed.

The timing could hardly have been more propitious. Charles Lindbergh had just made his heroic solo flight across the Atlantic Ocean and an enthusiastic and flight-minded citizenry had been swept up in the drama and promise of flight and what it could do for Louisville. The need for a terminal building to serve the newly established municipal airport was immediately addressed and the contract for its design and construction was awarded to the firm of Wischmeyer & Arrasmith.[1]

This contract was an important one in the development of the firm because it was a high profile commission that held the potential for raising the firm's visibility and enhancing its reputation. It provided an opportunity for the two partners to design a major public building that would serve as the aeronautical gateway to Louisville, and offered the additional prospect for an entree to more government projects in the future.

As the first permanent building at Bowman Airfield, the terminal had to serve several separate functions. Not only would it act as the airport's terminal for passenger traffic, it would also provide space for the airport's administrative offices and house the control tower as well. To satisfy these requirements, Wischmeyer and Arrasmith designed a four story Art Deco building using a simplified skyscraper motif common to this style. The facade was red brick with stone frieze work and caps. The three story central section contained a lobby which gave passengers direct access from the driveway and parking area to the airplane boarding ramp. The control tower was located on the airplane ramp side of the building's fourth story, and the terminal and administrative offices flanked the central lobby area.

The building was completed in 1929 but it was to be another ten years before the airfield received paved runways. In the early days of flight airports were nothing more than huge open fields, often a mile square in size. There were no designated runways, and pilots could land and take off from whatever was the most advantageous direction or location on the field. Because the early planes did not have brakes, the freedom of unrestricted use of the entire field unencumbered by specified runways was a safety as well as a convenience factor. The city planners' expectations for the success of the airport were realized early on in its operation as a municipal airport, and Bowman Airfield quickly became a major air link to other large metropolitan areas for passenger and contract air mail carriers. By 1934 Bowman Airfield was served by American Airlines and Eastern Air Lines, which would be joined in short order by other major carriers as air traffic continued to expand across the country.

During World War II, Bowman Airfield would be chosen by the Army Air Corps as a location for its new pilot training facility, and it would become one of the nation's busiest airports. By the end of the 1970s it was the country's second most active airport for local traffic. Although the control tower was moved to a new Federal Aviation Administration (FAA) structure in 1965 and newer structures have taken over many of the original functions, the Wischmeyer & Arrasmith building continues to serve the airport as an administration office building—a testimony to the success and flexibility of the firm's early design work and foresight.

Hermann Wischmeyer was a member and officer in several civic organizations and was especially proud of his standing in the Mason's Scottish Rite Lodge No. 400 in Louisville where he was both a Thirty-second Degree Mason and a Noble of the Mystic Shrine. His relationship with the lodge resulted in Wischmeyer & Arrasmith obtaining one of its earliest jobs, a commission for the design and construction of the new Scottish Rite Temple for the Ancient Free and Accepted Masons near downtown Louisville.[2]

This particular project represented a unique challenge. The Masonic Order, sometimes referred to as the Freemasons, is one of the world's oldest fraternal organizations and is rooted in traditions that date back to biblical times when Solomon's Temple was under construction. It brings together Christian men of various sects and opinions for personal growth and fellowship. Ceremonies dramatize specific stories associated with Masonry and are enacted with the use of elaborate costumes. The rituals of the Scottish Rite required that Hermann and Arra pay careful attention to architectural details of the new temple in order to conform with the society's needs.

The Scottish Rite Temple they designed contains a huge and lavish auditorium befitting the extravagance of the rituals performed by the Scottish Rite members. The quality of its materials and workmanship is exceptional and the interior rivals even the most elegant theaters of the era. Arra's hand is evident in this building, and its design echoes many of the features of the Kentucky Hotel, done while Arra was in the employ of Brinton B. Davis. The Scottish Rite Temple is neoclassical in style and is a superlative example of what the firm of Wischmeyer & Arrasmith was capable of accomplishing. The bulk of Arra and Hermann's effort, and most of the available budget for the exterior of the building, was expended on the front elevation with its superb detail and cornice work. The design focuses attention on the street front facade by utilizing comparatively plain side and rear elevations which have much less embellishment. The overall effect is most pleasing, and one would never guess that its execution involved even the slightest concern for budgetary rather than aesthetic considerations. The finished limestone temple was a credit to the young firm.

The Wischmeyer & Arrasmith firm was progressing particularly well considering the

difficult economic conditions. Two other important early commissions that materialized in additions to the Scottish Rite Temple included the Reelfoot Lake Hotel in Tiptonville, Tennessee, and the $300,000 remodeling of the Kosair Temple and Hotel in Louisville, Kentucky, for the Farm Credit Administration in 1934.

The growing firm often had its choice of commissions, enabling Hermann and Arra to devote virtually all of their efforts to the pursuit of commercial work. They did not generally accept commissions for residential work, a preference which dominated the balance of Arra's career. Over the years Arra did design homes for particularly insistent clients and a few friends who pleaded with him to assist their personal commissions—quite a concession for a man who would not even participate in the design of his own home. He often quipped that these people would then cease to be his friends.

Arra's aversion to designing his own home is not uncommon among architects. Many architects feel that such an undertaking would take away from time that could be devoted to winning commissions or completing projects, and that it would hamper their firm's main objective—earning income. It would also cut into the free time they might enjoy away from the job. Architects like Arra were also likely to be perfectionists, and they realized that they would undoubtedly spend untold hours overseeing their home's construction only to be less than satisfied with the completed structure. Architects often solved this problem by purchasing an existing house which would satisfy their need for a comfortable home without interfering with their professional practice.

But concerns about husbanding time would quickly prove to be immaterial. While the national economy was booming and the architectural industry was enjoying the boom, dark clouds were forming on the economic horizon that virtually no one seemed to notice, least of all anyone who attended the opening ceremonies of the new Bowman Airfield terminal. None of them had premonitions of what lay in store for the United States just a few short

Bowman Airfield terminal, Louisville, Kentucky, 1929.

months later when the stock market crashed on October 29, 1929, and sent the country into the Great Depression.

The building industry was among the first to feel the effects of this catastrophe. Except for projects already underway, commercial construction came to an almost complete stand-still.[3] With the economy so uncertain, no business enterprise wanted to commit itself to a significant and expensive undertaking that involved new construction.

Since architects were the first to be involved in any such project, they were the first to be hit when company after company decided not to build, remodel or refurbish ... just now. Architectural firms in Louisville and across the country experienced a very sudden and dev-astating loss of business. The annual building season, which would traditionally begin in the spring with a rush of clients ready and anxious to get their projects underway, never materialized. Louisville architects stood by their empty drafting boards with nothing to do. As Arra's friend and fellow architect Stratton Hammon put it, "It was as if the salmon for-got to show up at the appointed time in the Columbia River."[4] The old "no way but up" euphoria of the late 1920s and the Jazz Age had lulled just about everyone into expecting the good times to last forever. Wischmeyer and Arrasmith were not alone in wondering how so many people could have been so wrong.

Compounding the problem was the fact that the gold standard had recently been replaced by the managed money standard, and it was now up to the Federal Reserve Bank to adjust the availability of money to suit economic circumstances. This was the first crisis it had to face under the new monetary system and the board badly misread the economic conditions, tightening monetary purse strings just when they should have been loosened. This resulted in increasingly high interest rates accompanied by deflation. In Louisville, the cost of borrowing money soared as it did nationwide. Companies that had been consider-ing construction projects found themselves unable to finance those projects, and many were fearful that real estate ventures would not be wise investments for the foreseeable future. As a result, commissions that had been granted were withdrawn if construction had not yet begun, and even some projects that were underway were halted dead in their tracks. Archi-tects, along with virtually everyone else in the construction industry, were among the hard-est hit as the Depression tightened its grip on the national economy.

And perhaps most unfortunate of all, the momentum that firms like Wischmeyer & Arrasmith had carefully built up was now at risk of being dissipated just when it was begin-ning to take hold. How long could this state of affairs continue? How much damage would it ultimately do? What, if anything, could be done? These questions were on everyone's minds. The fact that Wischmeyer & Arrasmith survived these difficult times was due to a combination of talent, cooperation, and good fortune.

The crash put many Louisville architects out of business, but Wischmeyer & Arrasmith managed to hang on. The firm accepted whatever jobs it could secure. Expenses were reduced by cutting back on the entertainment of clients, adjusting staffing and carefully managing the costs of operation. Any decision to reduce staff was an agonizing one, especially if the individual affected was a colleague and close friend. Not only were jobs scarce, but there was no Social Security, no jobs program, no relief program, and no unemployment insur-ance. Anyone with a pink slip would find little in the way of public or corporate assistance to help get them back on their feet.

Two of Arra's friends and fellow architects, Stratton Hammon and Fred Elswick, had lost their jobs and decided to consolidate their resources by joining forces with Herbert Redman, a mutual acquaintance and Louisville architect. The three set up offices in the

Starks Building in downtown Louisville. Their offices became a gathering place for their friends and professional colleagues to work out personal and architectural problems, discuss ideas, and consider the circumstances that discomfited them all. Many times, Arra and Wischmeyer would drop by the Starks Building to participate in these gatherings. This informal club, formed as a result of the unfortunate economic conditions of the times, would eventually have a most fortuitous impact on Arra's circumstances. But good fortune of any kind was still a long way off.

It was now apparent that the economy was not going to immediately bounce back nor would the downturn quickly run its course. Governmental agencies and many major industrial organizations mounted efforts to stimulate the economy. Federal projects, including the well known Civilian Conservation Corps (CCC), the Works Progress Administration (WPA), and a multitude of other agencies, were organized to help stimulate the economy. These were designed to put the nation back to work and money back into the economy as part of President Roosevelt's New Deal.

Professional and industrial organizations initiated programs to prime the economic pump for their respective constituencies. A favorite way to stimulate economic improvement in the architectural community was to mount design competitions of various kinds for civic monuments, public projects, new home designs, and even utopian cities of tomorrow. Idle architects desperate for some challenging work and a prospect of monetary reward flocked to participate in these competitions, and Arra was no exception. Because business for Wischmeyer & Arrasmith was at an all-time low, which is to say almost nonexistent, Arra entered two competitions. One he entered on his own, the other with his fellow architects. The first competition that Arra entered was one involving a proposed War Memorial in Chicago, Illinois, and his submission to the competition reflects an architectural theme that was new to him.[5]

The Chicago competition offered Arra the opportunity to do what he wanted, unfettered by a client's tastes, needs, or design preferences. He could let his artistic talents take him where he wished. Arra chose to design the War Memorial on a theme that was reminiscent of the spectacular skyscraper renderings done by New York architect and draftsman Hugh Ferriss. This was Arra's first significant step away from the more traditional styles that had represented his work up to this point. Although the prize in the Chicago competition went to another entrant, the experience Arra gained enhanced his skill in the field of monumental architecture, something he had not previously had the occasion to explore. And, it was a harbinger of the direction his future design efforts would take when, in only a few years, Arra would find himself in the position of working on the largest single project of his career for the State of Kentucky.

The second competition was very different. It offered a degree of personal satisfaction as well as some concrete returns on the time invested. In an effort to stimulate work, the Louisville Real Estate Board announced that it would sponsor a citywide competition for the design of a house which was to be the centerpiece of the 1930 Home Show.[6] The prize was to be a cash award of one thousand two hundred dollars—which would have looked like a million dollars to an unemployed architect, or to just about anyone else for that matter. As might have been expected, almost all the architects and architectural firms in Louisville entered the competition. There were nineteen entries in all, including submissions by Stratton Hammon, Fred Elswick, Herbert Redman, and Arrasmith. Even though Arra disliked accepting residential commissions, this competition represented a different kind of challenge. He would not be working with a client, so he could concentrate on designing the

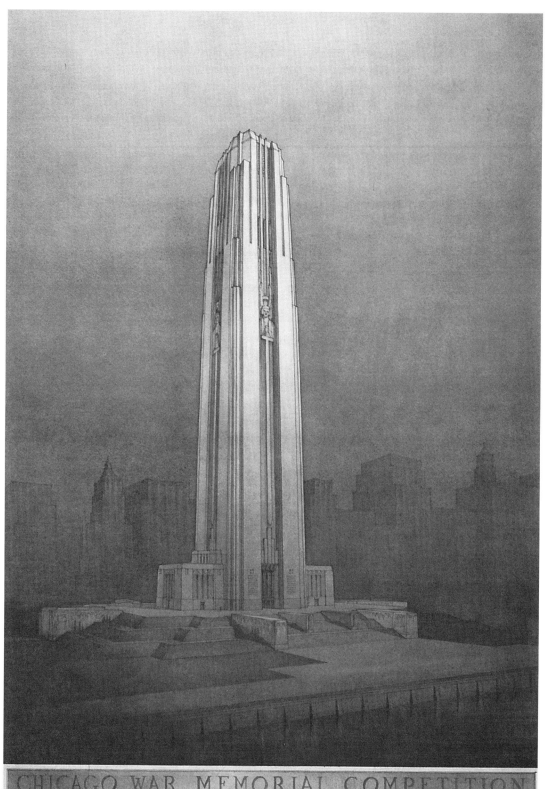

CHICAGO WAR MEMORIAL COMPETITION

W.S. Arrasmith rendering for a proposed Chicago, Illinois, war memorial.

ideal home without the need to make compromises to suit the requirements of a particular client.

When all of the entries had been evaluated, the judges awarded Stratton Hammon first place, Frederick Elswick second place, Herbert Redman third place and honorable mention to Wischmeyer & Arrasmith.[7] It was a clean sweep for the Starks Building friends. Moreover, their favorable showing in the competition promised all of them a place of prominence when new business started to trickle in the following year. At last it appeared that the tide had begun to turn, although slowly and almost imperceptibly at first, when the firm won the first of a series of commissions for the Steiden Stores in Louisville. And soon, there would be a dramatic and unexpected improvement in the fortunes of the architectural firm of Wischmeyer & Arrasmith that neither of the principles had anticipated.

In the wake of the Depression a number of changes occurred within Louisville's architectural profession. One of these changes had to do with the licensing of architects. Prior to 1930 in Kentucky, there had been no statutes governing the registration or admission to practice of architects. In light of the hard-pressed economy, Louisville's younger architects attempted to get legislation passed that would provide for the formation of a State Board of Architects. It was not the first effort to pass such a law in the state, but by 1930 many of the bordering states had similar legislation on their books, and if Kentucky was not willing to follow suit, the fear was that the state might be flooded with aspiring architects who could not meet the legal requirements in their home states. This was an important consideration in the early months of the Depression when commissions were few and concerns were many, and when a glut of competitors might have meant even leaner days for architects already practicing in Kentucky. The state was surrounded by relatively progressive states with large numbers of architects eager to obtain business wherever it could be found. A new registration law was desperately needed to protect practicing Kentucky architects from infringement by unqualified outside firms and architects.

Concerned Kentucky architects campaigned for protective legislation and, as a result of their effort, a bill setting forth registration and licensing requirements for architects passed the State Legislature and became effective June 21, 1930. Arra offered to design the certificate that would be issued to all the qualifying architects and the board accepted his offer.[8] The certificate he designed was elegant and understated in appearance, and was acclaimed by his colleagues. When the original certificate was ultimately retired in the mid–1970s it had been in use for over 40 years. Arra and his friends were among the first to be registered. Arra received certificate No. 5 in recognition of his work to achieve passage of the legislation, and also for his designing of the certificate. Wischmeyer received No. 6.

With the newly enacted registration law in place, Kentucky architects did not have to face potential competition from unlicensed out-of-state architects or from practitioners who might not even have received formal training in the field. However, the new law was not a totally unalloyed benefit.

Because Kentucky was economically less well off than its neighbors such as Illinois or Ohio, there were relatively few architectural commissions even in the best of times. Also, since their number was small, the architects all knew each other and many close friendships developed as a result. But now they faced the requirement they maintain their registration by paying annual fees to the Board of Examiners and this requirement soon pitted friend against friend in unexpected ways.

The first State of Kentucky certification to practice architecture, designed by W. S. Arrasmith.

C. Julian Oberwarth was well known to all Kentucky architects because he was largely responsible for the successful passage of the legislation that established the registration law. Because of his efforts, he was awarded Registration Certificate No. 1 and was appointed to the State Board of Examiners and Registration of Architects as secretary-treasurer, a position he held from 1930 to 1945. Among his duties was the responsibility for overseeing the collection of fees and renewal charges that were now required by the state. It was at this point that friendships began to be strained.

Arra and Julian had been friends for a long time and had worked together closely to pass the new registration law enacted but they found themselves on opposite sides of the issue regarding the annual fee. Money was tight and fees were one of the first places that Kentucky architects cut costs by delaying their payment as long as possible. And, like others, Arra delayed paying his fees. Julian would send him polite reminders and Arra would respond with lighthearted refusal to pay. Oberwarth would answer back with matching humor but increasingly direct requests that Arra catch up on his fee obligations. Deadlines were flexible but ultimately they had to become firm, and the threat of Arra's registration certificate being cancelled became a real possibility. The longer this stalemate went on the more tense the repartee became, while both men were trying to keep things from ruining their friendship. Arra had suggested that he might just change his title from "Architect" to "Archie-tect"[9] and avoid having to register with the state at all. It was at this tense point, after having received a stern letter from Julian on the matter, that the two friends exchanged poems lyrically confronting their differences. Arra penned the following verse which he sent to Julian:

"Sorry that my little note/ Seemed to get your nannie-goat./ You know me well enough by now/ Didn't mean no harm no how/ Everything is like you said/ I've been paid, I'm way ahead./ But if I aim to be, by heck/ I will be an archie-tect."[10]

After receiving this, Julian sent Arra a lengthy letter explaining how hard he had worked to uphold the law and protect the architecture profession in Kentucky and then closed with this poem in an Italian dialect:

> Now theesa here letter don't meena da ting Except for one leetla message to bring To the Bigga Lootenant what I like very good Whosa open da mouth between da food.
>
> But justa da same I was moocha da tired An wishin' to goodness dat I wasa fired From da job of catchin' da archies cold And sendin' em home withouta da gold.
>
> Denna my friend who knowa how hard I worka da Board to helpa da pard, Open da mouth and cussa da guy Whosa done jus a leetle, or at least hasa try.
>
> Before da day of the Architects Board He wasa clean inside the world that roared Arounda da poleece and alla da courts And now from da witness seat hesa got warts.
>
> Hesa been sued and sued others for things That filla da hert with hurts and stings. And all for da good of da Biga Professh And nota because of hes lova da flesh.
>
> Away down deep in da fulla da heart, Hesa soft and warm and not a bit hard. But justa you try thisa wisa guy stuff An' he'll get real hot and calla da bluff.
>
> So giva da hand and stoppa da kick And alla together da archies lick. So soma thees day alla da tresh Will be weed outa da Bigga Professh.[11]

This gentle exchange resolved a potential loggerhead for the two friends who found themselves on opposite sides of an issue that neither felt he could back down on. The Depression had been hard on everyone and although the amount of the annual registration fee was relatively small, it was a sum of money that many architects felt could better be applied to personal needs than sent to the Board of Examiners. But as time passed things began to improve and most architects could convince themselves that they thought they saw

the light at the end of the tunnel. The edge had been taken off the crisis and friendships were preserved.

Another aspect of the decade of the 1930s that directly affected Arra's life was the federal government's creation of the Civilian Conservation Corps (CCC). Designed as one of the many programs to help lift America out of its economic despair, it was one of the New Deal's most popular agencies. The CCC employed almost three million men who constructed innumerable public improvements including parks, roads, bridges, and dams, and undertook a multitude of restoration and conservation projects during the program's ten-year life span, from 1933 to the end of 1942.

Young men between the ages of 17 and 28 could volunteer for duty with the CCC. They were given a job, three nutritious meals a day, standard issue clothing, and were housed in camps which the US Army was responsible for building and running. These camps were run like a military training camp with reveille in the morning and group formations at the beginning and end of the day. The Army provided food, clothing, barracks, pay, etc., and the National Park Service and other governmental agencies provided the work that the CCC men were to perform. Regular Army and Reserve line grade officers (captains and lieutenants) were

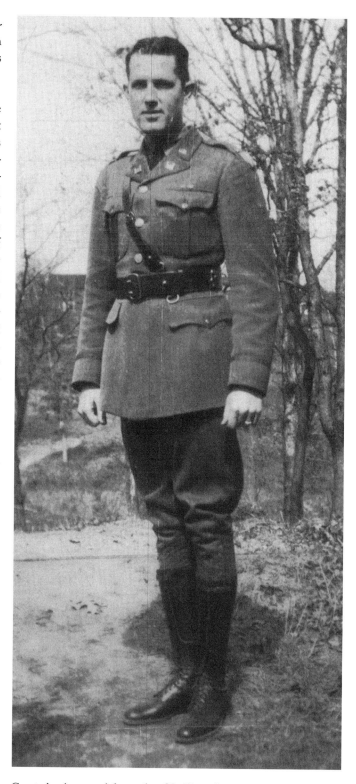

Captain Arrasmith at the Civilian Conservation Corps camp in Jackson, Kentucky.

given the responsibility of commanding the various CCC companies. Men had the dignity of doing honorable work, millions of families were helped financially, and the work that was accomplished by the CCC helped improve the nation's infrastructure, the environment, and the lives of many people, all of which constituted a significant contribution to the country's well being.

In fact, it was the CCC that would provide Arra with one of his earliest and most important commands as a military officer. Ever since he first joined the Reserve Officer Training Corps at the University of Illinois, Arra maintained a commission in the Army Reserve. He continued studying throughout his military life, ultimately achieving the rank of lieutenant colonel. In addition, Arra was demanding of himself and was driven to constantly improve his skills and abilities. He readily mastered self-study courses for advancement within his grade, and to a superior grade, as they concerned civil engineering, logistics, and management which came easily to him. Arra did most of his course work by correspondence while he was pursuing his architectural career.

As it turned out, Arra's affiliation with the Army would be the source of much pride when he looked back upon his life as an architect and a member of his country's armed forces. When time and events subsequently proved that The War to End All Wars did not achieve that lofty objective, Arra would be called upon to apply all his skills and experience to help America win World War II. But that was many years in the future.

In 1933, Army Reserve Captain Arrasmith was called to active duty with the CCC and assigned command of a CCC detachment.[12] Arra welcomed this opportunity to participate in such a worthwhile endeavor. Having retained a commission in the military since the days when he was a student at the University of Illinois, he always stood ready to respond to his

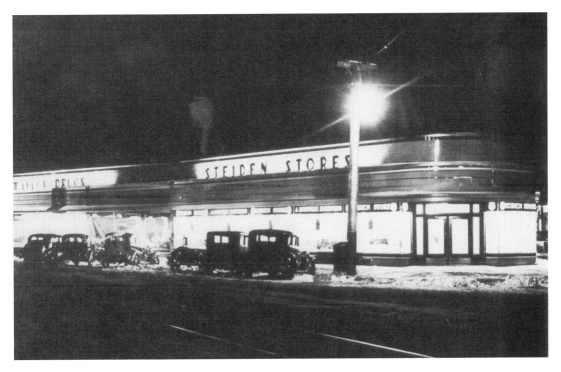

W.S. Arrasmith's first use of streamline styling was on this Steiden Stores building in Louisville, Kentucky, circa 1934.

nation's call. Of course, the security of a regular paycheck was a highly prized commodity at this point in the Depression and the Arrasmith family could certainly use the money. Although the firm of Wischmeyer & Arrasmith was doing better than most at this point in time, it still could not match the assured income of a regular government job.

The detachment to which Arra was assigned was made up of retired WWI army officers and had been charged with the task of overseeing a major building project in Jackson, Kentucky. As with many military assignments, it was impossible to know at the beginning of the assignment how long it would last or, sometimes, even where it would be. The firm of Wischmeyer & Arrasmith, as well as Arra's wife, Betty, and daughter, Anne, had to adjust to the uncertainty.

Arra's tour of duty with the CCC was a mixed blessing. It provided the Arrasmiths with a modest but steady source of income during an especially difficult period in the Depression, but it also meant that Arra would be away for an unpredictably long time. Fortunately, although he was in Jackson all week, Arra was able to return to Louisville on the weekends to spend time with his family. He would also go into the office on these weekend visits to do what work he could and things at Wischmeyer & Arrasmith progressed satisfactorily under these conditions, with the help of friends and acquaintances who filled in during Arra's tour of duty.

Conscious of the need to cut household expenses, and possibly a bit lonely as well, Betty and Anne accepted the invitation of Wischmeyer and his wife to move in with them. The Wischmeyers set aside three bedrooms and a bath in their spacious home for Betty and Anne.

When Arra was released from his tour of duty with the CCC in 1934, he returned to Louisville. He and Betty moved back into their house on Slaughter Avenue, and life began to return to normal.

Fred Elswick Joins the Firm

The economy had begun to show signs of recovery in the mid–1930s, and by 1936 prospects were improving for the firm of Wischmeyer & Arrasmith. It was at this time that they were presented with an exceptional opportunity. Louisville architect Fred Hoyt Elswick came to the firm with a proposition.[1] If Wischmeyer & Arrasmith would take him in as a partner, Elswick would bring with him the commission for a new State of Kentucky prison and hospital complex—the largest new architectural job in the State of Kentucky. This was a proposal that Arrasmith and Wischmeyer were only too happy to accept.

Frederick Hoyt Elswick, who was born March 15, 1896,[2] could best be described as a natural architect. He never attended high school, college or a school of architecture. Elswick's formal education had ended at the fourth grade. Like Henry Ford and Thomas Alva Edison, who were also virtually unschooled but who had made enormous contributions to American life, Fred Elswick was of the opinion that formal education was unnecessary and could even be detrimental to a creative mind.

Elswick's natural talent and abilities had been developed on the job. As a young man he worked for established architects, at first as a "gofer" and apprentice in the drafting room, later he took on assignments as a draftsmen and ultimately in his own right as a practicing architect.

Fred Elswick was described by his contemporaries and fellow architects as a superb crafts-man and excellent draftsman. As fellow architect Stratton Hammon put it, "Fred was one of the rare breed of master architects who could be locked up in a room with a drawing board, a sheaf of paper and specifications for a commission, and emerge in short order with a set of sketches, working drawings, specifications, full-size details, and a large perspective rendering in pen and ink or watercolor to show to a prospective client."[3]

Elswick's talents did not end at the drawing board. He was unusually capable of fol-lowing a commission from the proposal and design stage all the way through the construc-tion stage, and often made surprise appearances to check on and supervise construction at a building site. He thoroughly enjoyed seeing his designs take shape, and people who knew him often said that he would commonly have dirt on his shoes from visits to projects under construction.

Unlike his new associates, Elswick's real forte was in residential architecture. Almost all of his major residential work had been in his hometown of Ashland, Kentucky, where he could point to well over two dozen homes that he had designed—everything from the simplest one-story cottage to the grandest Georgian or Tudor mansion. Fred's family was a prominent one in Ashland, and his connections there served him and his new associates

well. He had also been successful in numerous design competitions, including ones sponsored by *American Home* magazine, *Model Homes Magazine*, and *Pencil Points*, a publication of the American Institute of Architects. And so it was that this affable man with extraordinary talent, who had spent many idle afternoons in the Starks Building with Arra, Wischmeyer, and other fellow architects, came to add his name to the firm, making it Wischmeyer, Arrasmith & Elswick.

The commission that Elswick brought with him to the new firm arose as a result of his appointment as designer for the Kentucky Emergency Relief Administration. It was the magnitude of this commission that drew him to Wischmeyer & Arrasmith, a commission that no architect, regardless of talent, could possibly execute on his own. In obtaining this commission Fred, as a sole practitioner, had followed the guiding principle Arra first heard espoused at his graduation ceremonies in 1921: "get the job." Fred got the job and he knew that he could enlist the help of his professional friends in Louisville to furnish the necessary manpower and talent to execute the commission. Because highly talented assistance was required, the team of Wischmeyer and Arrasmith was the first one Fred approached—luckily at the very time they could most benefit from his association.

Arra and Wischmeyer had been able to garner enough commissions to keep their office open during the Depression, but these were lean times that could go on indefinitely. The appearance of Fred Elswick and his commission was certainly a happy turn of events. They could now bask in the prestige of an expanded letterhead, the prospect of working with an old friend, and the challenge of a large, financially rewarding commission.

The Department of Welfare's prison and hospital commission was an extremely complicated and challenging one for Arra. The proposed prison consisted of 22 large buildings, together with an assortment of attendant connecting structures and annexes. Security considerations were foremost on this project and required an understanding of how prisoners were housed and how they moved about during the day since it was essential that all building placements and floor plans take into consideration the safety of prisoners and guards alike.

The hospital commission involved an even larger and more complicated arrangement of buildings. It consisted of two groupings of nineteen buildings each, plus their attendant connecting structures, together with a large administrative complex comprised of a central block with four connecting wings. An outlying building located on the far side of the campus opposite the administration complex completed the plan. The design of each building required careful consideration of its particular intended use. Although there were twelve individual architects registered on the project, the three members of the firm of Wischmeyer, Arrasmith & Elswick comprised the lead group.

Although the three architects were longtime friends, the state commission was the first occasion on which they were to work together as a team. And as might be expected, adjustments had to be made to accommodate their different work styles.

The steady flow of income from Fred's state commission provided welcome security for the partners, but unexpected difficulties in the working arrangements of the new firm soon began to make themselves evident. While Fred's artistic and architectural talents were, beyond a doubt, exceptional, his work habits did not fit neatly into the established office routine of his new associates. As a sole practitioner, Fred had been in charge of all aspects of a commission, and he was flexible in how he went about the work. Only the major deadlines of a project made him focus on a work schedule.[4]

Entering into partnership with Wischmeyer and Arrasmith changed all that. Elswick

was now a member of a three-man team. Each member had to assume specific responsibilities and meet obligations and deadlines that would allow the work of all three men to meld together into an end product. This turned out to be far more difficult for the three men to deal with than any of them had anticipated. Years of professional acquaintance and friendship were not enough to prepare them for the reality of running a firm together on a day-to-day basis, and especially so on a project as complex and important as the prison and hospital commission.

The Relief Administration commission had many facets. Most important of these was the necessity for the newly named firm to execute its architectural responsibilities with the highest degree of competence. This was something that Arra, Wischmeyer, and Elswick felt entirely confident in achieving. There was no question that these three highly skilled men were capable of producing what the commission required.

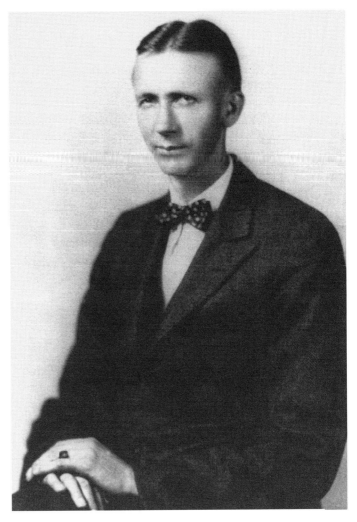

Fred Elswick, third partner in the firm of Wischmeyer, Arrasmith & Elswick.

What presented a far greater challenge was working within the realm of the political and hierarchical order of a government job—the maze of red tape that is extant in politically based endeavors. There were committees, agencies, offices, and personnel that had to be kept current on the progress of the commission and the various proposals and designs developed by the firm as projects moved forward. Meetings were numerous and time schedules had to be met if things were to go smoothly. In addition, the administration job was the firm's first commission for a governmental body, and if their performance was impressive enough, future opportunities might well come their way. So it was especially important that the firm put on a good show. Fred Elswick's part in all of this was particularly important because he was the lead contact with the state on the project.

However, as the project progressed, Fred's work habits and personal traits began to evidence themselves. Wischmeyer and Arra were accustomed to the ritual of regular office hours, but it became apparent that Fred Elswick was not. He found it difficult to alter his personal working style to one more comfortable for his associates. When he worked for

himself, he could work twenty-four hours straight, and then take a day or two off without disrupting anything. Now such a pattern created an unpredictable office atmosphere and sometimes left the firm in the position of appearing unreliable as when Elswick failed to appear for work or appointments as expected.

Fred was a hard worker, when he worked, but his penchant for being out of the office with his whereabouts unknown often caused considerable confusion and inconvenience to both clients and his partners. On occasion he would disappear for extended periods without telling his associates where he was or when he would be back. The fact that it was he who had secured the administration commission, that he was lead architect for the commission, and that his advice and consultation was needed at virtually every stage of the work compounded the problem. Fred contributed invaluably to the ultimate success of the project, but his artistic contributions were in many ways overshadowed by his many absences, and much of the day-to-day work fell to Wischmeyer and Arra.[5]

Toward the end of the administration commission the firm faced an embarrassing situation. As a result of their inexperience with handling a massive governmental project, the firm found that it had substantially overestimated projected costs, and that it would be necessary to refund some of the monies which had been advanced by the state. Since all of the advanced funds had been spent, the partners found themselves in the awkward position of having both overestimated and overspent. Because the firm had little other unencumbered income at the time, it was without resources to immediately refund the billing overruns.

Although Fred, as lead architect on the project, had responsibility for the project's financial management, Arra's office management philosophy may have been a contributing factor in this matter. He had a penchant for overstaffing when there was work to be done, and once he had hired an architect, he found it difficult to let that person go, even when

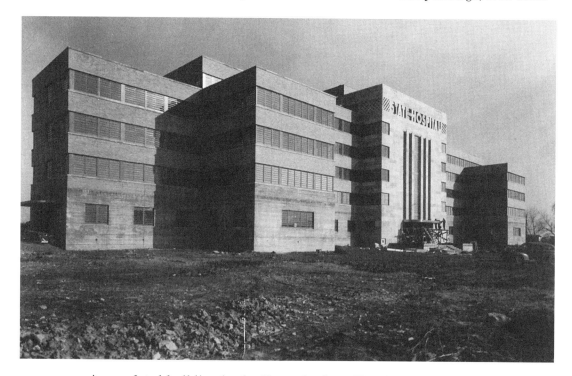

A completed building in the Kentucky State Hospital complex, 1937.

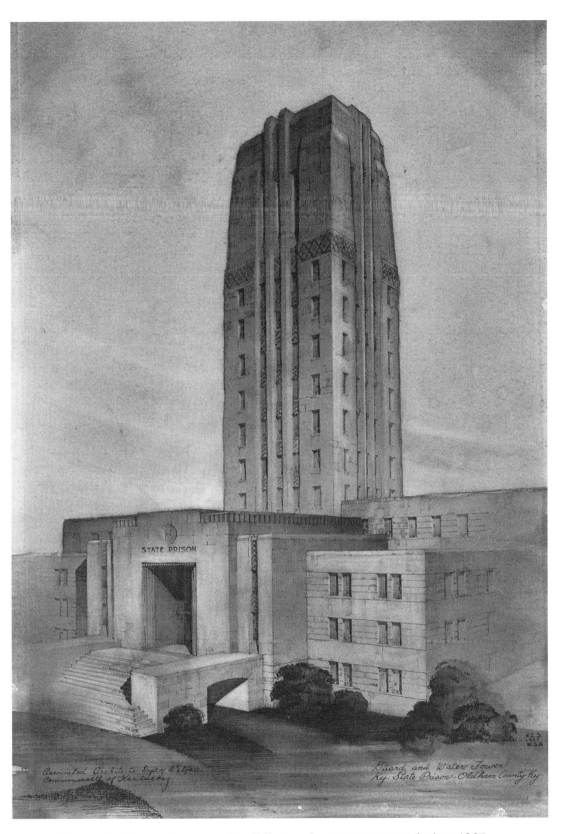

STATE PRISON

Kentucky State prison guard building and water tower rendering, 1937.

the extra manpower was no longer needed. Arra liked to have talented people around him, and, for better or worse, he felt that maintaining a relatively large staff was necessary, perhaps in part because of Fred's unpredictable habits.

A further complication was that Fred insisted that the firm not accept additional work during the time they were involved on the administration commission. He felt that these other smaller commissions would always be available, and that, for the moment, they would merely divert the attention of the firm when it should be concentrating all its efforts on the major project at hand. Such attention to one commission unfortunately gave the firm a reputation as a single-client office, which naturally made it difficult to attract new clients and income.

Through all of this the three partners got on well enough together thanks in part to the fact that they never lost their sense of humor or refrained from telling jokes about one another. Being able to look at the lighter side of problems that arose from time to time was a way to relieve the tensions when things got difficult. Arra would joke that he had "one partner that couldn't work but did [Wischmeyer] and another partner that wouldn't work but could [Elswick.]"[6] And his partners would in turn accuse General Arrasmith of running an office with an army-size staff. But it was all good humored kidding. Regarding Elswick, Arra often said he wished that he had the natural talent in his hands that Fred Elswick was blessed with, and he always held Wischmeyer in the highest regard as an architect of great skill in all areas of his craft. Their acquaintances were accustomed to the banter that always went on between the partners and they enjoyed taking part in it which added levity to their regular gatherings.

The longer the partners worked together, the more flexible Elswick became on the question of taking on new clients and new commissions for existing clients. Wischmeyer and Arra were able to negotiate some compromises with Elswick that allowed the firm to take three important new commissions during the administration job. One of these involved the Ashland Oil Company, a large account that Elswick brought to the firm. Because of Fred's involvement on the administration job, it fell to Arra to handle the Ashland Oil Co. account.

It was on the Ashland job that Arra developed a lasting relationship with Cornelius Hubbuch. As Arra often put it, it was his job to "build a beautiful lady" but someone else would have the responsibility of "dressing her."[7] By this he meant that he would design the structure but that he did not wish to be involved with matters concerning interior decoration. For this aspect of a job he looked to the assistance of an interior designer who was skilled in commercial applications, and he usually turned to his very good friend Hubbuch to fill this need.

Hubbuch was relatively new in the decorating business at the time, but he had secured an excellent reputation for quality work, something that Arra always demanded from the people he worked with whether they were employees or subcontractors. Hubbuch accepted the interior design job on the Ashland project and accompanied Arra to a meeting with the client so that Arra could introduce him to the Ashland people. Arra told the client that Hubbuch would be responsible for execution of the interior decoration for the new building, and Hubbuch made a presentation of his plan for the work. At the conclusion of the presentation, Arra inferred from remarks made by one of the Ashland's people that they thought that the firm of Wischmeyer, Arrasmith & Elswick might get a kickback from Hubbuch in view of what they considered to be a high price for the work Hubbuch had proposed to do for them.

As Hubbuch recalled the event, Arra was furious at the accusations. He jumped out of his chair and very heatedly told everyone in the room in no uncertain terms that whatever work Mr. Hubbuch would be doing on the job would be billed by him directly and that whatever price was to be arrived at with regard to his work was to be determined between Mr. Hubbuch and the Ashland Oil Company. Furthermore, if there were similar concerns about any of the other work subcontracted out, Arra would resign the commission. Silence cloaked the room. The statement was retracted, apologies made and all parties were able to resume their discussions and the question of honesty in billing never came up again.[8] Losing a large commission over a perceived insult to his integrity could have been a severe blow to the firm but Arra was not one to hesitate if his honor or that of a friend were placed in question. As in the case of *The Fountainhead*, professional integrity was not something to be compromised.

Hubbuch and Arra would work together again on other commissions, one of which would prove to be a pivotal job in Arra's long and fruitful career. In that instance, the two would literally work side by side to make a crucial grand opening deadline under circumstances that were well beyond the scope of an architect's obligations to his client. For Arra, an elevated level of dedication was the norm. The interests of his clients were first in all respects, and he would do anything necessary to see that a client was completely satisfied.[9]

While the firm was working on the Ashland commission, another one came their direction. This commission arose in an unusual way. Arra was in his office one day when the phone rang. He picked up the receiver and the gentleman on the other end of the line introduced himself as Mr. Duncan. He told Arra that he was staying at the Brown Hotel across the street from the firm's office in the Heyburn Building and he wanted to confer with them about a project he had in mind. Could someone meet him at his hotel suite? During the phone conversation it developed that Mr. Duncan had spent his boyhood in Crestwood, Kentucky, and he wanted to build a memorial chapel at the cemetery there, with vaults under the floor for the remains of his wife, who was recently deceased, and for himself later.

No one at the firm of Wischmeyer, Arrasmith & Elswick knew Mr. Duncan. For a commission to fall out of the sky like this was extremely unusual, even in the best of times. Arra told Mr. Duncan that one of his associates would meet with him right away. Because Fred was the firm's best architect on noncommercial structures, Arra asked him to meet with Mr. Duncan. Elswick wasted no time in getting over to the Brown Hotel, taking with him a sketch pad and a few samples of his work that he felt might be suitable.

After having been gone for some time, Fred finally returned to the office and Arra asked him what he had found out. Fred seemed somewhat incredulous. He said that Duncan wanted to build a chapel copied after one he and his wife had seen in England and no expense was to be spared to get it perfect. This was all too good to be true, especially in the severely depressed economic times of the 1930s.

The first thing Arra and Fred did was to look Mr. Duncan up in Dunn & Bradstreet. It came to light that Mr. Duncan was the "genuine article"—a millionaire several times over. This was the kind of commission that architects dream about but seldom encounter.

The chapel was designed by Fred Elswick and when the plans were approved, construction began. True to Mr. Duncan's word, no expense was spared. Only the very best skilled craftsmen were employed and only the best materials available were used. Mr. Duncan was very particular about how the work on the chapel was handled. So much so, that on one of his visits to the construction site, he found that some of the craftsmen's' work was not to his satisfaction and he told Elswick to have the masons knock out and rebuild entire

Duncan Memorial Chapel.

sections of some of the chapel walls. The total cost of the chapel came to $250,000, which at the time was a princely sum indeed.

When Mr. Duncan gave his final approval and the Duncan Memorial Chapel was accepted, he paid all of the contractors, subcontractors, materialmen, suppliers and the firm in full. Then a few days later, he married a chorus girl he had become acquainted with since his wife's death and they moved to California. Neither Mr. Duncan nor his new bride were ever seen in Louisville again.[10] (Mr. Duncan is buried at the chapel next to his wife.)

Gradually, the number of new commissions began to grow and the firm was able to straighten out its accounts with the State of Kentucky on the hospital and prison jobs. Always in search of new clients for the firm, Arra stayed closely in touch with what was being planned in the way of real estate development in Louisville, as did his associates.

The search for new clients was a never ending task. Arra's outgoing nature and engaging personality led to many commissions, which came through his contacts or word-of-mouth referrals. Hermann's long time associations within the Louisville community and Fred's jovial nature were also effective in attracting new commissions.

But, the most important factor in obtaining clients and keeping them was a reputation for good work. And it was this that secured for the firm of Wischmeyer, Arrasmith & Elswick its next most important commission and ultimately the firm's most important single client.

Greyhound Enters the Picture

Arra originally developed connections with Southeastern Greyhound Company in Lexington, Kentucky, while he was on his CCC assignment in the early 1930s.[1] He had done some work for the company on their Post House restaurants in downstate Kentucky and he continued to maintain these connections with the company, keeping close track of what Greyhound was planning for the future. It was through these contacts that, in late 1935, Arra got wind of the fact that Greyhound was intending to build a brand new bus terminal in Louisville. It was this opportunity that was the beginning of a relationship which spanned a thirty-six-year period and placed upon the architectural horizon of this country some of its most unique and striking structures.

Greyhound had built innovative terminals in other parts of the country, and the company was constantly replacing or updating older terminals as their business continued to grow and expand. At the time, Greyhound employed an outside architectural firm which did much of its major work east of the Mississippi. However, they also engaged a local architect, if not in a leading capacity at least in a consulting capacity, wherever they built or remodeled a terminal. Among local firms receiving multiple commissions from Greyhound in the mid–1930s to early 1940s were Bonfield & Cumming of Cleveland, Ohio; George D. Brown of Charleston, West Virginia; Thomas W. Lamb of New York, New York; and, W.D. Peugh of San Francisco, California.[2] Of these architects, it is likely that Bonfield & Cumming and Thomas Lamb were most actively engaged with Greyhound on work east of the Mississippi when Arra first became associated with the company.

Greyhound's proposed Louisville terminal would, as usual, require the services of a local architect. Arra correctly assumed that this job might not only bring important business to the firm of Wischmeyer, Arrasmith & Elswick, but it would also provide an excellent opportunity for Arra to design the kind of building that would take him in an entirely new direction stylistically. Like the work of Hugh Ferris, it could be a bold, unique and totally modern building in a vernacular which would reflect the image of speed, efficiency, cleanliness and modernity—attributes that Arra sensed Greyhound wanted to project.

Greyhound already had streamline buildings that had been designed by outside architects as well as by the company's own engineering department.[3] Likewise, some small businesses had previously utilized enameled steel panels in the construction of gasoline stations and fast-food restaurants.

What Arra proposed was to combine streamline styling with enamel exterior paneling on a scale never tried before. The modern style he chose was neither totally unique nor

totally original per se. It was the combination of design and structural elements Arra employed which was both unique and original.

Despite the fact that some of Arra's contemporaries predicted that the new streamline style had no lasting qualities or enduring characteristics and was merely a passing fad, the important thing was that Greyhound liked Arra's design, and liked it in a big way. The company accepted his design over all others, including those of its then leading commission architect Thomas Lamb. In addition, Arra was given the commission as sole architect without oversight by any of the company's other architects. Although this unprecedented compliment was clearly a harbinger of good things to come, Arra had no way of knowing that he would displace Greyhound's longtime lead architect within a few short years.

Arra's design proposal for the Louisville terminal portrayed a strikingly modern building. The most outstanding elements of its design were its color, contours, and facing materials. The building was entirely surfaced in Greyhound Blue enamel panels and featured rounded corners, curvilinear surfaces, and a horizontal rather than vertical emphasis—all of which were trademarks of the emerging streamline style. This design was particularly effective because of the corner site that had been chosen by Greyhound. The site allowed the terminal to be designed as an "island" structure that would optimize the flow of bus traffic around the building. The building site also isolated the north facing terminal from its neighbors and allowed it to be viewed detached from the distractions of any immediately adjacent buildings.

The terminal was a low tiered building—rather like a three-layer wedding cake—that gave the impression of only two-and-a-half stories. The front elevation lent a dynamic impression of movement with a slightly off-center location for the main entrance. The effect was helpful in evoking one of the images Greyhound especially wished to impress upon the public—that of speed, an illusion that could not have been as forcefully conveyed if the building had been taller or perfectly symmetrical.

Interrupting the strong horizontal theme of the terminal's facade were narrow ribs rising vertically up the face of the terminal and bracketing the main entrance. Centered over the entrance was a lofty pylon tower with the words "Greyhound Depot" spelled out vertically in letters so large that they could be easily read at a distance from either direction along the main street.

The vertical pylon theme was repeated at the west end of the building where streamlined pilasters ran from the sidewalk to just above the top of the second story and framed a large "porthole" style window at the street level. A racing greyhound on the second story facade was centered over the porthole window and a white band encircled the building above the second story windows. Between the main entrance doors was a large plate glass display case to exhibit information about services available in the terminal.

Inside the building a cafeteria and restaurant occupied the east side and commercial space (with a separate entrance) was situated on the west side. The central lobby area was bathed in artificial lighting. Wash rooms and offices were located on the second floor and the third floor accommodated the terminal's mechanical equipment. The layout of the Louisville terminal proved so practical that Arra would use it again and again as a basis for designing future terminals of similar size.

The terminal's facing material was unique for a building of its size, consisting of square panels approximately twenty-two inches on a side which were made of enameled steel. Enameled steel had been used before in the mid–1920s on relatively small buildings of very modest proportions, such as fast food restaurants such as White Tower and White Castle

hamburger shops. Although these enameled panels proved to be durable and to require very little maintenance, they did not begin to gain favor until the mid–1930s—and even then their use was limited to buildings only fractionally as large as Greyhound's Louisville terminal.

The enameled panels for the Greyhound building were supplied by the Louisville company of Pierre McBride,[4] which had experience in the manufacture of washing machines and other enameled iron equipment, but this was their first effort at making panels for architectural use. Although there were other manufacturers of enamel porcelain panels, Arra preferred to use a local Louisville firm so that he could closely monitor the process and thereby personally guarantee the quality and appearance of the panels.

Producing the panels involved fusing a glass-like enamel to a panel made of low-carbon and manganese steel which was engineered specifically for this application. The enamel-coated panel was finished by baking it at eight hundred degrees Fahrenheit. Extensive experimentation was required before the correct color for the Greyhound terminal was achieved.

These glossy enamel panels afforded the building a unique appearance and also greatly facilitated maintenance. As long as the porcelain panels received a minimum of care, they would last almost indefinitely.

Perhaps the most arresting aspect of the building was its color. The entire terminal was a striking Greyhound Blue, which was identical to the color of all of Greyhound's buses, reinforcing the impression of a building in motion. The white band that ran around the top of the building echoed the white roof line of the buses.

Arra's design was a masterful interpretation of Greyhound's requirements which included, among other things, optimum commercial utilization of the land together with the smooth and efficient melding of bus and passenger traffic—all packaged in a building that would express efficiency, speed and modernity. The building created a sense of excitement viewed in the context of the surrounding neighborhood of older commercial structures virtually all of which were traditional in style and wore the patina of time with obvious weight.

Because this job was his first major commission for Greyhound, Arra was personally committed to seeing that the job was done right, completed on schedule, and that it came in under budget. This turned out to be no mean feat since the actual construction of the Louisville terminal suffered from a long list of difficulties, including construction delays, lost shipments, and labor problems. There were also problems with building codes, financing, and most vexing of all, Greyhound's changes to what were supposed to have been finalized design plans. It was vital that these issues not interfere with the expeditious completion of the project. Fortunately, Arra had been practicing architecture long enough to know his way around the construction end of the business, and he was confident that his contacts with builders, contractors, suppliers and artisans would help meet the challenges of any contingencies. But all the careful planning and monitoring of the project did not preclude the occurrence of an unexpected crisis at the eleventh hour.

Shortly before the building was to be opened to the public, a heart-stopping drama began to unfold. Cornelius Hubbuch was a subcontractor on the Greyhound job, as he had been on the Ashland Oil Company work, and he was responsible for the interior finish. He, in turn, had subcontracted the interior painting to a company that was known in Louisville for being very inexpensive. This contractor had brought in his own painters and they happened to be a nonunion crew. When the unionized workers in other trades learned of this, they walked off the job. All work ceased, and Arra found himself in the middle of

a labor dispute that involved union and nonunion laborers as well as management. Negotiations of this magnitude were something new for him.

Meanwhile custom-made floor tiles had been ordered from the Tile Tex plant in Chicago, and immediately before the walkout, these tiles had been delivered, on time, to the work site. During the work standstill, the construction site was untended, and it was not discovered that the floor tiles had gone missing until the dispute was finally settled and workers had returned to the job. Desperate inquiries led nowhere. Absolutely nothing could be discovered as to the whereabouts of the tiles. This was a problem of no small proportion. Not only were the tiles very expensive, but it would be impossible to finish the interior work without the floor in place. Moreover, Tile Tex had made only enough tile to fill this special order, and there was no reserve stock. Even if more tiles could be made within the limited time that remained before the project's deadline, the tiles were supposed to cure for several days after they came off the line, steaming hot, before they were packed and shipped. There did not seem to be any way replacement tiles could be made, cured, and delivered in time for the floor to be laid and the interior work finished in time for the scheduled grand opening date.

Arra and Hubbuch made frantic calls to Chicago to see what could be done. After extensive discussions a solution was found. Tile Tex agreed to interrupt their production to accommodate one more run of this special order. The freshly finished asphalt tiles would be loaded, right off of the assembly line, into open wooden boxes which would be placed on flatbed trucks. The open boxes would allow the tiles to cure without warping and by the time the trucks arrived in Louisville, the curing process would be complete. The plan worked, and the tiles arrived in a matter of days. As soon as the tile trucks pulled into the construction site, all other work stopped, the tiles were unloaded, and their installation began immediately. It was a tedious and labor-intensive task and even Arra and Hubbuch joined the floor laying team to help finish the job. The floors were in place in just enough time for the interior work to be completed, and the grand opening of the new Greyhound terminal occurred precisely on schedule.

Getting the tile installed was not the end of the story. There remained the problem of paying for a second order of custom-made asphalt tile manufactured and shipped under

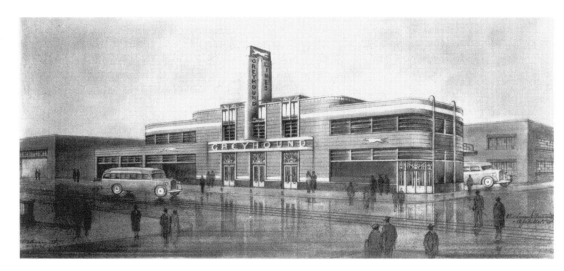

1937 Louisville, Kentucky, Greyhound Terminal, W.S. Arrasmith rendering.

special and therefore expensive circumstances. If Greyhound had to pay for the extra order of tile, the project could not be finished under budget. Wischmeyer, Arrasmith & Elswick were clearly not responsible for the lost floor tiles, but it was going to be difficult to determine who was. Because of the mysterious nature of the disappearance, it did not seem prudent to try to blame the workers for the loss or to try coercing the union into compensating Greyhound. Having exhausted all other possibilities, Arra approached the trucking company's insurance carrier about the loss. They were, of course, reluctant to bear the expense, but Arra had a case, and ultimately his powers of persuasion won out. Greyhound was compensated for the loss of the original shipment of floor tiles and the budget remained intact.[5]

Southeastern Greyhound was so pleased with the finished Louisville terminal and the resolution of the tile problem that they retained Arrasmith as consultant architect, and specified that all other bus depots that were to be built by them must have his approval in all aspects.[6] T.W. DeZonia, vice president of Southeastern Greyhound, offered this position to Arra in order to secure his services for a large building program the company was to undertake over the eighteen months that followed the completion of the Louisville terminal. W.S. Arrasmith now found himself in charge of the company's entire building program.

When the new position was announced, DeZonia said that Mr. Arrasmith was "exceptionally qualified as an architect and that his business ability and integrity were held in the highest esteem by S.E. Greyhound."[7] Arrasmith was also praised by Greyhound's then leading outside architect, Thomas W. Lamb, who once wrote that in his opinion, the character of Arra's work was excellent and that he had the very highest regard for Arrasmith's integrity and ability to execute any professional trust which might be given him.[8] Arra's high standing with Southeastern Greyhound Lines and the Greyhound parent company was assured. Wischmeyer, Arrasmith & Elswick had clearly cemented a close relationship with the company that was to become its most important client.

For its time, the Louisville Greyhound terminal was considered a shocking building. It was an instant landmark. There was nothing else like it in downtown Louisville or, indeed, anywhere in the country. It would be easy for any bus passenger or other traveler to find. No one could possibly mistake this building for any other. Everyone who lived in Louisville knew where the Greyhound station was and could direct a stray passenger to the terminal.

This building helped Greyhound realize one of its major goals, that of an integrated and unmistakable corporate identity. When illuminated at night, the building brought to mind an ocean liner or a Buck Rogers spaceship with its enameled sides reflecting passing car headlights and the glow of nearby street lamps. The long horizontal windows were backlit by the glow of light reflected from the pale blue interior walls which complemented the blue enamel exterior. Together with the exterior pylon's blue neon sign the building had an extraterrestrial glow. No other architectural style could have achieved so much to distinguish Greyhound's building from its neighbors on the street and from other bus terminals.

Of course, the terminal did have its critics. Adherents of the more conventional architectural styles then in vogue deprecatingly referred to the building as being too modern. Arra's close friend, Stratton Hammon, referred to it as "gas stove architecture"[9] implying that the use of enameled steel, clean lines and a streamline appearance made the building look like a kitchen appliance. Enthusiasts were not concerned. Comparison of the building with a clean, efficient appliance that facilitated comfortable travel, and that contributed to the image that Greyhound had hoped to achieve, was hardly an insult.

Good as all of this was for Arra, it indirectly created a problem for which he needed

the help of an old friend, Julian Oberwarth, secretary of Kentucky's architectural registration board. Greyhound had asked Arra to immediately begin design on other new terminals for them, one of which was to be in the state of Ohio. Arra furnished copies of his renderings and proposals to Greyhound so that they could make any changes before final approval. But their satisfaction with his proposal was so great that they took the plans Arra sent and immediately initiated construction of the terminal. Very soon thereafter, Arra received notification from the Ohio State Board of Examiners of Architects that since he was not registered as an architect in the State of Ohio, he was practicing architecture in Ohio in violation of the state's architectural registration law and he was directed to refrain from such practice immediately.[10]

This was doubly embarrassing for Arra because he had been deeply involved in working for passage of the law governing registration of architects in Kentucky. Julian Oberwarth agreed to assist Arra by writing a personal letter to the secretary of the Ohio Board of Architects vouching for Arra's good character, unwitting violation of Ohio's registration laws, and Arra's eagerness to do whatever was necessary to immediately comply with Ohio requirements. This calmed the troubled waters and Arra obtained Ohio state certification. Despite the solution of this most immediate problem, it is possible that the situation had an impact on a later project for the design and construction of a Greyhound terminal in Columbus, the state capital of Ohio, which will be discussed further on in this book.

After the Ohio experience, Arra took special pains to be sure he was properly registered with any state in which Greyhound intended to have him design a terminal. After applying for registration in the state of Indiana he received a letter from his friend Ossian P. Ward, secretary of the Kentucky Chapter of the American Institute of Architects, informing him that his application with the State of Indiana and appearance before the board there generated high praise for his sincerity, gentlemanly conduct, and obvious desire to cooperate with the board in every way. Mr. Ward emphasized that receipt of such praise from a state board was a very rare occurrence.[11] Subsequently, Arra obtained registration certification in over thirty other states with no further problems.

Between 1937 and 1938, as consulting architect for the Southeastern Greyhound Lines Division, Arrasmith designed terminals for Evansville and Fort Wayne, Indiana, and Bowling Green, Kentucky, all of which received Greyhound Blue enamel steel panel exteriors.

After the successful completion of these terminals, Arra went on to other client projects as there was no other available work under consideration for the Southeastern Division. Besides, Greyhound already had a number of architectural firms under contract when Wischmeyer, Arrasmith & Elswick came on the scene. The firm of Bonfield & Cumming in Cleveland, Ohio, had done four terminals in Michigan, George Brown of Charleston, West Virginia, had done terminals in four southern states and Thomas W. Lamb of New York City had long been an architect for Greyhound with terminals in New York, Pennsylvania and Michigan to his credit. Obviously, Greyhound was happy with the work of these and several other architects and Wischmeyer, Arrasmith & Elswick, notwithstanding Arra's prestigious position as consultant architect for S.E. Greyhound, simply had to find ways of staying informed of Greyhound's plans for new construction so the firm could submit competitive bids on future projects.

The year 1938 proved to be a turning point in the relationship between Arrasmith and Greyhound when a job came Arra's way that would make him Greyhound's chief architect for all of its divisions east of the Mississippi River. The two largest divisions in Greyhound

were Pennsylvania Greyhound Lines and Central Greyhound Lines. Both had their executive offices in Cleveland, Ohio. Swan Sundstrom was president of Pennsylvania Greyhound Lines and Robert Willis Budd was president of Central Greyhound Lines. Chief among the architects working for Greyhound at the time was the large and prominent firm of Thomas W. Lamb & Associates of New York City. This firm had designed and built terminals for Greyhound in Pittsburgh in 1936, and in Detroit in 1938 and Greyhound was now ready to award a commission for the design and construction of their all-important Washington, D.C., terminal. Lamb was a formidable architect with a national reputation in theater architecture and had designed and built many of the country's finest theaters in addition to many Greyhound terminals. It was widely assumed that Lamb would be selected as architect for the Washington, D.C., terminal.

Just before Greyhound made its decision, T.W. Lamb & Associates had completed a terminal for Pennsylvania Greyhound Lines in Hartford, Connecticut. On the day of the new terminal's grand opening a large number of Greyhound officials, local dignitaries including the mayor, and several other notable individuals gathered to witness the ceremonies. Among those present was a friend of Arra's by the name of Frank Fortune who was president of the Nickolock Co., a firm that furnished and installed pay toilets in railroad stations, bus stations, and hotels. Frank, who was known to his friends as the Five-Cent Millionaire, witnessed the events that unfolded at the Hartford grand opening. Frank related the story to Arra's postwar associate Ed Baldwin, who repeated it as follows[12]:

> As part of the grand opening proceedings at Hartford, a ribbon had been stretched across the entrance driveway to the terminal. A bus was to come down the street, turn in, break the ribbon, enter the terminal, and then the speeches would commence. The ribbon cutting ceremony was to be an important part of the grand opening and Greyhound had taken special pains to be sure that it would put its best foot forward for this event. An especially skilled driver had been selected to drive one of Greyhound's gleaming streamline Supercoach busses to break the ribbon. With the eyes of the assembled crowd riveted on the bus as it approached the new terminal the driver began his turn into the entrance driveway ramp. Just as the bus reached the apex of its turn, it lurched to a standstill, jammed in between the terminal building and the building next door. Instead of making a smooth and graceful entrance the bus driver was now trying desperately to free the bus from its predicament. He put it in reverse and tried to back up, gently at first but then more vigorously as his initial efforts had failed to free the bus. When that failed, the driver tried to move the bus forward, but the same procedure brought about the same results. The bus was firmly stuck between the two buildings. All attempts to free the bus were unsuccessful and a tow truck was called to extricate the bus. With the help of the tow truck, a cable winch, and a great deal of time-consuming effort the bus was finally freed.
>
> Needless to say this put a damper on the party much to the embarrassment of the Greyhound officials. Having observed all of this, Frank Fortune detached himself from the gathering of notables, went to a pay phone and called Arra in Louisville. He told Arra what had happened and said, "Now don't give me any of your smart cracks. Swan Sundstrom will be back in Cleveland tomorrow so you get on a plane for Cleveland first thing in the morning and put in your bid for the Washington terminal job. Swan is furious and just mad enough to give that commission to the first architect that walks in the door."

This chain of events gave Arra the opportunity to bid for one of his most important Greyhound commissions.

The Washington, D.C., terminal was a prestigious job and Wischmeyer, Arrasmith, &

Elswick had already made several proposals for the commission. So, Arra did just what Frank Fortune had urged him to do and as a result, successfully landed the commission for the design of the Washington, D.C., Greyhound terminal. But, Sundstrom drove a hard bargain. He stipulated that any cost overrun in excess of 2 percent would come out of Arra's fee. During the next four months, Wischmeyer, Arrasmith & Elswick prepared the most complete and thorough set of building plans and specifications that the firm was ever to do. Arra was not about to lose any of his commission. The finished product was a superb Streamline Moderne structure. Years later, while looking back on his effort to win the Washington, D.C., terminal commission and the hard bargain that Greyhound drove, Arra commented to Ed Baldwin "There is no profession in the world in which you have to know so much, work so hard and get paid so little."[13]

Greyhound was particularly proud of Arra's Washington, D.C., terminal. It was located on a sweeping corner at 1100 New York Avenue, near downtown just east of the White House. Arra utilized the location to enhance the streamline character of the building by making it flow with the curb line of the corner.

The main entrance fronted on New York Avenue directly under a massive pylon tower bearing the Greyhound name. The pylon was more an integral part of the building structure than it had been in the Louisville terminal and was in this way actually reminiscent of a pylon sign Arra had designed only a few years before for the Ohio Theater, located just up the street from his Louisville Greyhound terminal. The Washington, D.C., building had another feature that differentiated it from Arra's prior Greyhound Blue terminals. It was faced in Indiana limestone rather than enameled steel panels. The limestone was smooth, uniform in color, and produced an impression completely different from that of the shiny colorful surface of the Louisville building. The result was an excellent adaptation of a successful design that was thoroughly in keeping with the dignity of the nation's capital.

New York Avenue and Twelfth Street intersect at an oblique angle which presented Arra with some interesting design challenges. The unusual shape of the lot made it possible to enhance the terminal's island-like appearance and maximize the flow of bus traffic. In order to realize the most from the site configuration, the thirteen bus docks were constructed in a closing-fan arrangement. The complexity of this design demanded very careful calculations. Arra did not want to commit the same kind of error that got him the Washington terminal commission in the first place. There could be no risk of buses getting jammed while maneuvering into and out of the terminal or its bus docks. Arra's elegant and imaginative "sawtooth fan" design solved this problem admirably and proved to be practical as well.

When passengers entered the terminal from New York Avenue, they saw directly in front of them on the opposite side of the lobby a semicircular wall through which gates led directly to the bus docking platform. The entire interior decor was in harmony with the Streamline Moderne exterior including the domed ceiling with its large circular skylight.

The Washington, D.C., terminal demonstrated a maturation of Arra's Louisville design and proved to be a highly efficient terminal and was hailed as an unqualified success.

The firm of Thomas W. Lamb & Associates would do no more work for Greyhound and Arra's firm was awarded other commissions for Greyhound terminals in Atlanta, Buffalo, Cincinnati, and in several smaller cities. They also completed plans for a new terminal and headquarters to be built in Cleveland, Ohio, and a massive multistory terminal in downtown Chicago, Illinois.

During the years immediately preceding the second World War, Arra had acquired a

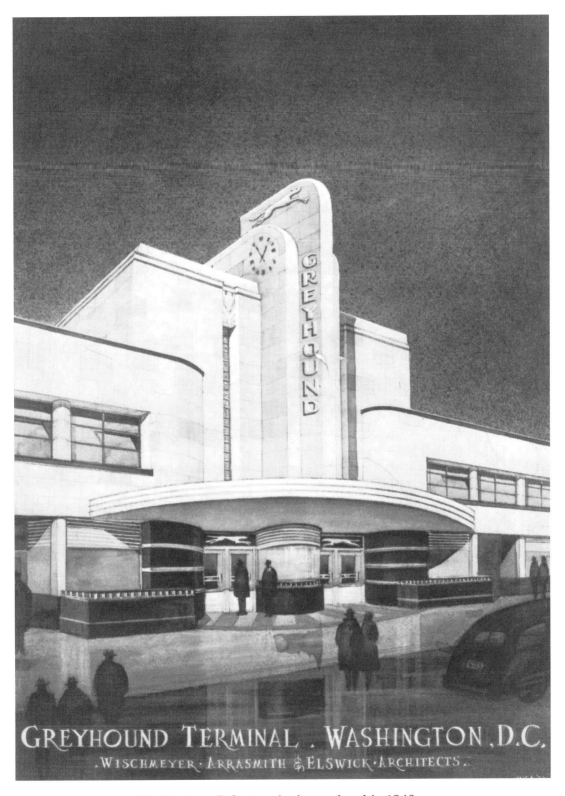

Washington, D.C., terminal completed in 1940.

national reputation as an architect and became recognized as the foremost authority on bus station design in the United States.[14] One thing was certain: all of Arra's bus entrance and exit driveways would provide easy access for buses entering and leaving, regardless of site limitations and street configurations. All other design considerations were, necessarily, secondary to the planning concerning the circulation of bus traffic in and around a terminal. Arra's work on this aspect of terminal design was meticulous and he spent hours working with bus turning radius templates on every Greyhound commission. Despite all of this attention to details which were important for the functioning of a bus terminal, Arra unfailingly designed buildings that were not only practical but imaginative and innovative.

Six

Arrasmith's Service in World War II

Busy as Arra was with his work for Greyhound in 1940, his thoughts often strayed to the growing conflict in Europe that threatened to draw the rest of the world into its orbit. The possibility that America might become involved in the war, while wishfully discounted by some, was acknowledged in most quarters. To Arra it appeared inevitable, and he was prepared to do his part if he was called to duty.

Arra's patriotism may have been characteristic of the time, but his level of commitment was more than routine. Arra was proud to count himself as a part of the nation's defensive forces. Ever since his days as an R.O.T.C. student at the University of Illinois he had remained active in the Army Reserve. He was now a captain and the commanding officer of his unit, as well as being area engineer and contracting officer for the Army Corps of Engineers for his region. As a college student he had volunteered to fight in the war to end all wars in Europe. During the Depression he had put his architectural practice on hold when he was ordered to command a unit of the Civilian Conservation Corps and, when the Ohio River Valley was inundated by floods in 1937, he commanded a Corps of Engineers unit which was assigned to build a temporary bridge across a flooded river in Louisville, Kentucky.[1]

Arra's unit was assigned to quickly and inexpensively construct a floating bridge to replace a highway bridge that had been washed away. Because floatation devices were not conveniently available through military channels, Arra approached the distilleries in the area for enough used whiskey barrels to float a span across the swollen waters. The resulting bridge satisfied all requirements. In addition, as the floodwaters rose and fell, the bridge readily accommodated changes in water level with minimal risk to the structure. The bridge quickly became known as the Whiskey Barrel Bridge, and it won Arra the admiration and thanks of the local community and the Corps of Engineers as well.

When Pearl Harbor was attacked by the Japanese on December 7, 1941, Arra knew that his call to active duty could not be far off, and in February 1942 the expected news arrived. He was assigned command responsibility for the construction of Camp Atterbury,[2] a new training camp to be built just ten miles outside Columbus, Indiana, on what was then only farmland. This huge undertaking had a projected cost of $26 million. Never before had he been responsible for anything approaching the magnitude of this assignment. The closest thing in magnitude that Wischmeyer, Arrasmith & Elswick had worked on was the Kentucky Emergency Relief Administration commission, but that job paled when compared to Arra's new responsibility.

The Camp Atterbury assignment was a supreme challenge and one that Arra might

well have felt he was not fully equipped to handle. But there was a war on and his assign-
ment was to get the camp built within budget and on time, period, so personal doubts were
put aside.

Fortunately, Arra could draw upon his previous military experience to help him through
the Camp Atterbury project. It was apparent that the ability most needed here was to be
innovative and imaginative and this was a talent that Arra had clearly demonstrated on pre-
vious assignments.

Although he had commanded small groups of men before, the Camp Atterbury assign-
ment presented the sobering prospect of having hundreds of army men under his com-
mand, in addition to dealing with a multitude of civilian contractors who would do the
actual construction work. Arra did not have the luxury of hand picking the men who would
be under his command, but he still had to make sure that they worked well together as a
unit. This aspect of the job turned out to be as challenging as it was occasionally educa-
tional. Arra did not always know much about the background of the people he was dealing
with and there were occasional surprises. During the Whiskey Barrel Bridge construction
work he complimented a reservist, who was especially effective as a crew foreman, for his
superior handling of the rough and tumble crew. When Arra inquired what the man did
in civilian life, the man confided that he was a women's hairdresser. He also asked Arra to
keep this fact quiet, which Arra did.[3]

Arra learned many things during the year he oversaw the construction of Camp

The Whiskey Barrel Bridge, more than half a mile long, was the only connection
between the Louisville Highlands and downtown in 1937.

Atterbury that would prove valuable when the war was over and he would return to civilian life as an architect. He rapidly honed his already ample skills of dealing with people of all ranks and stations in life, be they governmental bureaucrats, high or low ranking military personnel, civilian workmen, commercial contractors, corporate executives, community leaders and officials, community citizens, local and military police, and even the occasional miscreant.

He became especially adept at solving serious matters with good humor. Two incidents that occurred while he was overseeing the construction of Camp Atterbury demonstrate this ability.

As commanding officer and area engineer at Camp Atterbury, Arra had virtual autonomy and an ample staff to execute his orders. Although he was a commanding officer he had always enjoyed being with men of all ranks. He developed a close camaraderie with his co-workers and subordinates, and he was often out in the field talking with the men or checking on construction progress. In order to make it more convenient for the contractors to find him during the work day, he developed the practice of running the corps flag up the flag pole in front of his office when he was in. Whenever he would be out of the office, he would order that the flag be taken down.

One day, the general who had been assigned to take command of Camp Atterbury when construction was nearing completion came to Arra's office. Although the general had been at Camp Atterbury for some time, he had not happened by the office when Arra's corps flag was flying.[4]

Surprised to see the flag waving proudly at the top of the flag pole, he stopped his caravan and asked one of the men nearby who the flag belonged to and why it was displayed. Upon learning that it belonged to the area engineer, the general immediately gave orders for Arra to strike the flag because this use of it was not according to regulations. Of course, Arra did as he was ordered, but not without some feeling of resentment. Displaying the corps flag as an indicator of his whereabouts had become a pretty good system, and he did not like being told when he could and when he could not hoist the flag.

As soon as the general left, Arra ordered one of his men to go over to the general's headquarters and inspect the general's flag pole for defects, deterioration or any other deficiency that might appear. Within a few hours, the general's flag pole was gone, cut off about four feet above the ground. The inspection had apparently revealed that the flag pole was infested with termites and presented a threat to the numerous wooden buildings that had been constructed throughout the camp. Of course a new flag pole had to be constructed on orders from the general, but there were certain very understandable obstacles to a speedy replacement. Paperwork had to be processed, and material shortages had to be dealt with. It took quite some time before all the requisite paperwork could be processed, material requisitioned, and manpower assigned. Although this story may sound far fetched it was sworn to by Ed Baldwin and Stratton Hammon, both of whom were associated with Arrasmith during his duty at Camp Atterbury.[5]

Another example of Arra's use of humor to set things right at Camp Atterbury occurred within the city limits of nearby Columbus, Indiana. While parties and relaxation were not only an integral part of life at Camp Atterbury, they were a real necessity during the especially stressful days early in America's involvement in World War II. For Arra's men it was important to get off base and to have a chance to forget the pressures of the war effort from time to time, if only for a few hours. Unfortunately Columbus was a very straightlaced community in the early 1940s and the ever-increasing number of GIs that poured into town on the weekends began to upset the town's peace and tranquility.

Local standards for social behavior were on the conservative end of the spectrum, so much so that a lady who smoked in public would suffer the highest degree of disapprobation. One summertime solution for this problem was for such a lady, while enjoying the fresh air on her front porch, to keep a cigarette in an ashtray just inside the front door so she could enjoy a private puff or two. Such watchful monitoring of course also applied to the soldiers, making it rather difficult for them to let off much steam when they came to town. Just taking a local girl out on a date was considered suspect, and there was a limit to the number of places couples could go for entertainment, especially if they wished to have any time alone together.

One spot in Columbus did afford a certain amount of privacy, however. Columbus had a beautiful old church in the heart of town. Two of the church buildings were connected by a bridge spanning a reflecting pool. This basin was about ten feet below the surrounding lawn and offered some privacy to a couple sitting near the edge of the basin. The basin became a popular spot for enlisted men and their dates to hide from the prying eyes of the community's self-appointed chaperones.

Arra and his fellow officer friend from Louisville, Stratton Hammon, both had soldiers under their command who regularly went to town, picked up their dates and headed for a bar to drink and dance. Later in the evening, they would go over to the church pond and hide from public view for a few private moments together. It was not long before the town busybodies discovered the practice and, horrified at such goings-on late at night, on the grounds of a church no less, determined to put a stop to it.

One warm summer evening, the Columbus city police force raided the pond arresting all the soldiers they caught for loitering and took them to jail. The next morning, the town newspaper ran a prominent story that included the names of all the girls involved in the incident. Such outright prudery quickly came to the attention of Arra and Hammon and the next evening they went to dinner together to discuss appropriate countermeasures. By the time dinner was over they had developed a battle plan which they decided to implement the following Saturday night

When the designated evening arrived, the social situation in downtown Columbus appeared much as it had on previous weekends. As the evening wore on, anyone who was walking by the reflecting pond might have noticed the traditional drifting of couples down to the pond to relax in privacy and enjoy the evening air. Busybodies might have been shaking their heads in bewilderment that these people had not learned the lesson of the previous weekend. As Arra and Stratton had expected, among those who were watching the church grounds that evening was a detachment of the Columbus Police Department, apparently intent upon repeating their ambuscade of the previous week.

After quite a few couples had settled themselves comfortably around the pond, the police leapt into action. Over the crest of the hill by the pond came a rush of officers bent upon grabbing the revelers and cleaning up the church grounds once and for all. But this time the couples were ready for the police. Instead of an even mix of off-duty GIs and their female companions, the police squad found a detachment of soldiers, half of whom were dressed like women complete with dresses, hats, gloves, high heeled shoes and makeup. It was to the soldiers' advantage that the policemen were gaining speed as they charged down the slope toward the pond. When the police reached the reclined couples, the soldiers leapt up and did whatever they could to speed the policemen past them and on into the pond. As the police floundered in the water, the soldiers all made good their escape. The police and the busybodies had gotten their comeuppance but, not surprisingly, the next morning's

issue of the Columbus newspaper failed to report the episode. Subsequently, small numbers of the more traditional couples returned to the church grounds to enjoy themselves during the remaining warm summer evenings, unmolested by the local constabulary.[6]

Notwithstanding these and similar diversions, Arra was totally dedicated to his assignment and finished building Camp Atterbury within the time frame and cost budget estimates. In addition to gaining experience in defusing potentially explosive situations, Arra acquired an enlarged understanding about administrative matters including supervising a large staff, operating on a limited budget, achieving an objective regardless of difficulty within the time allotted, setting up and managing an office, and overseeing a massive construction project so as to keep it running efficiently and smoothly. Although the basis for these skills had been established through Arra's prewar work for Greyhound and other clients it was his military experience which exposed him to these administrative matters on a much larger scale. All of this would be invaluable to him after the war.

The architectural and engineering aspects of his assignment at Camp Atterbury taught Arra many valuable lessons as well. He became familiar with the way the government approached building design and construction. He learned how government specifications were established and applied, how the government job bidding process worked, how to navigate the blizzard of red tape that always wraps itself around any government project, and how to "get around" it to expedite things. He also learned much about flow chart techniques for managing a construction process, and he honed his ability to coordinate suppliers and contractors so that materials would arrive on time and work could proceed uninterrupted.

But perhaps the most valuable thing to come Arra's way during his days at Camp Atterbury was the renewal of his acquaintanceship with engineer and fellow U of I alumnus Edward W. Baldwin, who would come to play an indispensable part in Arra's postwar professional career.

Baldwin had graduated from the University of Illinois in 1932 with a degree in civil engineering, and like Arra, had been in the R.O.T.C. program. Upon graduation Ed entered the Army with the rank of second lieutenant. He worked in the United States Engineering Offices in St. Paul, Minnesota, for a time, and was then reassigned to Louisville where he joined the same Army Corps Reserve unit that Arra was in.[7] Their friendship grew during the year that Camp Atterbury was under construction. As the war progressed they went their separate ways but Arra told Baldwin that they might work together when the war was over and they promised to keep in touch.

By the time Arra completed the construction of Camp Atterbury he had matured into a more rounded architect with a great variety of new and enhanced talents. But before Arra could return to civilian life, the Army found a need for his talents overseas where the actual fighting was going on. Soon Arra was in Europe, swept up in the invasion of Italy. His contribution to this part of the war effort involved work on the plans for the invasion itself and he was able to see the results of his efforts when he waded ashore with the troops as the invasion began.[8]

It was not until after the Allies had liberated Italy that Arra was able to look forward to returning to his practice of architecture at home in the United States.

Greyhound's Architect in the East: The Move to Cleveland

As the war in Europe wound down Arra renewed connections with Greyhound and made them aware of his interest in returning to work for the company as it began its postwar rebuilding program. Greyhound officers Swan Sundstrom and Robert Budd contacted Washington, D.C., and requested that the military release Arra so he could assist them with Greyhound's all important building plans.[1] In an effort to win Arra's early release the two men reminded government officials of the vital role Greyhound had played in the movement of servicemen and civilians during the war effort.

Their arguments proved effective and Major Arrasmith was ordered back to the United States to be released from active military duty, but was asked to remain in the Army Reserve. Arra told them he was agreeable to this proposal if they would promote him from major to lieutenant colonel. When he returned to his home in Louisville in October of 1944, Arra wore a pair of shiny silver leaves on his shoulders, the insignia of his new rank.

While Arra was in Italy people at Greyhound were making plans for him. Budd and Sundstrom, two of Arra's closest associates at Greyhound, had received draft deferments because of their positions in the transportation industry, which the government considered to be critical to the war effort. Sundstrom was president of Pennsylvania Greyhound Lines, and Budd, president of Central Greyhound Lines of Cleveland and the Cleveland Terminal Corporation—all of which companies were subsidiaries of Greyhound. The two men had crafted a proposal for Cleveland's newest travel center, which they hoped to complete as soon after the end of World War II as possible. This was to be the world's largest bus terminal. Approval for the project had been received from the parent company and steps had been taken to implement what was to be the most ambitious building program in the company's history. Greyhound was the nation's largest transportation company and the war effort had taxed its terminal system to the utmost. Modernization of older terminals and construction of new ones was now a top priority.

During the war, shortages of materials and manpower had brought all building projects to a complete standstill, and even maintenance of existing terminals and equipment had been impossible to continue at prewar levels. With the war's end in sight and the impending flood of returning soldiers about to put heavy demands on the nation's transportation system, America would be on the move and Greyhound wanted to be ready.

Before the war, Arra had conducted all his work for Greyhound from his firm's offices in Louisville, the city in which he had practiced architecture since 1922. While Arra was

away at war, his two partners in Wischmeyer, Arrasmith & Elswick carried on the firm's business. Unfortunately, Hermann Wischmeyer died shortly before the end of World War II and the firm was dissolved with Fred Elswick opening his own office as a sole practitioner.[2] As fate would have it, this circumstance turned out to be a blessing in disguise since Arra was no longer bound to a firm or to Louisville, Kentucky.

For their new postwar projects Greyhound wanted Arra to be near their headquarters in Cleveland so that terminal network planning could proceed without the inconvenience of the two-hundred-fifty mile distance between Cleveland and Louisville. Freed of his ties to Louisville, Arra, Betty, and their daughter, Anne, moved to Cleveland shortly after Arra's return to the United States. The Arrasmiths purchased a new colonial style house, faced with clapboard siding and Lannon stone, in Cleveland's eastern suburb of South Euclid. The house was situated on a winding boulevard with a wide tree-filled grass center strip, and was no more than thirty minutes from Arra's office in downtown Cleveland.

After settling into his new home, Arra threw himself into the intensive planning effort for Greyhound's postwar future. As Greyhound's inhouse architect Arra, for the first time in over twenty-five years, had become a salaried company employee. Greyhound, like virtually all other industries on the home front that were not directly involved with producing war material, had been making do with whatever was in place at the beginning of the war. In Cleveland, Greyhound had gone through the war years with a terminal that was originally a theater. When the building opened as a terminal in 1931, its location on the eastern edge of downtown Cleveland at Superior and East 9th Street had been completely satisfactory and the facilities more than adequate. The interior of the building had been completely reconfigured with a waiting room, offices, and other facilities and amenities for the traveling publics' needs.

W.S. Arrasmith with Greyhound officials. Left to right: Robert W. Budd, Swan Sundstrom, Arrasmith, and Clifford Graves (1948).

However, by the early 1940s Greyhound had outgrown its location and by 1944 the terminal was totally inadequate. With the increase in bus traffic generated by war-related travel, what had been a bad situation became intolerable. There was not enough space to park on the street and as a result, buses might have to stop two deep to take on and discharge passengers. The loading and unloading of passengers and their baggage swamped the streets, the sidewalks, and the depot. Baggage piled up on the curb, automobile traffic was snarled, and tempers flared as motorists were caught in the congestion. The situation was as unavoidable as it was intolerable. The City of Cleveland demanded that something be done, the Cleveland Police Department was impatient with the problem, the motoring public was becoming incensed, and sidewalk pedestrians were verging on riot.

Greyhound had been working to resolve the problems caused by the old terminal as early as 1941. In fact, before Arra was called to active duty that year, he had designed a new Cleveland terminal that was to have been constructed at 1900 E. 13th Street, not far from the existing terminal. The war prevented any further work on this terminal and, as events developed, it was a fortuitous happentance. By 1944 it had become painfully clear that more space than was available on E. 13th Street was needed for any new terminal that Greyhound would construct in Cleveland. It would be necessary to obtain a new site that would afford the room needed to construct a much larger building for an expanded terminal and corporate offices. If this could be arranged it would make the city, the passengers, and the motoring public happy, and Greyhound would have a new landmark terminal.

Once Arra, Budd, and Sundstrom had outlined the company's postwar building program and a plan for its implementation, it was agreed that it would be more beneficial for Greyhound and Arra if he were to open his own independent architectural office in downtown Cleveland rather than to continue as a salaried employee of Greyhound. Working on his own, Arra could act as a consultant to Greyhound to effect the realization of the building plans he had just helped put in place, yet be able to function independent of restrictions typically found in corporate organizations.[3] This arrangement would afford Arra an opportunity to once again be on his own as a sole practitioner, and Greyhound would have the benefit of a supervising architect who knew the company, but who was not tied to corporate politics or constrained by corporate red tape. Arra did his best work when he was in complete control of a project and so he was pleased with the new arrangement.

Arra's new business letterhead showed the name William S. Arrasmith, Architect and gave the address of a building at 2341 Carnegie Avenue.[4] It listed his position as consulting architect for both Pennsylvania and Central Greyhound Lines, and also noted his registration with the NCARB (National Council Architects Registration Board) and his certification to practice architecture in Indiana, Kentucky, Virginia, New York, Georgia, Maryland, Ohio, Pennsylvania, Tennessee and the District of Columbia. The building was owned, and its upper floors were occupied by, Walker & Weeks, one of Cleveland's most highly regarded architectural firms, while a Lincoln automobile dealership took up the street-level space.

The Carnegie Avenue office was relatively small and as work on Greyhound's projects increased Arra began a search for larger office space. His search was quickly rewarded when he found a new location on the second floor of the Euclid Avenue Rogers Building—just one block south of the site of the soon to be constructed Cleveland Greyhound terminal on Chester Avenue.[5] The office was in the heart of Cleveland's Playhouse Square theater district and possessed the requisite northern exposure so favored by artists and architects alike. Coincidentally, the new location was near the offices of Bonfield & Cumming, the

Cleveland architectural firm that was associate architect with Arra on the unrealized Cleveland terminal project which had been shelved when the country entered World War II.

The new office was especially attractive because of its convenient location and the fact that his staff could ride the streetcar to the building's front door. Even though new cars were very hard to obtain immediately after the war Greyhound furnished Arra with a new DeSoto sedan that had been part of the company's fleet.

Another reason Arra found this particular property appealing was the landlord. The building was owned by the Rogers family and Mr. Rogers, the scion of the family, was a millionaire who personally managed the building. He and Arra became friends and they enjoyed swapping stories and telling jokes whenever time permitted. Rogers was a personal friend of John Philip Sousa, the world famous band director and composer, and had many stories about Mr. Sousa that he shared with Arra.

In anticipation of the move to his new office Arra had begun to pull together a staff of talented assistants. It was at this time that a fortunate coincidence put Arra in touch with Ed Baldwin, his fellow U of I alum and Army acquaintance. The two men had lost touch after the war, but Ed remembered Arra's suggestion that they might work together one day. Baldwin held a B.S. degree in civil engineering from the University of Illinois, which he received in 1932. Before joining Arra in Cleveland, Baldwin had worked in municipal and highway engineering, and had been an engineer with the United States Engineer Offices in St. Paul, Minnesota, and Louisville, Kentucky. During World War II, Baldwin served as area engineer in charge of constructing the Army's military base at Bowman Air Field in Louisville, Kentucky, was assistant area engineer at Camp Atterbury in Columbus, Indiana, and was area engineer in charge of the construction of George Field, Lawrenceville, Illinois.

By the time that Baldwin, now a major in the Army, was released from active military duty in Europe at the end of World War II, he had distinguished himself as company commander of the 158th Engineers, and been recipient of three wartime decorations including a Silver Star for gallantry.

And now, Ed was in the market for a new job. Once he discerned Arra's whereabouts, Ed phoned to see if Arra needed a structural engineer. Arra was pleased to hear from Baldwin and immediately asked him to come to Cleveland as his firm's structural engineer.

Russ Schwab, who was working for Fred Elswick at the time, and Stan Arthur who in Baldwin's words were two of the best draftsmen the Cleveland office would have, came up from Louisville to join their old colleague.[6] Arthur came first and stayed with the firm until 1947 when Schwab joined the staff. Both of these men were exceptionally skilled at their work and

Ed Baldwin, structural engineer for W. S. Arrasmith.

could produce drawings quickly and accurately. Schwab in particular was a natural talent. Although he was not a registered architect, he was a superb architectural draftsman and delineator, and worked on the Youngstown, Akron, and Toledo commissions. Of Schwab, Baldwin recalled that he was "the best I had ever seen before or since. He could do the work of three ordinary draftsmen and I have seen him turn out a complete working drawing in one day's time. The work just seemed to flow out from under his hands. He had a profound knowledge of architectural materials and methods and seldom had to look anything up."[7]

Unfortunately, Schwab suffered a stroke in July of 1950 and died. Arra paid all of his colleague's medical and hospital bills and subsequently contributed to the support of his wife and son. To fill the void left by Schwab's death, Arra hired Breck Durand of Oberlin, Ohio, another highly skilled draftsman.[8]

Other staff members included architects Dick Mackey and Dave Carter. Arra hired Virginia Toomehy to assume the secretarial duties for the office including typing, maintaining business records, making appointments and generally keeping the office running smoothly. She also assisted with drawing up job specifications.[9]

When Arra moved into his new Cleveland office during the first week of January 1946, he was faced with the very real problem of purchasing and installing the necessary office furniture and equipment. However, after nearly four years of war there was nothing on the market in the way of new or used architectural office furniture such as drafting boards, tables, file cabinets, stools, etc. None of these items had been manufactured during the war and it was necessary to do a certain amount of improvising. Improvisation was not new to two World War II Army officers like Baldwin and Arra, who had often been called upon to "make do" under the most trying wartime conditions. A little sleuthing turned up just what was needed. A source for the necessary equipment was found just southwest of their office on Prospect Avenue where there was a block-long row of small merchants. In the center of this row was an office furniture and supply store operated by a resourceful merchant who had leased basement space on both sides of his store along the entire block for storage purposes. During the war years he filled this space with all manner of office furniture—mostly used. When Arra and Baldwin surveyed this treasure trove they found almost everything they needed for the new office.

Although the merchant had no drafting boards or tables to offer there were several sign painters' display boards that were three feet wide by sixteen feet long, and a quantity of wooden sawhorses together with a number of steel machinists' shop stools with arms and backs. Arra bought two display boards, ten sawhorses, and five machinists' stools. The display boards and sawhorses were taken to a carpenter who cut the boards into three sections, each five feet four inches long, to form drafting board working surfaces. Trapezoidal wooden pieces were mounted on the sawhorses so that the drafting boards would have a slight slope and be the proper height for the stools. Although rough-hewn and makeshift in appearance, the finished product was efficient and inexpensive, and the circumstances of the situation undoubtedly evoked memories of their Camp Atterbury days.

As Baldwin recalled, even after the newly created drafting tables and office equipment were installed, the new Euclid Avenue office was spartan. It had fluorescent ceiling lighting, a brown colored linoleum tile floor, and undecorated walls. There was a sink in the drafting room with a cloth roller towel machine above it, and just outside the office in the hallway was a drinking fountain.

The innovatively constructed drafting boards dominated the work area. Each one had a fluorescent light with a long flexible neck that was clamped to the board. Arra and the

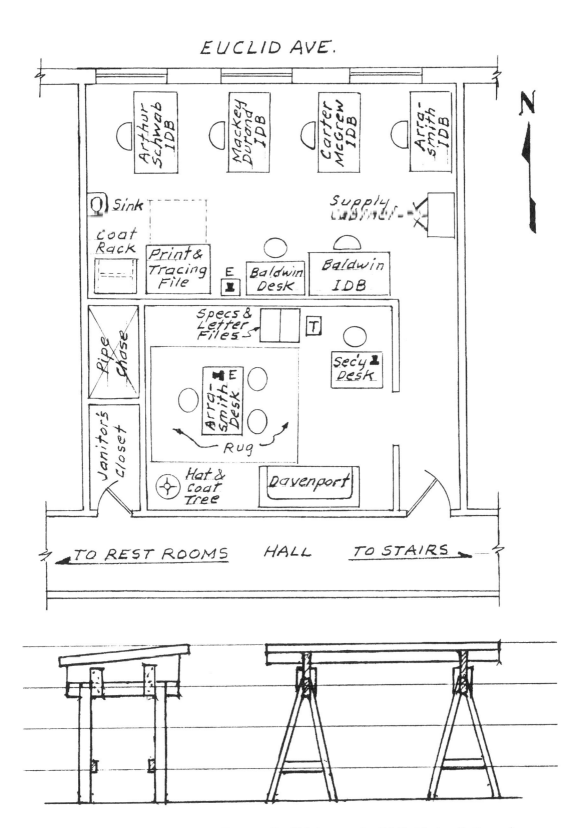

Top: Rendering of Cleveland offices on Euclid Avenue by Ed Baldwin. *Bottom*: A saw horse drafting table as drawn by Ed Baldwin

office secretary each had light oak colored wooden desks equipped with a desk lamp and wooden in-out box. One outside phone line served the office. Arra and the secretary each had a telephone and there was also an extension phone located in the drafting room. There was no wall clock, but everyone would be too busy to notice its absence.

The office staff was responsible for providing their own drafting tools. This was standard practice in the architectural and engineering professions from before the turn of the century to around 1950. These instruments were generally kept in a leather case and consisted of ruling pens, dividers, large and small compasses with ink and pencil attachments, and an extension arm for the large compass. The case also held an array of triangles, French curves, architects' and engineers' triangular scales, protractor, erasing shield, scissors, penknife, brush, lettering pens and pen holders. The firm had the responsibility of furnishing black India ink, pencils, erasers, drawing paper, linen tracing cloth, tracing paper, calculation paper pads and such other supplies as might be required to produce preliminary and working drawings. The firm also provided the normal items required to run an office such as letterhead stationery, writing paper, and carbon paper.[10]

Prior to 1947 all existing blueprint processes required sharp ink drawings on treated linen cloth. Pencil drawings on cloth did not print legibly so it was necessary to make pencil drawings on manila paper and carefully trace them onto cloth in black India ink, using a variety of the drafting instruments. This very time consuming process for making working drawings was used for the Cleveland terminal job, but in 1947 blueprinters improved their process so that pencil drawings on pencil cloth or high grade tracing paper could be legibly printed, and ink drawings on expensive linen cloth became a thing of the past. Baldwin commented that the only instruments he used out of his set after that were the large and small compasses with pencil attachment. In fact, until computers came along, pencil drawings on special pencil cloth or high grade tracing paper remained the norm.

Office drafting supplies were obtained from a blueprint and supply company which loaned Arra forty-eight-inch T-squares, and metal edgers that could be clamped along the left side of the makeshift wooden drafting boards. In exchange for this courtesy, Arra purchased all of his paper, pencils, tracing cloth and other supplies from them and gave them all of the firms blueprinting and blue line printing business. To fill out the remaining office needs, Arra brought some things over from his office on Carnegie Avenue. These items included his desk and a large print and tracing file. All the rest—desks, chairs, typewriter, waste baskets, letter and specification files, supply cabinets, etc.—were purchased from the merchant on Prospect Avenue. These transactions were done on a strictly cash basis as was customary just after the war.

All calculations were done by hand with the aid of a slide rule. The office equipment did not include an adding machine until 1953. Occasionally, when a job called for particularly complex calculations the firm would rent an electric 100-key Marchant or Monroe mechanical calculator to speed up the calculation work.[11]

From time to time during the ensuing years there were as many as three structural engineers on the staff, which, at the time, was quite unusual for a smaller firm, but completely understandable considering the amount of work that had to be done for Greyhound. When the workload reached a point at which additional help was required, temporary personnel and design specialists were brought in. When the office was fully staffed there were as many as sixteen to seventeen people working on Greyhound projects. On almost all new terminals outside of Cleveland, Arra and his office would be involved with a local architect or architectural firm which helped with various matters such as local zoning, prevailing

practices, and keeping an eye on the construction work. For this work the associate received one-twelfth of the 6-percent fee Arra received from Greyhound.[12]

The new Cleveland terminal was only one facet of the Greyhound account that was handled by the Euclid Avenue office during the next five years and the work fully occupied Arra's time and attention while he was in Cleveland. During this inordinately busy period Arra and his staff developed an efficient system for designing Greyhound terminals by concentrating on basic features and design concepts common to all Greyhound projects. This saved the client considerable expense and also guaranteed speedy completion of new terminals. It was not a cut-and-paste system, but provided an outline for approaching each new terminal commission in the most efficient manner. The underlying elements of a functional and attractive terminal had been identified and consequently it was no longer necessary to design every terminal as if it were being done from the ground up for the very first time.

By organizing his office efficiently, Arra was able to focus on the developmental design work of Greyhound terminals while his staff tended to details on projects already underway. Arra designed the complete exterior and interior of a terminal, all the requisite furniture, ticket counters, and other amenities, and determined the terminal building's disposition on the site. The location and design of the bus docks, driveways, and parking areas were also his exclusive domain. Arra retained full personal responsibility for the design of all the terminals the firm did for Greyhound, and as time passed he was able to produce a finished design product in a relatively short time. This meant that his staff had to work hard to keep pace as they sometimes were required to completely redraft working drawings or execute supplementary drawings. A hectic schedule like this often led to extra work being done on weekends so that revisions involving out-of-town jobs could be put in the mail before Monday. Arra could be impatient when this weekend work got behind, but in most other respects the general office atmosphere was relaxed and free of tension.

As different aspects of the project were finalized, drafting work was parceled out. The mechanical, heating, ventilating, electrical and plumbing systems were given to contractors who specialized in these fields. They received a fee of 4 percent of the cost of the mechanical work, which often made up 25 percent of the total cost of the entire project.[13]

The balance of the work flowed through the office in a manner that was reminiscent of an assembly line. Once Arra had completed the terminal design, he would turn the plans over to Baldwin who was responsible for "holding it up with something"[14] as Arra jokingly put it. Baldwin's duties more specifically were to make structural drawings including the engineering of the steel structure and concrete work. Baldwin would furnish the associate architects and staff draftsmen with sufficient sketches and details, together with beam, column, footing and foundation schedules, from which structural drawings could be made. In addition he drew up all of the plot plans. Baldwin had two years of experience as assistant city engineer for the city of DeKalb, Illinois, which proved invaluable for plot plan work involving curb cuts, concrete pavement for bus driveways, passenger loading platforms, and sidewalks. When it was necessary to meet with city officials he was able to go over things with the city engineer and street department officials and speak their language.

As part of his responsibilities, Baldwin traveled frequently to job sites during construction of the foundations and the framing of the buildings. He inspected the out-of-town jobs during the early stages of construction and Arra inspected them in the final stages. Only occasionally would they travel together since only one of the two men could be away from the office at a time. Most of the traveling was done by train. Arra had a Greyhound pass

but used it only once. As a matter of fact, none of the Greyhound executives traveled by bus, but instead chose to go by either train or plane.

When a terminal's steel frame was completed and the construction workers had placed an American flag on the top of the structure, that was the last Baldwin would see of the terminal. He then moved on to the next project and as a result saw only two terminals after they had been completed—those in Akron and Cleveland.

Arra hired a summer intern in 1947 and 1948 to help relieve the draftsmen of many of the unavoidable incidental tasks common to the many large projects that passed through the office. The intern's name was William Morris, an architectural student at Cornell University and a Cleveland area resident.[15] Morris' father, a lawyer, was not very enthusiastic about his son's interest in architecture, but was supportive—at least insofar as suggesting that his son put the summers at home to constructive use.

To fulfill his father's wishes, the eighteen-year-old Morris began his job search by turning to the Cleveland yellow pages and the listings under Architects. The first name in the listing was "Arrasmith." He made a phone call to the number listed and Arra answered the telephone on the first ring. A little surprised by this immediate answer Morris nevertheless retained his composure and expressed his interest in working as an intern that summer. Arra, after listening to Morris and asking some questions, decided he liked this aggressive and resourceful lad, and hired him over the phone.

Morris' starting salary was ten dollars a week and his hours were from nine in the morning to five in the afternoon five days a week, and a half day on Saturday. Morris was expected to wear a suit and tie to the office like all the other men, but while at work in the office shirt sleeves were the norm.

Arra assigned Morris the responsibility of executing construction project renderings for use by the media. The pen and ink renderings that Morris made were all completed with the relatively primitive drafting instruments which were in use at the time. A metal nib of the desired thickness inserted into a wooden pen holder then dipped into a bottle of ink on a frequent basis served as his pen. Morris remembered well that "it was not easy to draw a straight uninterrupted line of any length because it would require several trips to the bottle of ink to keep the ink flowing properly. The nib could not be overloaded with ink because it would change the darkness of a line, or worse yet, blot the paper and ruin an almost completed rendering that had required hours and hours to prepare."

Perhaps remembering his own days as a student intern, Arra was very solicitous about Morris' work and personally supervised everything he did. Always the consummate Southern gentleman, Arra was easy to work for, provided the work done for him was good. Even on days when Morris arrived at work late, Arra was not hard on him as it was Arra's nature to ignore the inconsequential things so that the important business could be handled unimpeded by trivial matters. This was a part of Arra's character that office secretary Virginia Toomehy, distinctly recalled. His personal problems or difficulties never influenced the way in which he treated his staff.

Morris worked on four of the Greyhound commissions including terminals at Lima, Akron, and Cleveland in Ohio, and Battle Creek in Michigan. His first assignment was on the Streamline Moderne Cleveland terminal, but since he had been schooled in a more avant-garde form of modernism, he felt that the Cleveland building was a throwback to the prewar days and much preferred working on the more modern Akron terminal. In addition to renderings for the media, Morris did shop drawings which were to be supplied to

contractors who would construct accessories for the terminal, such as waiting room benches and ticket counters. He also had to compare the shop drawings with specifications prepared by the draftsmen to be sure that all dimensions were accurately transcribed.

An incident that left a lasting impression on Morris occurred one day when he was working diligently on a rendering and Arra told him to drop what he was doing and come to his office. When Morris arrived, Arra nonchalantly handed him a couple of pieces of paper and asked him to run them up the street to the Society National Bank. When Morris looked at them he saw that one was a three thousand dollar check and the other was a deposit slip. From the perspective of a struggling intern making only a few dollars a week it was a memorable moment. As Morris put it, the incident served to encourage him to study even harder when he returned to school. When the summer internship was finished and Morris went back to Cornell, he knew he would be returning to the office on Euclid Avenue the next summer. But this time his salary would be much more generous—twenty five dollars a week—an impressive salary for a summer job.

For two diehard baseball fans like Arra and Baldwin, Cleveland during the late 1940s was the perfect place to be. The Cleveland Indians baseball team had a new owner, Bill Veeck, whose uninhibited enthusiasm for the team brought the sport to life for Cleveland fans. The team had improved steadily from 1946 to 1948 when it won the World Series against the Boston Braves. But, the typical work day was so busy that the two men were able to take an afternoon off only once during this entire time, and that was to watch an old timers' baseball game at League Park, which the Indians had left in 1947 to move to the larger Cleveland Municipal Stadium because attendance at games was growing rapidly.

Relaxation for Baldwin, Arra, and the staff had to be woven into the working day. To relieve the tedium of hours of unbroken drafting, the men would tell jokes and engage in light banter with one another as they worked. Arra had a drafting table in the "bull-pen" working area used by the draftsmen, and spent a considerable amount of time at it. He always stood up while drafting and was almost never without a smoldering pipe in his mouth. After a day of drafting work the floor around his board would be littered with spent matches and tobacco ashes, all of which had been ground to a powder by Arra's constantly shuffling feet. The other draftsmen repeatedly accused him of smoking the tobacco, the ashes, and the matches since there was always a cloud of pipe smoke around him. Arra was a gifted raconteur and his lighter moments were enjoyed by all. He liked to tell amusing stories and sometimes he would quote biblical passages he had learned as a boy, or recite lines from a play he and Betty had seen—but none of this interfered with the production of professional quality work. When it was lunch time the men would adjourn to a nearby lunch counter, eat and talk for forty-five minutes, then it was back to the office to work until five o'clock.

Arra developed numerous contacts and formed many associations while in Cleveland. As in Louisville, it was important to stay in contact with people who were not only friends but potential business acquaintances. Because of his open and gregarious manner, Arrasmith was never short of companionship when it was time to unwind. Since Arra enjoyed being with other people, socializing was a natural adjunct to the Arrasmiths' life in Cleveland. There were many parties, both at the Arrasmiths' home and at the homes of friends. Greyhound executive Swan Sundstrom and Arra had been close friends since before World War II which led to an especially close relationship between Betty, Arra, Swan and his wife, Josephine, which benefited Arra's relationship with Greyhound. The Arrasmiths also held membership in the Canterbury Golf Club in Shaker Heights, and the Hermit Club in downtown Cleveland. The Hermit Club is a meeting place for businessmen and professionals

interested in the performing arts. Organized in 1904 by Cleveland architect F. Bell Meade (who also designed the building), the Hermit Club was housed in an English Tudor style structure tucked away on a back alley corner only a few steps away from Arra's office. Here Arra and Betty especially liked participating in plays and skits that the members put on on a regular basis for each others' amusement. When Arra was at work, Betty devoted much of her time to the Women's Auxiliary of the Cleveland Orchestra. Although the Arrasmiths' daughter, Anne, would marry within a year of the Arrasmith move to Cleveland, she elected to stay with her parents while her fiancé, John Lewis, concluded his tour of duty in the Navy. In the meantime, Anne found employment as a secretary for a dentist just a block from Arra's office.

EIGHT

The Cleveland and Akron Terminals

Of all the new building construction Greyhound undertook immediately after the war, the Cleveland terminal was to be not only the company's first, but also its most ambitious. Once planning and design work for the Cleveland terminal had been completed, construction commenced with a groundbreaking ceremony on October 22, 1946. From then on the building process went at top speed until March 30, 1948, when Greyhound held the grand opening of what the *Cleveland News* called "The World's Largest Bus Terminal."

The seventeen month construction period may have seemed interminable to a city that so urgently needed the new facility, but it was, all in all, exceptionally quick for a building of the Cleveland terminal's size and complexity. Running changes were made to the original plan during construction, causing some delay. The most vexing was the result of Greyhound's request that the terminal be modified to accommodate additional floors above the central concourse area. This alteration required extensive structural redesign work but, as things turned out, it was all for naught since the additional floors were never built.[1]

As if the design and construction of the Cleveland terminal were not enough to keep him busy, Arra was simultaneously engaged in designing and supervising the construction of another terminal in Akron, Ohio, twenty-five miles south of Cleveland.[2] Although the Cleveland and Akron terminals were designed and built within a year of each other, they were markedly different in appearance. The Cleveland terminal was Greyhound's last terminal in the prewar Streamline Moderne style while the Akron terminal was rendered in a more avant-garde form of modernism that was beginning to take hold in American commercial architecture.

The two styles bore similar design elements yet were distinctly different in appearance. Streamline Moderne emphasized horizontal lines with rounded corners and smooth surfaces, while the more modern style featured square corners and textured brick facades. Although the horizontal theme of Streamline Moderne was retained in the new style, it was no longer as dominant an element. Streamline Moderne evoked the feeling of speed and movement through the use of strong horizontal lines, whereas the newer avant-garde style conveyed a greater sense of attachment to place.

Since 1936, Arra had been designing ever-more-refined streamline buildings for Greyhound, and the Cleveland terminal was a final statement that distilled all the best elements of that style. Streamline's characteristic features of dramatic curvilinear flowing lines, smooth sleek surfaces, cool gray color, and free standing sign pylon had all symbolized the promise

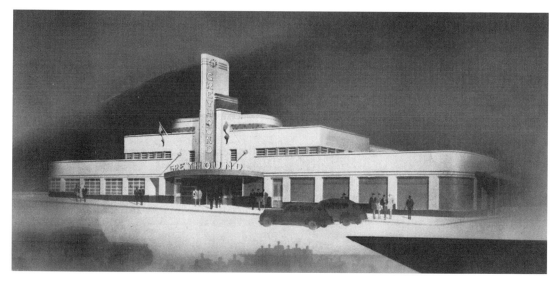

Preliminary rendering of Cleveland, Ohio, Greyhound Terminal (circa 1941).

of the now-arrived future. In its place came a new style with ninety-degree corners and crisp execution as exemplified by the Akron terminal. Surfaces were now largely tan and brick rather than the smooth cool gray of Indiana limestone. The pylon tower sign had became a structural tower. The two terminals conveyed different messages: the Akron terminal appeared to be no more than what it was, a contemporary building, whereas the Cleveland terminal was a building which symbolized a graceful machine in motion.

There were several reasons why the Akron and Cleveland terminals were executed in totally different styles. The Cleveland terminal had initially been designed in 1941 with final drawings made in January 1942, just before Arra was called up for the war. Although these detailed plans were discarded, the original styling theme for a stand-alone Streamline Moderne building was retained. The Akron terminal, on the other hand, became part of a proposal by the Pennsylvania, Baltimore & Ohio, and Erie railroads to build a transportation center on Akron's downtown perimeter. Greyhound executives learned of the proposed style of the complex when the company became a participant in the project. The railroads' architect in charge of the project had selected the more modern avant-garde style for the Union Station portion of the complex. Although Greyhound originally proposed constructing a terminal identical in appearance to the one in Cleveland, the company agreed to conform to the style chosen for the Union Station, even though the bus terminal was situated on the other side of the tracks, so that the finished center would present a uniform and cohesive appearance.[3]

The Cleveland and Akron terminals were on the cusp between the waxing and waning of these two architectural styles. Arra was moving with the times as well as complying with the interests of the railroads when he adopted the modern style in Akron while at the same time making his final and most eloquent statement of the Streamline Moderne style in Cleveland.

The Akron terminal set the theme for the appearance of Greyhound's postwar terminals. Arra was able to make the transition in style smoothly and successfully while the basic principals of bus terminal design, the ones that he had become famous for, remained the same. The eastern edge of Greyhound's property abutted the right-of-way of three railroads

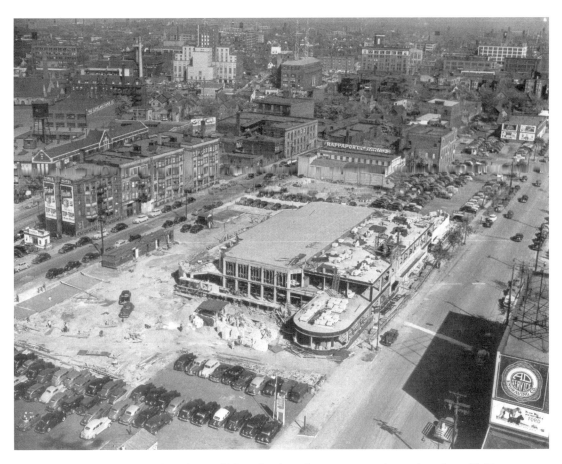

Cleveland, Ohio, Greyhound Terminal under construction, circa late 1947.

and a covered passage connected the Greyhound terminal to the three railroads' Union Station platforms some thirty feet below street level. The passageway allowed bus and rail passengers to transfer from one mode of transportation to the other with ease and convenience. This interconnection became the first instance in the United States in which these two competing modes of transportation had so intimately joined their operations. Perhaps this unique level of cooperation for postwar passenger traffic arose out of a mutual apprehension that rail and bus companies would soon face increased competition from the automobile and airlines as the public's desire for convenience and speed in travel increased.

Arrasmith's structural engineer, Ed Baldwin, recalled that the Akron terminal presented Arrasmith with the opportunity to design something he had always jokingly threatened to do—a monumental approach to a manhole. The pedestrian passageway between the railroad facilities and the bus terminal passed over the centerline of a manhole for Summitt Alley, a street that ran behind the bus terminal. Because the passageway now made access to the original manhole impossible, the manhole access structure had to be raised to the level of the passageway and a manhole cover situated in the middle of pedestrian access at the top of a staircase. This accidental situation was the subject of endless office humor during the project and encouraged Arra's staff to produce fanciful design embellishments that were so excessive they overwhelmed the terminal itself. In the end, the manhole

cover received the usual restrained treatment, but Arrasmith felt he had realized one of his lifetime's most whimsical architectural wishes.

During the postwar period, changes in Arra's business relationship with Greyhound were beginning to take place. Up until this time Arra had enjoyed close personal and business relationships with Greyhound executives, which always served to smooth over any occasional points of difference with staff-level Greyhound personnel. However, at the same time that Greyhound undertook its ambitious postwar building program, there was a major change of the guard at the company.

Retirements had taken their toll and some of the people Arra had worked with before the war had been reassigned while others had left the company. This meant that a number of new faces had been brought into the administrative structure, and people Arra had never worked with before were now in positions of power. The efficient "old boy network" of informal discussions and negotiations was gone. A new and unfledged management team was now in place, doing its best to find its wings. One of the greatest problems that Arra encountered at this time was dealing with people who had no technical background, but had been promoted to positions which put them in charge of reviewing architectural plans. At one very frustrating point in a plan negotiation meeting with a newly-elevated purchasing agent, Arra summed up the situation he now faced when he said, "Dammit DeRoy! You purchasing agents are all the same. You know the price of everything and the value of nothing."[4]

Business meetings were now very formal, as opposed to the casual productive discussions of the past when the two sides had the common goal of doing what was best for Greyhound and could efficiently achieve balance between quality and cost. The new company officials, unaccustomed to this very practical method of doing business, were often aloof and on occasion seemed not to trust Arra, despite his many years of service to the company. Sometimes, previously settled points would be brought up, and Arra would be confronted with a flurry of new demands for cheaper and cheaper ways of doing something.

As is always the case when new management comes into a company, accountability to stockholders—meaning the bottom line—becomes paramount. Arra was aware of this, and always did his best to assist the new management, but it was not easy. There was a difference between doing things economically and cheaply—something the old management understood but that many of the new purchasing agents failed to grasp, due in large part to their

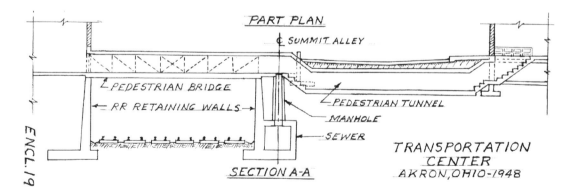

Drawing for Akron, Ohio, terminal pedestrian bridge and "monumental approach to a manhole."

lack of expertise in the technical aspects of a building project. As a result, cost cutting often became the sole point upon which decisions were based. Arra found himself caught between what he ruefully observed to Baldwin as the need to "show them something bigger, better, and cheaper,"[5] while at the same time struggling to maintain his high standards and professional integrity.

The change of the guard at Greyhound did not affect the quality of Arrasmith's work or the effort he and his people put into Greyhound commissions. Baldwin recalled that Arra always held the interests of Greyhound foremost in his mind, and he did all he could to please them fully. He worked over the job cost estimates as if he were a Greyhound employee, being sure that they would get the most for their money on each and every job. And he worked diligently to have job proposals prepared as quickly as possible, so as not to delay Greyhound in its drive to modernize its terminal facilities—even though this often meant reworking many designs and drawings as compromises were reached.

Arra did not charge Greyhound for this extra work, which was not of insignificant value. Nevertheless, he always paid his staff in full for all their work, whether he billed it out or not. Often this would mean that a 6-percent margin on a job, that was to have been his profit, would gradually evaporate until there was only 1 or 2 percent left at the completion of a job.

With a regular staff of five to seven men, rent to pay, and overhead to be met, this left slim rewards for Arra. It was one of the reasons that, although the Arrasmiths lived comfortably, they were not truly well off financially. This did not affect their style of living in any way because they had always preferred to live modestly. To them possessions were not as important as work, friends, and service to the community.

Occasionally, Arra's generous nature regarding his employees proved to be to his financial detriment. He would retain staff members when there was no longer any real justification for keeping them on the payroll. He valued the loyalty of his people, and he was in turn loyal to them. But the camaraderie and comfortable working atmosphere that were engendered by these practices were their own reward.

From the commencement of construction on the first postwar terminal at Cleveland

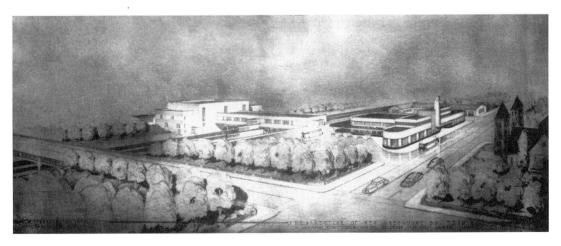

Preliminary rendering of Akron, Ohio, Greyhound Terminal as first envisioned. The original design featured a streamline style Greyhound bus terminal similar to that built in Cleveland, Ohio. The terminal as built was done in the avant-garde style to harmonize with the other buildings in the transportation complex (circa 1947).

until the end of June 1950, Arra completed no less than eleven major terminals for Grey-hound, plus modifications on numerous existing structures. Major new construction was done in the cities of Cleveland, Akron, Athens, Toledo, Youngstown, and Lima in Ohio; Battle Creek, Flint, and Grand Rapids in Michigan; and in Norfolk, Virginia, and Birm-ingham, Alabama. Only the Cleveland terminal was in the Streamline Moderne style and only the Akron terminal approached its size and $1 million cost.[6]

During the time Arra worked in Cleveland he was normally too busy to take on other commissions beyond those he handled for Greyhound. There were two exceptions, how-ever. One involved the remodeling of the ground floor of his office building to accommo-date a bank. Among the amenities he designed for the bank was Cleveland's first drive-up teller window. The other commission was for the residence of a friend in the well-to-do east-ern suburb of Willoughby, Ohio.

Arrasmith Returns to Louisville

By 1950, the initial phase of Greyhound's postwar building and renovation effort had been completed. There were a number of projects yet to be finished, but the nature of the remaining work did not require Arra's ongoing presence in Cleveland. That the work could now be handled from some other location was agreeable to both Betty and Arra, who had always considered Louisville and the South to be their real home, as it had been since their arrival there in 1922. They had both lived and worked in Louisville for nearly twenty years before Arra went to war. While her husband was away, Betty had remained in Louisville enjoying the support of their many friends, family, and other acquaintances until Arra returned from overseas. In addition, it was in Louisville that Arra had first built a reputation as a leading architect so Betty and Arra were happy to return to Louisville.

Once the couple settled into their new home in Louisville, Arra began the search for office space. He wanted to locate downtown and soon found an ideal space in the Lincoln Bank Building.[1] The office was in the northeast rear corner of the building and had about the same floor space as the Cleveland office. All the Cleveland office furniture was shipped to Louisville and installed in the new office. Even the improvised drafting boards that had been constructed from sign board and sawhorses came along as part of the office furniture in Louisville.

The firm functioned in Louisville much as it had in Cleveland. The size of the office staff and the work load remained about the same, since most of the work for Greyhound would take at least another three years to complete. However, now that Arra was back in Louisville where he was well known, the firm's commission base broadened and grew to include more and more work for clients other than Greyhound. This was a big contrast with the Cleveland years during which time Arra had the reputation of being Greyhound's captive architect and, as a result, his firm executed only a handful of other small jobs.[2]

Work for Greyhound continued to dominate the firm's attention initially, as it comprised about 70 percent of the office work for Arra's first two or three years back in Louisville.[3]

From 1950 to 1953 Arra continued to work independently, and together with Baldwin and his regular office personnel, he was able to comfortably manage Greyhound's work while obtaining and executing other commissions that came his way. Work began once again to feel much like what it had been before the war, even if Arra's associates and staff members were different. Arra did not wish to reestablish the old partnership of Wischmeyer, Arrasmith & Elswick since Hermann Wischmeyer had passed away at the end of World War II, and Fred Elswick was now working on his own.

In 1953, however, as the Greyhound work began to slacken off, Arra decided that it

would be beneficial to have a partner in the firm. Arra was looking for someone who would be capable of bringing in important commissions to help expand the clientele base, and who could also assist with other business matters. Ideally it would be someone who was currently well connected with the business community in Louisville.

Before Arra left Louisville in 1942, the Arrasmiths were members of numerous community and social organizations. Upon returning in 1950, they renewed their associations with these groups. By 1953 their names could be found among the members of several influential and prominent organizations and clubs including the Louisville Country Club, the Harmony Landing Country Club, the Pendennis Club and the Wynn Stay Club. Needless to say, these affiliations were beneficial to Arra in his business as most of Louisville's important and influential citizens and industrial leaders were also members. But equally important to the Arrasmiths was the fact that many of their closest friends were members. The Arrasmiths enjoyed being with their friends and meeting new people, and these organizations provided a convenient place to socialize and relax with their acquaintances in comfortable and gracious surroundings.

It was through these associations that Arrasmith and Will Tyler, another Louisville architect, became acquainted. Tyler was from a socially prominent Louisville family that had been longtime members of the same organizations to which the Arrasmiths belonged. As Tyler and Arra's friendship grew, their mutual professional interests drew them together more and more frequently. So, in 1953, Arra approached Tyler with an invitation to join him in a partnership.[4] Tyler had excellent connections in Louisville, and possessed the ability to attract valuable commissions. It seemed that a partnership would be beneficial for both parties. Arra had been searching for an associate for some time and he felt that he found the partner he needed in Tyler.

Louisville was, at that time, a relatively small town when viewed from the perspective of a professional architect, and it was unusual for a given architect or architectural firm to specialize in any particular field of practice. Having been a captive architect for Greyhound, Arra needed some help breaking out of that mold. It was evident that work for Greyhound would continue, but on a much more modest scale, and it did not appear that it would ever be enough to carry the firm as it had for so many years in the past. Finding new commissions was vital, and Tyler was uniquely positioned to do just that. The general idea was that Tyler would generate the work and Arra would do it, but both parties understood that all aspects of the partnership work would be shared.

Ed Baldwin continued with the firm as an associate and retained responsibility for structural engineering. Other work that related to mechanical, electrical, heating, ventilating and plumbing systems was subcontracted to people or firms that specialized in these areas. Although Baldwin was not an architect and was not a full partner, his position as an associate in the firm gave him the right to a bonus each year, as well as having his name on the firm's letterhead.

Tyler joined Arra in the Lincoln Bank Building in 1953 and Louisville's newest architectural firm, Arrasmith & Tyler, was in business. As Baldwin put it "When Arra and Will came together, they set out to become Louisville's premier architectural firm and they hired the best architects within one hundred miles of Louisville."[5] As a result, staff levels peaked at a total of fifteen permanent engineers and architectural draftsmen. This was a very large number of engineers and draftsmen for a Louisville architectural firm. At least three of the engineers were qualified as both structural engineers and working draftsmen, which allowed two to three major commissions to be underway simultaneously. All of this additional

Lincoln Building offices, Louisville, Kentucky, as rendered by Ed Baldwin.

personnel required more space and by the end of 1953 the firm had moved to a new and much larger "L" shaped office in the 200 Madrid Building.

In order to use the new office space to the greatest advantage Arra and Tyler shared an office, two secretaries shared an adjoining office, and Baldwin was given an office to share with James Stansbury, a newly hired graduate of the University of Illinois architectural engineering school. The drafting room had space and furniture for ten of the fifteen draftsmen and it was sometimes necessary for them to share drafting tables. It was only at this point that the improvised drafting tables and the davenport that had served Arra for eight years were dispensed with. In their place came new commercial drafting tables and, for the first time, an adding machine, which was located in the secretaries' office. Nevertheless, the architects, engineers and draftsmen soldiered on with the traditional pencil, paper and slide rules for their calculations.

From 1953 to 1957 the firm of Arrasmith & Tyler did over fifteen million dollars worth

of commercial work. Non-Greyhound commercial work was substantial and included the Louisville Police Building, the Cotter-Duvalle School, Clarksville High School, and the E-Town Time Corporation building. During 1957, because of expanding business plus the desire to conserve funds, the partners decided to redirect their six thousand dollar annual office rent expenditure into a facility of their own.[6]

A magnificent old private home on Park Avenue at the edge of downtown Louisville was purchased that year and, although it required a complete renovation, the building was

Madrid Building office, Louisville, drawn by Ed Baldwin.

exactly what the architects were looking for. They left the exterior of this large residence untouched. The original interior woodwork and stained glass windows on the first floor were also left intact. The library became the partners' office and the dining room was made into a conference room. The grand entrance and reception area was given over to the secretaries. The second and third floors were remodeled to suit the firm's needs and to accommodate the engineers, architects and draftsmen. A small apartment was retained on the third floor for a caretaker and his wife. Renovations, which included installation of an air conditioning system, were completed in 1958 at a cost of sixty thousand dollars.

Shortly before moving to Park Avenue in 1958, the firm received a call from Greyhound for help with its newest venture. The company had decided to enter the rental car business. Greyhound's thinking was that making rental cars available to Greyhound passengers at their destinations was a natural extension of the transportation service they already offered, since many of the passengers who arrive at a bus terminal are often without convenient personal transportation, making them a captive market. Moreover, the basic facilities needed to handle the rental business—a sales counter and ample parking—were already in place and could easily be expanded to take care of the new business venture. Existing personnel or a slightly expanded staff could serve the rental car customers. Ticket agents could handle the leasing, and bus maintenance people could oversee the cars. It appeared to be a natural.[7]

This new venture of Greyhound's involved Arra and Tyler in one of the company's most complex undertakings. It was a huge project and included the design of massive new terminals in Pittsburgh, Detroit, New Orleans, and Indianapolis, all but one of which incorporated the new rental car facilities. The only exception was the Indianapolis terminal, which was not built to the original Arrasmith & Tyler design. These were very big commissions, but as fate would have it, they would be the last significant work Arrasmith & Tyler would do for Greyhound.[8]

All of Arra's earlier commissions had come to him by way of Greyhound's original management team which included Carl Wickman, founder of Greyhound, and Orville Caesar, his right-hand man. The two men had guided Greyhound from its earliest days well into the 1950s. It was during the height of Caesar's reign—from the mid–1930s into the 1950s—that Arra did his core Greyhound work.

Caesar, who had become president of the company, was always pleased with Arra's performance. However, in the mid–1950s, Caesar left the company and the board of directors replaced him with Arthur Genet. Although an outsider, Genet had an impressive background in transportation management, as he had been vice-president for traffic with the Chesapeake and Ohio Railway.

On January 1, 1956, Genet was given the joint posts of president and chief executive officer of Greyhound. He immediately applied himself to streamlining company operations.

One of his first important changes was the dismissal of Greyhound's longtime advertising agency. The move proved beneficial, and the new advertising agency started off auspiciously by producing one of Greyhound's most memorable slogans: "Go Greyhound—and leave the driving to us."

The other important change was the implementation of a rental car business as an integral part of bus terminal operations. Greyhound's first rental car operation was introduced at the Cleveland terminal in 1957 and met with enough initial success to encourage Genet to mandate the program's expansion to 122 other terminals around the country in a mere 12 months. This proved to be a classic case of too much too fast.

Although this program did not work out to Greyhound's advantage, it at least did not

cause any inconvenience for Arrasmith & Tyler, as they were fortunate enough to retain the commission to design four new terminals to incorporate the rental car business. Three of these were completed.

The great expense of the unsuccessful rental car business proved to be a major factor considered by Greyhound's board of directors when they decided to find someone to replace Genet. This time, they settled on one of their own number—a man who had been in the

(Above) First floor plan of Park Avenue office, Louisville, drawn by Ed Baldwin, and (opposite) an invitation to the open house for Arrasmith & Tyler's new offices.

- DATE Nov. 30TH
- TIME 5:00 P.M.
- PLACE 501 PARK AVE.

- PROGRAM
 EAT DRINK AND BE MERRY
 ALSO INSPECT NEW OFFICE
 FACILITIES (INCLUDING
 LIQUID ASSETS)

THE ARRASMITHS
(BETTY AND ARRA)

R.S.V.P. TW 5-1987,

bus transportation business all of his working life: Fred Ackerman, who was elected president of Greyhound in 1958.

One of the first problems he encountered was related, not unexpectedly, to the rental car business. Clearly, the effort to implement this new service as quickly as possible had resulted in some oversights. One unfortunate example was reflected in the company's inventory of rental cars. It was found that records had been so poorly kept that it was impossible to locate all of the vehicles. This meant that over 16,000 cars and trucks were not properly accounted for. Additionally, Greyhound was obligated to honor 122 leases on expensive downtown locations, signed with the expectation that substantial income would be generated by the rental car business.[9]

Ackerman was ultimately successful in extricating Greyhound from the leases, and he disposed of the rental car business by selling it to a credit company. Because Greyhound's core business operations generated a large daily cash flow, it was possible to pay off much of the car rental debt, permitting Greyhound to continue business without interruption.

Although many of the changes which Ackerman made were beneficial for Greyhound, one was unfortunate for Arrasmith & Tyler. Among the many people at Greyhound that Arra had been working with since the 1930s was Robert Budd. When Budd was targeted for dismissal, Arra could not help but reflect on the way things had been changing: "All of my friends at court had either expired, been fired or retired, and I had been banished to the provinces."[10]

Unfortunately, what was good for Greyhound now became bad for Arra. It was during the Greyhound recovery that Arra's long association with Greyhound began to dissolve.

It began with the plans regarding Greyhound's New York City terminals. The company had two terminals in New York City. The depots had become obsolete and were now clearly

inefficient. Greyhound wanted to build a new terminal combining all services at one central location. The city and Greyhound argued fruitlessly about this for some time until Mayor Robert Wagner proposed that Greyhound rent space in the soon-to-be-built Port Authority terminal. This broke the deadlock and Greyhound was guaranteed a very attractive central location at the terminal with fifteen loading docks which would be capable of accommodating at least four hundred Greyhound buses a day. In addition to this, Greyhound was given permission to build a new maintenance garage only a few blocks away from the Port Authority terminal.

Greyhound's problems were resolved but the architects for all this work would not be Arrasmith & Tyler.

Arrasmith & Tyler were now doing work for only the Southeastern Greyhound Division in Lexington, Kentucky—the very place Arra had started out with Greyhound in 1934. And things there were not progressing in the right direction either.

The Greyhound Work Ends

The shrinking Greyhound account exposed partnership problems that had previously been settled but not entirely resolved.

When Greyhound comprised a large percent of the firm's business, a certain flexibility in the way costs were determined on its projects had worked satisfactorily. Arra had always employed an after-the-fact billing philosophy when it came to the Greyhound account, so that expenses incurred while preparing a proposal before a commission was granted were never charged directly to the client as a specific expense, but were factored into the costs when a project had been completed. Thus, if a bid was made and not accepted, the firm absorbed the cost of the preliminary work. To Arra, this expense was just a cost of doing business, like taking a client to lunch.

Now that Greyhound was no longer a major client, Tyler felt that this policy was inappropriate.

Arra's special relationship with Greyhound no longer existed. Now commissions were being awarded without consideration being given to the extra work that might have been done for Greyhound behind the scenes and at no cost. Under these circumstances, Tyler's concerns were totally justified, as pre-commission work could represent a major part of the finished product and its costs.

Billing procedures aside, there were other sources of tension. Tyler did not appreciate the fact that it took about three times as much technical work to do a one-million-dollar job for Greyhound as it did to complete just about any other million-dollar commercial building. The Greyhound work was highly technical. It was not like designing an office building or a house because of the high degree of public use. There were numerous special considerations involved concerning street traffic flow—both pedestrian and vehicular—bus docking, turning radiuses, curbcuts, and elements of bus movement and flow that involved evaluation of the surrounding area's street and highway systems, among other complex issues. Inside the building there were matters such as baggage handling, ticket sales, adequacy of passenger facilities, projections of normal and peak traffic loads, and a multitude of other problems that needed to be analyzed.

A bus terminal required far more detailed work on each aspect of the design and construction than almost any other type of public commercial building of the time. It would sometimes require up to two or three times the number of skilled architects and draftsmen required on a typical job, and it also would take much more time. Just looking after the adequacy of bus turning radiuses and docking access was enough to keep Arra occupied for days. The mathematics involved were not simple and calculations frequently had to be done

without the aid of anything more advanced than paper, pencil, and slide rule, a time-consuming process.[1] Baldwin's unique experience as an assistant city engineer before he joined Arra helped reduce the time and expense that might otherwise have been involved, but to Tyler, all of these matters were open for discussion.

The Greyhound work also required extensive travel and sometimes extensive leaves of absence from the office when either Arra's or Baldwin's presence was required at the job site while the actual construction was in progress. When Arra was out of town, Tyler was left to manage the firm in Louisville without Arra's help, which placed an extra burden on Tyler.

There was yet another problem for the partners to deal with. Although Tyler was able to secure clients for the new firm, as was expected, he was not especially interested in performing design and drafting work that was necessary to successfully execute the commissions. This necessitated bringing in more manpower, which put pressure on available office space and added to payroll expenses.

Other complications developed as well. Early in the existence of the partnership, Tyler suggested that because Arra's longtime associate, Ed Baldwin, was not an architect, he should not be listed as an associate of the firm or be entitled to bonuses. This suggestion put a strain on Arra's relationship with Tyler and left him with divided loyalties and a situation that presented no easy solution. In order to smooth the waters with his partner, Arra reluctantly told Baldwin that his position as an associate entitled to bonuses would be terminated, but both Arra and Tyler hoped he would stay on as the firm's structural engineer. Fortunately for Arrasmith & Tyler, Baldwin, after considerable soul searching, agreed to stay with the firm under the new arrangement.[2]

Perhaps the greatest cause of tension between Arrasmith and his partner was the fact that Arra was one of two bosses, and he could not exercise complete control over decisions affecting the firm. This was something that Arra had not had to deal with for over fifteen years. He had always been the man in control on all projects—from Camp Atterbury through the Cleveland years and beyond. But now things were different. And the Greyhound work which had always been at the center of their difficulties took on new significance.

When the partnership was formed there was an understanding that Arra would continue to handle the Greyhound account, based on the assumption that Greyhound would remain a firm client. Tyler had no problem with this arrangement, but did question how much time and money the firm should devote to possible future Greyhound commissions, without guarantee of remuneration.

At the time, architects were paid commissions of 6 percent for new construction and 12 percent for remodeling. Out of this fee, the architect had to pay all his expenses including the firm's staff, personnel hired outside the firm, office overhead, supplies, and travel.

There was yet one more vexing problem, and this related to the firm's checking account. Both men were writing checks drawn on the firm's account, and occasional lapses of communication resulted in overdrafts. While there was never a problem in covering the checks, there was the inevitable embarrassment from time to time because of the accidental oversight.

In the final few years of the Arrasmith & Tyler partnership, the firm had one attractive commission which unfortunately did not make it to the drawing boards, and three very interesting buildings which did—and were built to great acclaim.[3]

Southeast Greyhound approached the firm with the intriguing idea of recreating terminals based on the original 1937 Louisville terminal designed by Arrasmith in all its

William and Elizabeth Arrasmith often attended grand opening ceremonies together.

technicolor glory. Arra was flattered and enthusiastic, but this, like many projects of artistic merit which cannot be justified financially, did not come to fruition.

However, the firm did produce three very noteworthy buildings: the Commonwealth School, which involved a new concept for the construction of multilevel buildings; the Kentucky State Office Building in Louisville; and The 800 Building, Louisville's first skyscraper and largest apartment building up to that time.

The Commonwealth School was to be the first example of a "raised building" and it was the firm's only experience with this method of construction. Floor slabs were poured in molds at ground level, and then jacked up, inch by inch, to the intended level that the slab was to assume in the finished building. The lifting mechanism was controlled by a large keyboard so that each hydraulic jack could be instantly and minutely adjusted. The concept was thought to offer lower construction costs because all the work was being done at ground level. It was also believed that this new method would revolutionize current building and construction techniques.

Although the method attracted some attention and a few other buildings were constructed using this technique, it did not prove to be economically practical. The controlling mechanism for lifting the slabs was extremely complex and the slightest malfunction could, and did, cause disastrous effects when slabs were raised unevenly, or were not properly aligned. Arrasmith & Tyler had no problems with this system but another firm's designers were not so lucky. All eight tiers of a parking garage in Cleveland, Ohio, seemed to have been successfully lifted into place when the work ceased at the end of the work day. However, when the crew returned the following morning, the slabs and the

supporting apparatus had assumed a twenty-degree list and the one-hundred thousand dollar structure had to be demolished.[4]

In the case of the Kentucky State Office Building, the firm was associate architect on the project. The building had been designed by a firm located in the state's capital, Frankfort, Kentucky. Arrasmith & Tyler found itself caught in between the preferences of the state government for a traditionally styled three-story building which had been commissioned, and the firm's belief that a contemporary structure would be more appropriate. Tyler went to great lengths in an effort to persuade the government to alter the design from its 1920s appearance to one more in tune with 1959, but to no avail. The firm acceded to the state's wishes regarding the building's exterior appearance, but prevailed when it came to designing a more modern, flexible and practical interior.

Arrasmith & Tyler had previously had a similar encounter with governmental authorities in Lexington, Kentucky, when Arra was commissioned to design a new Greyhound terminal there. The Architectural Commission required that the building be in the Colonial Williamsburg style in order to conform to the other buildings on the street. This would have required putting a false front on a totally modern structure. Arra referred to this style as "ye olde coach stoppe" and refused to do the job for his old client. It was the only Greyhound commission he turned down.[5]

The firm's third major project was Louisville's first high-rise apartment building, The 800 Building. It was of a unique shape, being significantly wider at the center than at the ends and was an excellent example of 1960s architecture. The building immediately became a highly visible Louisville landmark. As an expression of the client's satisfaction with the finished building, Arra was given a conference table in the shape of the building's footprint.

With the completion of The 800 Building, Tyler and Arrasmith decided to end their partnership arrangement. They had been together for over seven years and although the firm had been successful in terms of its ability to secure commissions and support itself, the two men had come to the realization that they would be better off working as sole practitioners. So it was mutually agreed that the association, which had lasted from 1953 to 1960, would be dissolved, with Arra buying Tyler out of his interest in the firm, and the name Tyler being dropped from the firm name.

With the termination of the Arrasmith & Tyler partnership, the full time employment of a structural engineer could no longer be justified. Baldwin had worked for Arra for fifteen years, longer than anyone else, and his contribution to Arra's success had been immeasurable. Baldwin had known Arra since 1937 when the Whiskey Barrel Bridge was built, he had been with Arra during the construction of Camp Atterbury when the country entered World War II, he had joined Arra in Cleveland in 1945 to help Arra execute all of Greyhound's commissions during that time, and he had followed Arra to Louisville in 1950. The two friends parted company on good terms in 1960 and Baldwin took employment with C&I Girdler of Louisville, a company owned by relatives of Arra's best school days friend, Girdler Webb.[6]

Arra now began to realign his practice toward a new clientele base knowing that it would be very difficult if not impossible to obtain another major client as significant as Greyhound. Once again a sole practitioner, Arra was at the threshold of a new era. The Greyhound commissions which previously had been central to his work were now only an incidental part of the firm's potential future business.

With the dissolution of the Arrasmith & Tyler partnership and the departure of

Baldwin, Arra paradoxically found himself on familiar ground—that of a sole practitioner with a modest staff. But business continued at such a level that Arra could not manage indefinitely without the participation of an associate. With Baldwin gone, he was forced to resort to the standard practice of contracting out much of the technical work to various consultants and other engineers. But Arra had to do all the work himself when it came to securing commissions and performing tasks only an architect could perform.

Arra was now in his early 60s and, while he did not seriously contemplate retirement as many men were doing at that age, he was beginning to see some changes in his life, and especially in his health. The unbounded energy he had been able to bring to his work for decades had diminished noticeably. He was also suffering somewhat from exhaustion which was beginning to affect his ability to work long hours. While these physical limitations did not affect his creativity, his well known sense of humor, or his well-regarded ability to secure important commissions, they did make it apparent to Arra that he needed someone to share the responsibility of keeping the firm vital and productive.

Cautious about becoming involved with another partner, Arra continued to work as a sole practitioner until 1963 at which time he joined forces with Louisville architect Arnold Judd to form Arrasmith & Judd, the last of Arra's many partnerships.[7] Judd was twenty years younger than Arra and a native of Denver, Colorado. He had come to Louisville in 1939, arriving on the day that Germany invaded Poland. Judd had earned a master's degree in architecture from the University of Illinois in 1937 and an architectural engineering degree from the University of Colorado in 1939. Like almost all young men in 1941 Judd was drafted and served with the Army Corps of Engineers in World War II. Upon returning to Louisville at the end of the war, he went to work for Hermann Wischmeyer's old firm, now renamed Nevin & Morgan. He then opened an office with Roger Steet in 1959, leaving that firm to join Arra in 1963. Arra was excited about the prospects of this collaboration and was looking forward to another ten good years of productive work.

W. S. Arrasmith (1959)

The new partnership got off to a strong start as Arra continued to exercise his skill for attracting prize commissions. Over the thirteen years since Arra had returned to Louisville, he had built a strong network of friends and professional acquaintances and had cemented connections with the community. By the time he and Judd came

together, Arra had become an important member of the building and architectural community of Louisville and his work was widely known.

Despite the fact that the potential for Greyhound work had dwindled appreciably after their unfortunate venture into the rental car business, Arra and Judd completed two Greyhound terminals between 1963 and 1965.[8] In addition, the state government work that the firm secured became an important part of its work. The new partnership developed smoothly with the two architects finding that they had well matched and balanced talents and temperaments.

Arra's partnership with Judd was probably one of the best business associations Arra made. Judd handled the management of the office and oversaw the staff design work while Arra concentrated on the conceptual designing of commercial buildings. He dealt with how they looked, where they would be situated on the site, where the mechanical elements would be located within each structure and how the completed building would satisfy the needs of the client. Each partner retained the overriding responsibility for designing buildings for clients that he brought into the firm but each critiqued the other's work and assisted whenever necessary.

The work of the firm now began to take off in new directions. For the first time Arra was involved with the design and construction of health care facilities which in time came to make up three-quarters of the office work.

However, health problems began to intrude more and more on Arra's ability to spend long hours at work. He found it necessary to take more frequent breaks from the work-a-day load and it frustrated him that physical limitations now interfered with his ability to do his job. In the past, dogged determination and long days were all that Arra needed to see a job through. Now things were different.

Arra finally consulted his doctor and was told that his symptoms indicated an enlarged heart, and it would be prudent to cut back on his work load. Although Arra listened to the doctor, he did not heed the advice, and continued to work hard on active commissions and pursue new ones, thereby aggravating his condition.

By the end of 1964, the firm of Arrasmith & Judd had completed commissions for the Baptist Hospital, had done some additional work for the State of Kentucky including designing a new dormitory for the State University at Bowling Green, remodeling the Kentucky Highway System rest areas, and expanding the State Office Building in Louisville, a building which Arrasmith & Tyler had worked on when it was first built. The firm also handled the construction of the District Office Building in Covington, Kentucky, and the University Hospital in Louisville.

The demanding work on these projects, while welcome from a professional standpoint, was not kind to Arra's health, and his condition worsened. He was forced to spend more time resting at home but never left the office without some design work in hand to be done at home. While confined to home Arra often worked on renderings for potential commissions such as one for a General George W. Patton Museum in Knoxville. It was this conceptual aspect of architecture that had always intrigued Arra the most and the one for which he had the greatest flare. One benefit of working at home was that it was easier to take a break and enjoy lighthearted moments with visiting friends and business associates.

When Arra succumbed to heart disease in 1965 at the age of 67,[9] Arrasmith & Judd had become a successful and highly regarded firm which could confidently claim a position among Kentucky's leading architectural partnerships.

After Arra's death, Arnold Judd brought Graham Rapp into the firm as a partner.[10]

Rapp was not entirely new to the association having frequently worked for Arra in the past. The firm retained his name and became Arrasmith, Judd & Rapp. The firm continued to do occasional design work for Greyhound, including two new terminal buildings in the early 1970s, one in Lexington and the other in Louisville. The Louisville terminal was the last Greyhound terminal to bear the name of Arrasmith, and it stands only a few blocks away from where William Strudwick Arrasmith's first blue enamel-clad Greyhound terminal rose in 1937.

Although Arra did not personally lend his hand to the design of this terminal, his contribution to its existence had begun over thirty-three years before, when, as a young, engaging and talented Louisville architect, he envisioned a fresh new style of bus terminal that captured the attention of one of the country's largest and best-known transportation companies. His imagination and creativity left an indelible mark on the nation's architectural landscape and today the firm of Arrasmith, Judd, Rapp, Chovan, Inc. continues in the practice of architecture from offices located in downtown Louisville.

PART II

The Streamline Era of Greyhound Bus Terminal Design

A Short History of the Greyhound Bus Company

What is now the nation's largest intercity bus line got its start because of a brand new 1913 Hupmobile automobile that no one wanted to buy. Carl Eric Wickman, owner of a Hupmobile and Goodyear tire dealership in Hibbing, Minnesota, was frustrated that he could not find a buyer for the dealership's sole automobile, a seven passenger touring car. Try as he might, the car remained a fixture on the dealership showroom floor.

Hibbing was a mining town filled with hard working men, many of whom did not have enough money to own an automobile. These men had to walk to work at the iron ore mines and, during their free time, they had no way to conveniently travel to neighboring towns.

At this point, Wickman had an inspiration. Seeing a connection between the workers' need for transportation and his dilemma regarding the Hupmobile, he purchased the car for his own use, paying the dealership $600.

He made it known to everyone in Hibbing that his Hupmobile was available to take miners to the nearby town of Alice, the location of a saloon that was popular with the miners. The fare was fifteen cents for a ride from Hibbing to Alice and, with a capacity of seven passengers, Wickman could gross a dollar and five cents per trip. With gasoline at only four cents a gallon, he calculated that he would be able to make a very nice profit.

The service was an immediate success, and soon, Wickman found himself so busy that he began to operate on a regular schedule with departure and arrival times. He did not know it then, but Carl Eric Wickman had just established America's first intercity motor bus transportation company, and along with it, a new industry.

Within a year, business had grown to a point where Wickman had to take on associates to help fund the burgeoning business. One of these men was S.R. Sundstrom, who would remain with the company his entire working life. And, it would be Swan Sundstrom who would play a role in helping William S. Arrasmith obtain his first commission for a Greyhound terminal.

In 1922 Carl Wickman decided to venture down new paths and sold his interest in what now was the Mesaba Transportation Company to some of his business associates for $60,000. He and Sundstrom then moved to Duluth, Minnesota, where they established a new intercity bus company, the Motor Transit Corporation, and began buying up other intercity bus companies. Wickman's plan was to knit these systems together so that he would be able to sell one ticket to anywhere on his greatly expanded bus line. Up until then,

passengers had to make transfers from one bus system to another when they traveled long distances, because no one company had an extensive route system.

With the consolidation of numerous local systems into a network, Wickman began making improvements. All bus drivers were required to wear snappy military style caps and uniforms and the buses were standardized in appearance and type, so as to facilitate maintenance and make them readily identifiable to the public. Among the competing companies Wickman purchased was one which was using the name Greyhound. The name Greyhound had a more evocative ring to it than Motor Transit Company, and in 1930 it was decided to change the parent company's name to Greyhound Corporation.

When the stock market crash of 1929 ushered in the Great Depression, Greyhound business suffered. Ridership dropped dramatically and competition among bus companies increased to a fever pitch. Price cutting and intense competition for passengers created new ground rules for the business. Bus stops became battlefields for passengers and fares plummeted to the point where it was possible to ride from New York City to Chicago, a nine-hundred-mile trip, for the magnificent sum of one dollar.

In 1935 the Interstate Commerce Commission stepped in to stop the price wars that were threatening to destroy many of the smaller bus companies. Even with this intervention, companies continued to compete aggressively which held fares at a level that was about twenty percent below rail fares for similar destinations.

During these difficult times Greyhound managed to remain competitive, and was even able to expand at a time when other bus companies were being forced to curtail their services. By 1939 the company had 9,500 employees, 4,750 stations, 2,500 buses, a system with 54,000 route miles, and operated over 200,000,000 miles annually.[1]

It was during this time in the mid–1930s, when so many small bus companies were failing, that Greyhound decided to capitalize on its own success and adopt a unified theme for the appearance of its buses and terminals. The streamline style, which was then moving to the fore in the field of transportation design, was selected. This style had created publicity sensations when the sleek DC-1 airplane and Burlington Zephyr train were introduced to the public in 1934.

By integrating the style of its corporate architecture with its buses, Greyhound was boldly moving beyond its railroad and airline rivals in creating a unified public image. Although it could not mount as dramatic a demonstration of speed as its railroad and airline competitors were able to do, Greyhound could project the impression of speed and efficiency in its design motifs. The company did this by taking advantage of its numerous highly visible downtown terminal locations, and its equally visible highway coaches, to attract passengers. Both the coaches and the terminals of this era were done in the streamline style which seemed to capture the imagination of the traveling public, as Greyhound experienced its most successful period during its streamline years.

The Evolution and Design
of Bus Terminals

History

In the early days of public motor vehicle transportation, operations were very basic. All that was required was a capital investment in the form of a new or used automobile and a driver, who was more often than not the owner of the automobile. This aspiring businessman, by way of word of mouth and signs posted at major street corners, advised the public that they could catch a ride between specified destinations at certain times during the day and night. The fee for the ride was usually collected before departure and used to pay for filling the gas tank. Tickets were not required. By conducting business in this manner, an enterprising operator could convert a street corner into a bus terminal, free of cost.

This pretty well describes the state of affairs when Greyhound Bus Lines founder Carl E. Wickman entered the business in 1914.[1] At the time automobiles and roads were more suited for local transportation than extended trips and, although railroads provided fast long-distance travel, they served only select urban centers across the country. Bus companies filled the gap between local and long distance travel, providing reasonably priced transportation between numerous small towns and metropolitan centers. As more and more entrepreneurs began to compete for business, the street corner terminal, which had previously been a convenience and financial benefit, became a liability. Competitors adopted the practice of pirating customers from one another by arriving at the street corner ahead of the time posted on another company's schedule. The passengers, anxious to be on their way, would be swept into the waiting conveyance, and be off before the scheduled driver arrived on the scene. This rivalry among companies often became intense and could result in heated discussions between competing drivers, with possession of a passenger's luggage being the football of contention. Although not a common occurrence, it was not unknown for a particularly aggressive driver to hoist a passenger's luggage into his vehicle and threaten to drive off with it—whether the owner of the luggage went along or not.

It soon became apparent that a more manageable arrangement was needed, both to more comfortably accommodate passengers and also to assure each operator that he would not lose his intended clientele to a competitor. Operators began to abandon the street corner and instead establish passenger depots at a variety of business locations such as drug stores, hardware stores, pool halls, and other similar locations. In the early 1920s, retail businesses such as these were most often situated in the heart of every city's downtown district,

whether the town was large or small, and thus were convenient and practical for both the passengers and the bus companies. These proved superior to the street corner as they provided a low cost way for an operator to obtain a location where passengers could purchase tickets and wait in a relative degree of comfort for their bus.

An important drawback to this arrangement, however, was the fact that the host business establishment controlled the location and the bus operator was at most a sublessee. Additionally, some of these locations were not attractive to female passengers and families, particularly those with a predominantly male clientele such as pool halls and hardware stores. Other complications abounded. Such a location was open only during normal business hours which meant that passengers who traveled at night or on weekends would be inconvenienced. The clutter of suitcases and luggage that accompanied arriving and departing passengers and buses often clogged the business establishment and sidewalk outside, to the detriment of the host store and its neighbors, the passengers, and sidewalk foot traffic. The commotion of each bus arrival and departure was also an extremely hectic and disruptive time.[2]

To alleviate many of these problems, bus operators and bus companies began to establish storefront depots of their own in the larger cities, although they continued to utilize sublessee type arrangements in small towns. Wherever this change was adopted it gave a bus company complete control over its depot arrangements. Depot operating hours now coincided with bus schedules, and passengers found safe and comfortable waiting rooms with benches, restrooms, and even refreshment stands open at all hours. There were benefits for the bus company as well. Ticket operations could be more expeditiously handled, there was adequate storage space for luggage and freight, and the potential loss of business to a rival carrier was virtually eliminated.

In response to the ever-increasing demand for bus transportation, larger and larger downtown storefront locations were established to provide for the comfort and convenience of passengers. However, the increase in bus traffic resulted in anything but comfort and convenience outside. More and more buses parked in the street in front of a depot, causing increased inconvenience to passengers and passersby, with sidewalks in turmoil during each arrival and departure due to the flood of passengers and mounds of luggage. At the same time, vehicular traffic was severely impeded.[3]

These conditions predominated into the late 1920s and early 1930s, during which time it became apparent that something had to be done to improve the situation. Not only were bus companies anxious to find a solution to this problem, but the cities themselves began to demand that something be done. It was thought that, instead of separate bus company locations, the establishment of a central storefront depot location for all major bus companies would be the answer. Unfortunately these efforts to correct the situation actually did just the opposite by multiplying all of the disadvantages that had been experienced at the smaller single company locations and focusing them in one spot. The arrival of two or three buses at a single location was bad enough but when well over a dozen buses were parked on the street in front of a central bus depot the havoc in the street and on the sidewalk could create desperate circumstances.

In order to correct this situation it was decided to move the central depots into purpose-built structures which were commonly known as union bus terminals because they served all major lines. These facilities were a vast improvement over the storefront depots that passengers, bus companies and cities had been living with for so many years. Indicative of the change in thinking about how to best manage the melding of buses and passengers with

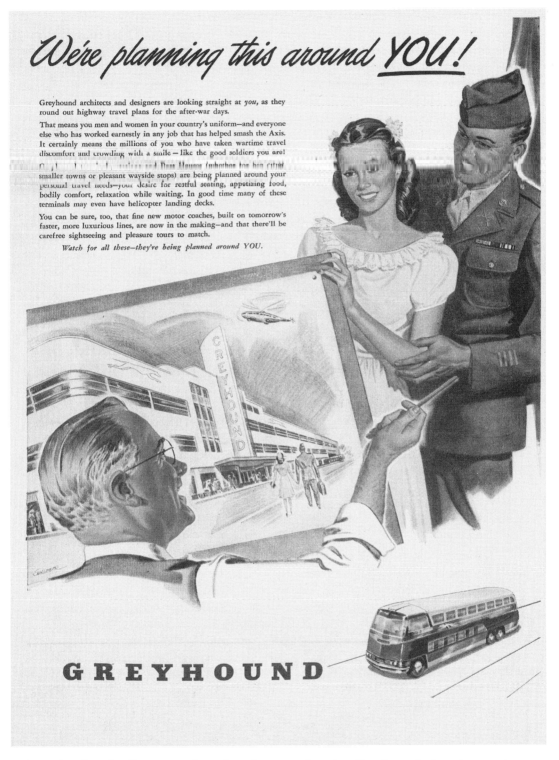

Saturday Evening Post magazine advertisement showing Greyhound plans for new terminal construction after the end of World War II. The terminal illustration in the advertisement is Arrasmith's proposed 1942 design for the Chicago terminal.

the urban environment was the substitution of the word "terminal" for "depot." This change in terminology was significant as it indicated that bus companies had adopted a far more sophisticated approach to the business of transportation. Depots were places to briefly deposit passengers, baggage, and freight. Terminals, however, were not mere stopping-off places or temporary storage facilities, they were full-service 24-hour-a-day transportation centers. These new terminals not only served as major hubs for long distance and local bus transport, but they also made extensive provision for passenger comfort and many had bus fleet maintenance facilities.

Viewed from a practical standpoint, perhaps the most important single advantage realized by the construction of these terminals was that they alleviated street congestion by providing for off-street parking of buses.

As significant an advance as the union terminal was, it did not afford a bus company its own exclusive domain. Each one had to operate in the presence of all of its competitors in order to share costs. For the smaller bus companies this was a real benefit. A union terminal allowed them to provide their passengers with service at a higher level than would have been possible otherwise. Their passengers could use the same public accommodations as those of the big bus lines while their share of the cost was relatively small. On the other hand, a large company such as Greyhound would certainly have found this arrangement to be something of a disadvantage. Because Greyhound would typically handle far more traffic than any other terminal tenant, and because assessment was based on usage, Greyhound would have carried the heavier financial burden.

As a result of this and other considerations, Greyhound, in the mid–1930s, decided to design and build bus terminals for its exclusive use in some larger cities. In 1936, after having experimented with various architectural styles of company-owned terminals, Greyhound initiated an aggressive program to establish a large national chain of its own bus terminals. Because Greyhound had a well known name and a national network with buses which were universally recognizable, the company was ready to take this bold step. Greyhound felt that it was ready to build bus terminals which were as unique and streamlined as its buses.

It was at this time that Arrasmith received his commission to design Greyhound's Louisville terminal.

Striking out alone to build its own terminals was an entirely new venture; there were no precedents. Prior to the advent of the purpose-built union terminal of only a few years earlier, there had been little consideration given to designing facilities specifically adapted for bus transportation. As a result, an entirely new area of architecture evolved quite rapidly during the decade of the 1930s, one specifically devoted to the design and engineering of bus terminals. A number of architects and architectural firms quickly developed expertise in bus terminal design. Along with W.S. Arrasmith, most prolific among those who did work for Greyhound during that time were Bonfield & Cummings, and Ralph W. Cumming (Cleveland, Ohio), George D. Brown (Charleston, West Virginia), and Thomas W. Lamb (New York City).

Design

The Greyhound Corporation's C.E. Wickman said that the most difficult problem in planning a bus station was to determine its proper size and to determine the future growth

of the business at its location over the subsequent ten to twenty years. This opinion was shared by Harry S. Pack, one of the first industrial designers and consultants specializing in bus terminal design. He felt that each project must be designed for its own specific situation. In doing so it was necessary to look at economic and operational design factors which included the type, size, and geographic location of the city, the location of the site within the city, and the type of operation, be it main line, feeder line, rest stop, meal stop, or pickup point.

The considerations that went into the design of a particular terminal were manifold. The size of the city would determine if the terminal was capable of generating adequate revenue from the sale of bus tickets to support itself. If not, the extent of provisions for ancillary sources of revenue had to be considered, including such things as retail space, restaurants, and newsstands. Site selection was particularly important because it affected both the cost and convenience of operation. As the process evolved designers developed two basic plot plans for terminals, the island type and the parallel type, both of which referred to the nature of bus traffic as it circulated through the terminal.

With many of the larger terminals serving more than 5 million passengers annually, the complexity of bus terminal design placed heavy demands on architects. Providing enough space to accommodate large intermittent bursts of traffic, while still keeping the interior of the building on a human scale, presented formidable challenges. As Arrasmith put it, "Bus terminals have the busiest walls in the world ... but nothing is worse than a waiting room that is too big."

By the end of the 1930s, architects had worked out the basic elements of bus terminal design and W.S. Arrasmith and Harry Pack collaborated on the following list of these factors for *The Architectural Record* in 1941[4]:

Initial Considerations

Plot Layout. The plot plan and building arrangement are governed by placement of the bus lanes and loading platform. A square lot (most desirable) permits efficient and economical concourse layout, provides for loading busses on two or three sides of waiting room, and makes approach to all busses approximately the same. An alternate scheme provides loading on two opposite sides only. Both plans are know as "islands." Narrow deep lots necessitate stretching elements into a "parallel" plan in which busses are loaded from one side of the building only. Increased distance between elements makes this type less efficient.

Bus facilities. Except where bus traffic parallels both sides of a building which extends through from street to street, one bus entrance and one exit are normally sufficient. Their width depends on street width and bus turning radius; 14 ft. is minimum, 16 to 18 ft. preferred. Bus movement should be clockwise since passenger loading door is on right side of bus.

Passenger Requirements

Street entrances should be 2 to 6 doors wide. Entrances should be centrally located; from them the elements of the terminal radiate.

Waiting room should be directly accessible from street. Access to concourse should be through multiple doorways or "gates" so located as to distribute passenger traffic uniformly without congestion even during peak load periods. Seating may be based on approximately 1/3 passenger capacity of loading docks, assuming 35 to 37 persons per bus. Space allowances range from 15 to 35 sq. ft. per person; 20 to 24 sq. ft. is considered satisfactory. Total area

[of the waiting room] averages 20 to 35 per cent of total building area; the smaller the building the larger the percentage. Eight-place settees with or without separation arms are commonly used. Drinking fountains, trash baskets, and ash receptacles are also needed.

Baggage room should be accessible from both waiting room and concourse. Outside freight has to be delivered without interfering with concourse traffic. Baggage is usually checked over counter from waiting room and trucked to busses, and vice versa. Area of baggage room should be 10 per cent of total building area or contain 50 sq. ft. for each bus loading dock—whichever is higher. Large storage space (usually basement) is desirable for holdover and unclaimed baggage. Standard metal racks, one or two units deep and four to five shelves high, are suitable for baggage storage.

Check lockers are desirable in addition to the above facilities and are generally paying concessions. Number of lockers is based on potential earning capacity.

Toilets must be convenient to waiting room. Cement or terrazzo floors and bases are preferred. Wainscot should be 4½ to 5 ft. high. Number of fixtures depends on size of terminal, but as many as economically possible should be provided. Women's lounge should be large enough for a couch, vanity or dressing table and several chairs. Men's lounge is not desirable.

Ticket office should be prominent in waiting room. In small stations proximity to concourse is desirable but is not essential in large terminals 50 sq. ft. should be provided per selling position. One position may be provided for each 25 or 30 waiting room seats; but number of positions is usually based on personnel normally required and on anticipated extras for peak periods. It is not necessary that ticket office be connected to other offices. Counters should be 42 in. high; cages or windows are not desirable.

Administration and Concessions

Dispatcher's office controls bus movement and should be on concourse at a point from which all loading docks can be supervised. It need not be related in plan to waiting room or ticket office but is usually connected by telephone and TelAutograph [a pre–FAX technology which employed an electrically-controlled pen to transmit handwriting and drawings] to ticket office, manager's office and bus garage. Public address system is used to announce arrivals and departures of busses.

Office for terminal manager, passenger agent and switchboard are usually sufficient. These need not contain more than 100 to 200 sq. ft. each. In larger terminals, offices for regional manager, clerical force, meeting rooms, etc., may be required.

Driver's quarters are usually limited to lounge and toilet facilities (with shower) in basement or on second floor and require private entrance accessible from concourse. Space is needed for reading table, lounging chairs, shelves for tool kits. Sleeping quarters are usually provided at local bus garage, not in terminal.

Restaurant is usually necessary for all terminals, has floor area ranging from 15 to 20 per cent of building area; usually, the larger the terminal, the larger the percentage. Larger restaurants have counter and tables. Patrons prefer booths, tables are more flexible, so both are used. Counters generally receive bulk of business. Soda fountain should be included. In larger terminals soda fountains may be installed in waiting rooms. Kitchen area is from 15 to 35 per cent of restaurant area, depending partly on storage facilities; these are often in basement.

Newsstand should be adjacent to waiting room and restaurant.

Telephone and telegraph booth is mandatory. In larger terminals a telephone operator is sometimes desirable.

Barber shop and stores are often included. Space economically available, anticipated demand, size of terminal, etc., have to be considered in allocating space for this type of concession. In small terminals some means of increasing revenue is essential; concessions

may be the answer. Drug stores are sometimes included. Beauty parlors are seldom included at present.

Travel bureau is important, particularly in large terminals. It should be on or near street, adjacent to waiting room. A show window may be provided on street front.

Services and Construction

Air conditioning is widely used, especially in large terminals. In northern localities this is often supplemented by steam or hot water radiation.

Lighting in public spaces is often fluorescent, either direct or indirect, with a three stage control to permit adjustment of light level to variable passenger traffic.

Intercommunicating system includes telephones and TelAutograph connecting dispatch, ticket office, manager's office and bus garage, cutin on public address system is usually provided so switchboard operator can page individuals.

Construction should be "fireproof" and is ordinarily steel frame or reinforced concrete depending on building design, availability of material, costs, etc. Partitions are usually tile or gypsum block and should be planned for economical changes if required for expansion.

Interior finish where subjected to public use must be rugged and easy to maintain. Terrazzo or tile floors are usually employed; smaller buildings often use cement. Wainscoting in main areas should be able to take abuse. Ceilings in restaurants, waiting room and telephone office should be acoustically treated.

Exterior finish is often cut stone. Glass block is extensively used. Brick terra cotta, stucco and concrete are also used; and glazed brick is commonly employed for concourse wall and rear of building. Concourse bus lanes and yards are constructed of 7 or 8 in. thick concrete slabs, of 2,500 lb. concrete, reinforced top and bottom with No. 40 mesh. A surface hardener should be employed.

Loading Docks

Parallel loading requires an excessive amount of space per bus. Usually busses in rear cannot move out until first bus exits. In a large terminal several lanes would be required and overhead or underground passage [for passengers] would be necessary [if there are] several island loading platforms. Otherwise passengers would cross bus lanes, an extremely dangerous practice which creates a liability on the bus company.

Right-angle, or head-on loading is acceptable but disadvantages include the outswinging bus door which forms a barrier around which passengers must go and difficulty of maneuvering each bus into its berth. This type of loading is useful when the bus yard is deep, but concourse is limited in extent.

Straight sawtooth loading is efficient, and is employed where lot is comparatively narrow and deep. Passenger has direct approach to loading door, baggage truck can operate between parked busses for loading into side baggage doors.

Radial sawtooth loading is most efficient. Busses may swing into position along a natural driving arc. A minimum of concourse frontage per bus is required. In this system each bus space is narrow at front and wide at rear, making maneuvering easy and conserving space.

Number of loading docks is based on average peak loading conditions, size of lot, and size of structure. Abnormal peak conditions such as occur on holidays can be taken care of by "doubles," that is by parking additional busses in the lot and immediately running them into loading docks as scheduled busses depart. Limited dock space is not a serious drawback if ample parking space can be provided for "double" busses.

Passenger concourse is protected from weather by overhead canopy which cantilevers over passenger doors of busses in loading docks. This protects passenger getting on and

off busses as well as front baggage doors on sides of each bus. Holiday crowds can be controlled by using airplane cord barriers.

Bus Yard

Area depends on type of loading used and number of busses to be parked. Parallel loading requires approximately 12 ft. (width) per driveway; right angle loading requires approximately 40 ft. from rear of bus to property line; sawtooth loading (straight or radial) requires about 50 ft. from front right wheel of bus to property line (assuming busses parked at 45 degrees, berth 12 ft. 6 in. wide).

From this list of considerations drawn up by Arrasmith and Pack, one cannot help but be impressed by the sophistication of bus terminal architecture, design and engineering.

An article in Louisville's *Courier Journal* May 26, 1957, quoted Arrasmith as saying that there was only one basic change to the standards he helped draft in 1941: "The ideal place for a terminal today is on the fringe of a central business district, not smack downtown. We used to think you had to get right across the street from the post office or City Hall.... That's out the window. It costs too much to get a site. Ideally, any new terminal should be on the fringe of downtown at the intersection of a broad boulevard leading downtown. Narrow downtown streets are no place for today's double-decker busses."

Streamline Styling, 1937 to 1948

Streamline styling was not new to Greyhound before Arrasmith designed the 1937 Louisville terminal. Horizontal and curvilinear lines, long window rows, rounded corners, smooth surfaces, and a freedom from embellishment were key elements of streamline design which had already been incorporated in two Greyhound terminals—New York City and Charleston, South Carolina—designed by Thomas Lamb. What Arrasmith brought to the design idiom was his ability to manipulate the style in a new and innovative way while still remaining completely consistent with the underlying philosophy of streamlining which espoused efficiency, cleanliness, speed, and technology.

Arrasmith introduced some entirely new elements to streamline styling, expanded what streamline styling was, and demonstrated what it could become. The most effective things Arrasmith did were to use color as color had never been used before, to use thoroughly modern materials where they had not been used before, and to introduce a practical approach to bus terminal function and design. Arra's concept was to change the bus terminal from that of a building in which an activity was housed into one designed specifically to aid in the activity's efficient fulfillment.

Arrasmith's combination of new materials, colors, and shapes resulted in a reinterpretation of the streamline style of architecture turning a bus terminal into a glistening technological landmark. Arrasmith melded the building and the bus into an operational unit. What had been a place where people went to catch a bus was raised to a higher level through a new interpretation of what the building's function was intended to be.

The first step in the evolution of Arra's streamline bus terminal design was his Greyhound Louisville terminal. Once a passenger approached the 1937 Louisville terminal, the transportation process began. The sleek appearance of the building connoted motion. Exterior and interior colors complimented those of the buses. The ticket counter was streamlined in appearance and the individual seats in the waiting room were identical to those on the bus, with blue leather upholstery and chrome steel tube framing. Gone for now were the traditional long wooden benches which were dark and uncomfortable.

The use of exterior porcelain enamel steel panels on the scale of the Louisville terminal was also a first. Although such materials had been used before, the application had been limited to small structures housing fast food enterprises and gas stations. And, when porcelain panels were used, they were white, with the use of color relegated to trim and signage. No attempt was ever made before to cover a structure of any size in colored porcelain enamel panels, and certainly never using such a dramatic color scheme as Greyhound Blue.

The overall profile of the Louisville terminal was not unlike that of a contemporary

stove or Bakelite table radio, when its dimensions were mentally adjusted for scale. This is more than mere coincidence. In fact, the Louisville supplier that made the panels also manufactured porcelain panels for stoves, refrigerators, and washing machines. The use of Greyhound Blue porcelain panels would recur again in quick succession on three of Arrasmith's subsequent terminals, but they would be the last to use porcelain panels to cover an entire building facade.

The Greyhound Blue terminals were very successful and very popular when first built. Despite this a shift was made away from colorful terminals toward a more sedate streamline style in 1938. Perhaps it was felt that the blue terminals were too flamboyant. Although the blue terminal theme was dropped, streamline design remained Greyhound's underlying corporate architectural theme.

After the era of porcelain Greyhound Blue terminals, Arrasmith modified his style to reflect the earlier streamline themes of Thomas Lamb. Thus, the appearance of these subsequent terminals was more conservative. Finished in limestone, a standard facing material for commercial buildings, they were generally gray or white in color, which was by itself enough to change the entire character of the building.

Arrasmith firmly put his own stamp on all of these terminals but it was the 1940 Washington, D.C., terminal that set the theme for the buildings to follow. When the front elevation of the Washington terminal is viewed straight on there is something hauntingly familiar about its shape, and for a good reason. Its origins are traceable to one of Arrasmith's first major transportation buildings, the 1929 Bowman Air Field terminal built in Louisville.

With the exception of the swept-back wings on either side of the Washington terminal's central tower block, and its limestone facing material, the frontal elevations of the two buildings are virtually identical. The most basic changes were the stripping away of Art Deco detailing and the rounding of corners, which helped achieve a more streamlined appearance. The end result was a building that was conservative enough for the nation's capitol but still expressed a new streamline genre in the Arrasmith mold. Although the new back-to-the-future streamline styling swept away the visual impression of an appliance for the production of transportation, the function of the terminal was just as effective at melding passengers and buses smoothly and efficiently. What the building did remained the same, it just sported new, more reserved clothes.

For the most part, the new Washington terminal design features were employed in the other terminals Arra completed between 1940 and 1942. Two terminals that were constructed during this time period should receive special mention, those in Atlanta, Georgia, and Erie, Pennsylvania.

The Atlanta terminal, opened in August of 1940, restated the design of the Washington terminal in a bolder manner. The central block tower element was gone and the building was only two stories tall. The impression of a conventional building configuration was also gone but it retained the island type design. The front elevation emphasized asymmetry, both in the off-center location of the second story and in the reversed "L" of the pylon sign and canopy. Greyhound Blue, which colored the earlier porcelain paneled terminals, was reintroduced in the strongest statement of its use since 1937. Blue tile rose above the main entrance with a centered porthole window and white Greyhound mascot. A broken band of tall windows ran along one side of the ground level facade and curved around the corner of the building. The opposite side was punctuated by two storefront entrances, and a short window row curved around the corner as well.

Atlanta is particularly important because it pointed to what the future of Streamline

Moderne would hold when Arrasmith returned from the war to continue with his Greyhound work.

A Lilliputian Greyhound terminal would not seem to merit much consideration but in the case of the 1940 Erie, Pennsylvania, terminal this is not so. It is a remarkable demonstration of how almost all the rules defining a specific design style can be violated and yet the end result remains a successful statement of the genre. Thus, the Erie terminal distilled the Streamline Moderne style into its core characteristics.

Both Erie and Atlanta are Streamline Moderne buildings, but the first follows all the basic precepts for the style while the other violates half of them. Atlanta, the quintessential prewar Streamline Moderne terminal, is a strongly horizontal two story building 139 feet long and rising a mere 30 feet. Erie on the other hand is a very vertical building only 36 feet wide, including its wing wall, and twenty-five feet tall at the top of its second story. Whereas Atlanta has an asymmetrical mass, Erie is essentially a solid squared off mass. Atlanta is an island building, while Erie is located in the middle of a city block and shares one wall with an adjacent structure. The location of the L-shaped pylon sign canopy and main entrance are centered but asymmetrical in the case of the Atlanta terminal, but they are at one extreme end of the Erie terminal.

The remainder of Streamline Moderne's defining elements are met by the Erie terminal? smooth surfaces, rounded corners, pylon sign, and window rows. With four of the eight defining elements of the genre not just missing but, instead, blatantly violated, is there enough in the remaining four to qualify the terminal as Streamline Moderne? Or is it merely a conventional building with Streamline Moderne "frosting"?

The Erie terminal is in fact a genuine and very artful adaptation of Streamline Moderne design to an almost impossible situation. By bending four of the main precepts of Streamline Moderne design, Arrasmith created a new version of the style. He established the essence of the style by showing what a Streamline Moderne building should be when it cannot meet the standard rules. Streamline styling was a core element of Greyhound's corporate image, just like the Greyhound Blue of their buses, and that appearance was essential regardless of site restrictions. Erie is a successful expression of the Greyhound image, achieved despite its unlikely location.

Placing the pylon sign and canopy at the extreme left end of the facade allowed the Erie terminal to "lean against" its neighbor as if the missing half of the terminal was behind the adjacent building's facade. The pylon sign acts as a divider which separates the terminal from its neighbor but it also incorporates that building's mass into its own overall impression. The effect is to give the viewer the feeling that the terminal facade actually is horizontally symmetrical, you just cannot see it all. The result of this design sleight of hand is to downplay the verticality of the Erie terminal. It is as if it were emerging from behind its neighbor like a bus pulling out of the dock. The effect is reminiscent of the 1937 Greyhound Blue porcelain terminals in that it evokes the image of the terminal as a bus.

The absence of a wedding cake facade is muted by the slight stepping back and lowering of the contours of the office wing of the terminal. Because the scale of the terminal is small, the modest nature of the step-backs remains effective and the mind's eye paints in the intended visual impression.

The lack of an island location for the Erie terminal was effectively compensated for by utilizing the bus driveway as an isolating element, separating the terminal from the building to its right while further reinforcing the visual impression of unity with the building to its left.

Despite the fact that it fails to honor many of the precepts of Streamline Moderne style, when viewed in its context, the Erie terminal is consistent with that style. In it, Arrasmith masterfully overcame the limitations of a difficult location to create a harmonious and satisfying overall impression.

The Greyhound Super Coach

The year 1937 was a pivotal one for Greyhound. The company had finally implemented its program to create a new corporate image, integrating architectural and vehicle designs, and commenced a massive program of building terminals that would be under its exclusive control and suit its needs. The buses and the terminals were to be streamlined, bear the same color schemes, and incorporated modern materials for maximum efficiency. Greyhound was the first major company to achieve a unified company image on such a large scale. The buses complemented the terminals and visa versa. Even the waiting room furniture resembled the seats in the new Super Coaches. The end result was that the bus felt like the building and the building resembled the bus.

Streamlining began as an industrial design philosophy which applied to all aspects of design from architecture to transportation, and from office equipment to home appliances. Even calligraphic styles and business logos were part of this all-encompassing design philosophy. And, Greyhound incorporated it all when creating the company's new image.

Greyhound's Super Coach was the first bus to fully adopt the streamline design

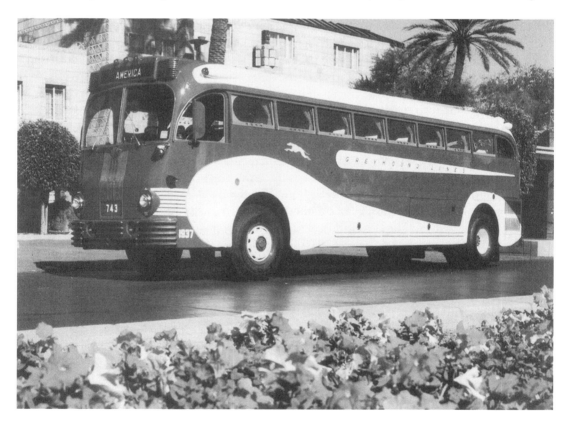

The 1937 Greyhound Super Coach.

concept, thanks to Raymond Loewy, one of the country's foremost industrial designers. Loewy's first commission for Greyhound was in 1933, when he was asked by Greyhound's chief executive officer to redesign the silhouette of the running Greyhound mascot. Loewy's initial impression of the mascot was that it looked more like a mongrel than the type of sleek and graceful animal which was needed to complement the company's fresh new image.[1]

His redesign of the mascot, which endures to this day with only minimal alteration, was so well received by Greyhound that it led to additional commissions, the most significant of which was his creation of the 1937 Super Coach.

Loewy designed this bus with a slightly slanted front which imitated the famous "shovel-nosed" Burlington Zephyr streamline train that had set a speed record for a run between Denver, Colorado, and Chicago, Illinois, in 1934. Called the "ultimate in bus design" by Greyhound and many others, it was the first intercity bus to boast all-metal construction and, compared to its predecessors, it was the most modern thing in bus transportation imaginable.

Earlier buses were designed like automobiles, with the passengers riding a mere step above street level and their baggage stacked above them on the roof of the bus. The Super Coach changed all of that. Its smooth envelope body was as sleek as Arrasmith's new Louisville terminal. The engine was moved from in front of the driver to the rear of the vehicle, and the driver and passengers were seated far above the road with baggage stored beneath them in special compartments. A sleek Loewy-styled Greyhound mascot graced the flanks of this colorful bus, and white bow waves accenting pontoon-like wheel openings evoked an image of speed.[2] The new Super Coach fully embodied the design concepts of streamline styling and projected an image of clean, modern and efficient transportation.

The streamline design of the new bus also had many tangible benefits for the company. Fuel economy increased forty percent thanks to the more aerodynamic contours of the Super Coach, its use of a diesel engine, and its aluminum construction. Super Coaches were easier to keep clean since there were fewer dirt-catching seams and corners. Because the bus now utilized height to give it increased interior space, more passengers could be accommodated along with their attendant baggage, so revenue per mile went up. Creature comforts were added, such as individually adjustable reclining seats and air conditioning. The new buses proved to be so successful that Greyhound undertook a program to convert its entire fleet to Super Coaches.

Thus in 1937, for the first time ever, buses and their terminals were unified in design, appearance and efficiency. A Super Coach bus parked next to a streamline Greyhound Blue terminal projected an impression of cohesiveness that could not have helped but make a favorable impression on the clientele, while the comfort and efficiency of the terminal mirrored that of the coaches. This gave the passengers the feeling that they had actually begun their journey once they approached one of Arrasmith's new porcelain paneled terminals In contrast, prior to Greyhound's new approach to integrated transportation design in the 1930s, bus terminals were built in any architectural style that seemed appropriate for their setting from colonial to classical.

This practice was not unique to bus companies as the same held true for railroads. For years, both local train stations and big city rail terminals had all been designed in either a traditional railroad style or undistinguished plain architectural style. These structures in no way reflected the fact that the trains which now visited these terminals in the late 1930s were streamlined in both performance and appearance. Certainly nothing in any of these rail terminals brought to mind the speed and comfort of train travel in the same

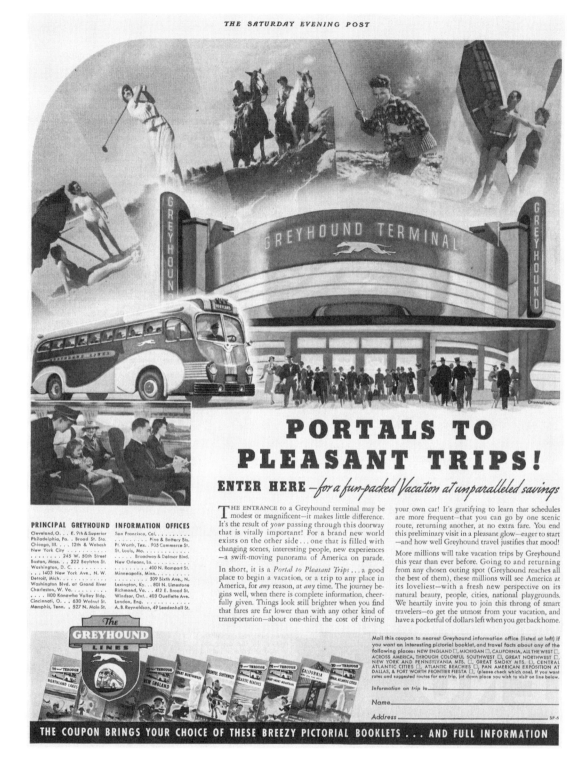

A Greyhound terminal and new Super Coach bus as they appeared in a 1937 magazine advertisement.

way that Greyhound's terminals gave a feeling of the speed, comfort, and modernity of bus travel.

Both the Super Coaches and the technicolor terminals exuded attributes of the modern age, speed, and efficiency. It was an experiment at a unified corporate image that was unique in the transportation business.

The Silversides Greyhound Bus

Once, Greyhound had established its new streamline image, the company felt ready to refine it. The most noticeable difference was that its next generation of terminals was not clad in bright blue porcelain panels. Instead, a more subtle version of streamline design was adopted, one which called for less vibrant colors and employed a totally different building material, limestone.

Limestone was an excellent material for Streamline Moderne architecture. It had qualities which made it perfect for incorporating stronger horizontal lines into a building than were possible with metal panels. It also could be powdered and cast to provide the sculpted graceful curvilinear corners which were an important characteristic of the style.

However, the impact of limestone as a building material meant more than a change in the silhouette of Greyhound's terminals, it also introduced a new color theme for the company; gray supplanted blue as the predominant color.

As Greyhound began to move away from its metalclad Greyhound Blue terminal design

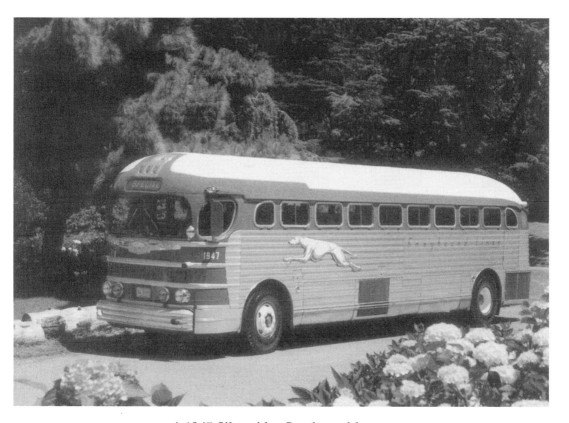

A 1947 Silversides Greyhound bus.

toward the more muted gray of limestone, it also changed the appearance of its buses. The new bus, totally redesigned by Raymond Loewy in 1940, was known as the Silversides, which referred to its fluted stainless steel body.[3]

Stainless steel had displaced Greyhound Blue on the buses just as limestone had replaced enamel cladding on the terminals. The new sleek stainless steel sides conjured up an image of a swift streamlined train. The analogy was further enhanced by the incorporation of a round "drum head" on the back of the bus, which bore the company name or a running Greyhound mascot, and was similar to those found on observation cars at the rear of streamline trains.

With the exception of the Greyhound Blue front of the bus and color bands of Greyhound Blue which ran between the windows and white roof, the new bus was a vision of sleek stainless steel. Once again, the bus was the terminal and the terminal was the bus, but not as emphatically as before.

Greyhound's Transition to an Avant-Garde Style

After the war there was a distinct shift in the architectural taste of the nation and Streamline Moderne with its curvilinear lines was being replaced by a more crisp avant-garde style. For Greyhound the shift occurred between the construction of the Cleveland terminal, which was Greyhound's final Streamline Moderne statement, and the Akron terminal, which was the first built expression of the new style that Greyhound would follow from that point forward.[1]

At first glance, the two styles appear to be too different to permit a shift from one to the other, while still retaining the distinctive corporate image. The curvilinear Streamline Moderne and the square-cornered avant-garde gave different impressions. Where Streamline Moderne was all smooth surfaces, soft flowing lines, and melting horizontal masses, avant-garde's sharp lines were vigorous, brash and unyielding.

Nevertheless, Arrasmith had to preserve the thematic appearance of Greyhound's prewar terminals in order to carry over to the new terminals the architectural image the company had so carefully developed. Greyhound wanted its new terminals to be as up to date as possible, yet retain the readily identifiable appearance of existing terminals.

Bringing these two styles together in such a way that they would remain thematically consistent and serve to complement each other was not an easy task. It required melding the essential elements of both into a single harmonious new form. The coming together of these two design types created a new style of Greyhound terminal that was unique unto itself, yet instantly recognizable as a Greyhound terminal.

Arrasmith took the crisp sharp lines, square corners, and total absence of curvilinear forms of the new style and applied them within the height limitations of the old style, using long window rows to create strong horizontal dynamics. One of the most important elements carried over to the new style was the signature L-shaped pylon sign and canopy. Although the texture of the building facade was no longer smooth, the use of color, although less vibrant than Greyhound Blue, was once again a familiar and important factor in the building's appearance.

The overall success of this transition between the two is clear. If one mentally replaces the square corners of the Akron terminal with rounded corners, there is no mistaking the new style's streamline origins. The sleek silhouette was preserved, and the 1930s and the 1950s were made to meet in harmony.

Since Cleveland was the first postwar Greyhound terminal to be built, one might wonder why Greyhound did not take this opportunity to start its massive building program with the new avant-garde modern style. Several factors could explain this situation.

Greyhound had commissioned design work on new terminals right up until the United States went to war. Arrasmith had produced renderings for new Greyhound terminals in Chicago and Cleveland shortly before being called to active duty in 1942 and both of these were done in the Streamline Moderne style. World War II did not end until September 2, 1945. During the war the nation's focus was on winning the war. Although companies did give some consideration to what they thought design styles would be like after the war, there was little time to put to the effort. This is best illustrated by the fact that the "new" automobiles which appeared in showrooms immediately after the war were virtually indistinguishable from their prewar counterparts, and most automobile manufacturers would not introduce truly fresh styling until the very end of the 1940s. Likewise, in 1945 Greyhound was still locked into its prewar Streamline Moderne style.

When the war ended Greyhound wanted to start immediately on its program for building a new terminal network. Just like the automobile companies, Greyhound found that the quickest and most efficient way to get results was to complete projects which had been started before the war. Once the postwar building program was underway, time could be devoted to designing truly new buildings and buses.

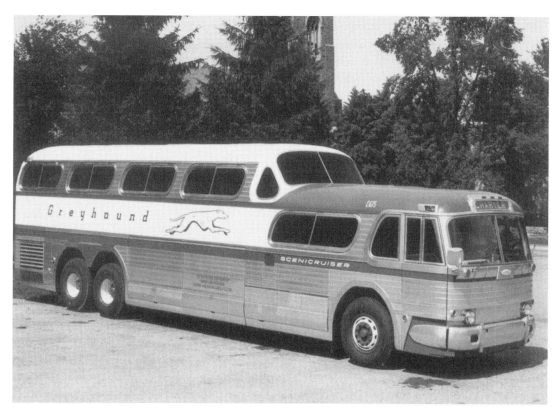

Introduced in 1954, Greyhound's Scenicruiser, which featured air suspension and double deck design, was the first new bus since the Silversides. This Raymond Loewy–influenced bus arrived on the scene at the nadir of the avant-garde era of terminal design when the nexus between the bus and the terminal ended.

Another factor that may have played a part in the timing of the Cleveland-Akron style shift can be found in the chronology of the development of the two terminals. Arrasmith arrived in Cleveland early in 1945 and resumed work on the Cleveland terminal immediately. Ground was broken on October 22, 1946, and the terminal opened on March 30, 1948. Ground was broken for the Akron terminal on March 23, 1948, and it was opened to the public February 15, 1949. Once the Cleveland terminal was under construction, Arrasmith was able to turn his attention to the Akron commission. By then he had the benefit of the preceding year and a half during which time the postwar direction of architectural styling had a chance to evolve. Additionally, new bus designs were in the offing and they too would be moving away from the early teardrop shapes that typified Greyhound buses 1930s and 1940s. The buses and the buildings would evolve together utilizing forms that were more crisply defined, while still clearly preserving Greyhound's identity.

Arrasmith's work for Greyhound placed him at the forefront of architects who were working in the streamline idiom. No other architect produced so large an array of streamline buildings, nor did any other architect utilize streamline styling so consistently over such an extended period of time. Although he did not participate in the birth of architecture's streamline style, Arrasmith molded the style into its ultimate definitive statement before ushering it into the post-streamline era with imagination and insight. Arrasmith's accomplishments with the streamline style and its application to architectural design fairly place his name among other contemporary practitioners of streamline design including Raymond Loewy, Otto Kuhler, Henry Drefuss, and Walter Dorwin Teague.

During all of these years, no new terminal was opened, nor any new coach introduced without festivities to mark the occasion.

The Grand Opening

From the 1930s well into the 1960s, it was customary when a new terminal opened in any community for Greyhound to make it a media and public relations event.

These all-day affairs were an important occasion in any community and generated excellent newspaper coverage. Articles regarding a grand opening would usually run one full page, often on the front page. In large metropolitan areas, or when the terminal was a significant structure in the community, an entire section of the local newspaper might feature articles about the terminal and the people and companies involved in its design and construction. It was customary for the trades, companies supplying materials, and those directly involved in the construction of the terminal to take out large advertisements congratulating Greyhound on its new terminal. Greyhound Corporation would also place an

Cake made for grand opening of the Akron Greyhound Terminal

advertisement thanking the architects and all involved in bringing their new terminal to fruition. These features would sometimes appear in souvenir sections of a newspaper and were excellent publicity for Greyhound.[1]

During the grand opening it was not uncommon for numerous local governmental officials or even the State's governor to appear in addition to high level Greyhound officers.[2] Entertainment was always featured and usually consisted of either a small band or a solo organist to serenade the celebrants. Balloons and clowns were on hand to amuse the children, and women were presented with corsages or flowers. Often there would be surprise

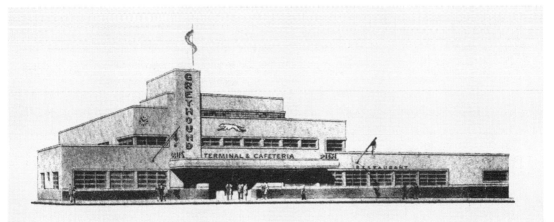

You are cordially invited to attend the

Formal Opening

of the new

Akron Greyhound Terminal

Tuesday, February 15th, 1949

Guest Preview - 11:00 a. m. • *Public Dedication Ceremony - 11:30 a. m.*

We would like you to be our guest at

LUNCHEON • HOTEL MAYFLOWER

R. S. V. P. — 2600 Hamilton Avenue
Cleveland 1, Ohio

J. L. SHEPPARD, President
Central Greyhound Lines
(Division of The Greyhound Corporation)

Invitation to grand opening of the Akron Greyhound Terminal

gifts for the visitors during the event, and refreshments were offered for all. As evening came on, high-powered searchlights would pierce the darkened sky to attract attention to the event and draw spectators.

All terminal grand opening celebrations included a ceremonial presentation of the key to the terminal to the city mayor and in some cities, if a terminal opening coincided with an election, the opening would be an occasion for politicians to shake hands and greet constituents, which of course swelled the ranks of dignitaries present.

Grand openings of Greyhound terminals varied in style from terminal to terminal, ranging from extravagant affairs to relatively simple celebrations. It was not always the largest terminal that presented the most impressive affair. Many times, the scope of a celebration bore more of a relationship to the importance of the new Greyhound terminal to the community than to Greyhound itself. In smaller communities, a new Greyhound terminal was a significant addition to the community's built environment and a point of civic pride which could easily exceed that of a large new Greyhound terminal in a major city.

The 1949 grand opening celebration for the Greyhound terminal in Lansing, Michigan—a city one-tenth the size of Cleveland, Ohio—was very similar in scope to that for the Cleveland terminal which had opened the preceding year. Festivities were broadcast live, and then rebroadcast later in the day for those who had missed the live presentation. An important portion of the local newspaper contained articles about the terminal and Greyhound, as well as the usual congratulatory advertisements by suppliers and contractors. Entertainment at the terminal included live organ music, and a bevy of beauty queens from local high schools were engaged to act as hostesses for the celebration, all of whom were named in the local newspaper. Refreshments and souvenirs were provided and a new "sound and color film" that had been produced by Greyhound, called, *Amazing America*, was screened for guests. The film was also made available at no charge to local schools, churches and other organizations.[3]

Special local touches always added to the variety of the affairs. In Battle Creek, Michigan, the new terminal was filled with flowers from well-wishers, and after ceremonies were concluded, the flowers were distributed to community hospitals and placed at war memorials.[4]

Regardless of the size of a grand opening celebration, the new terminal would remain open for inspection until 10:00 PM, then at 12:01 the next morning, the day-to-day business of transporting passengers would begin, and without fanfare and only a few bus ticket holders on hand, the new terminal would commence its job of serving the traveling public.

The Greyhound Terminals of W.S. Arrasmith

A Chronological Survey

1937 Louisville, Kentucky

When this streamline Greyhound Blue terminal opened on Wednesday, April 28, 1937, there was no other building comparable to it anywhere. What appeared on the corner of Fifth Street and Broadway in this conservative community was an instant landmark. When the Greyhound terminal was viewed in its context, surrounded by an eclectic assortment of Gothic, classic, and more traditionally styled commercial structures, it looked like a spaceship that had just landed in Louisville. People who had seen the new terminal the night of its grand opening readily recalled, over sixty years later, the indelible impression the sight had left on them.

Its arresting Greyhound Blue porcelain enameled surfaces glistened. At night, the windows emitted a blue glow from the interior lighting and pastel blue walls. Headlights of passing automobiles danced along the terminal's smooth surfaces, and lent an other-worldly look to the building.

The most unusual thing about the new Greyhound terminal was the lavish use of enamel-clad steel panels for the terminal's outer skin. Such an extensive use of this material was a first for Greyhound and for W.S. Arrasmith. Prior Greyhound architects had used glazed brick or architectural glass to incorporate the Greyhound Blue color into their buildings. Because of the physical properties of these materials they could not be conveniently made in large sizes. However, a metal panel could be made to almost any dimension without compromising its structural integrity and without adding significantly to its weight or thickness. The manufacture of sections of enameled steel panels for rounded corners was little different than the techniques used to make flat panels. When assembled on the terminal, these panels gave its surface an almost seamless appearance, contributed to the unity of the building, and enhanced its streamline appearance.

A contemporary publication, *Railroad and Bus Terminal and Station Layout*, declared that the Louisville terminal's exterior finish and interior functional trim utilized an elaborate amount of plate glass, glass block, and perhaps more enameled steel panels than any other building in the world.

Arrasmith had created his own personal interpretation of the streamline Art Moderne style already in use by Greyhound. Window rows at each end of the building wrapped around the corners, helping to visually tie the building together. The sign pylon was the focal point of the facade and dominated what was already an irresistibly eye-catching building. Arrasmith intersected the strong horizontal theme of the building by repeating the pylon's

125

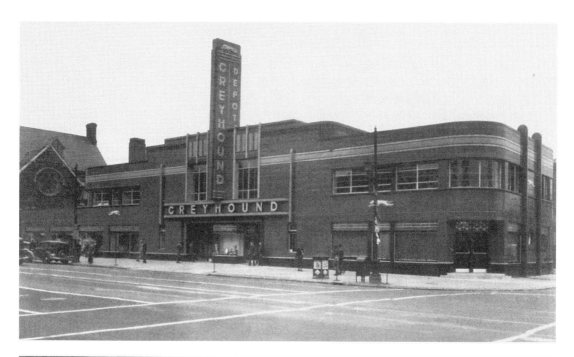

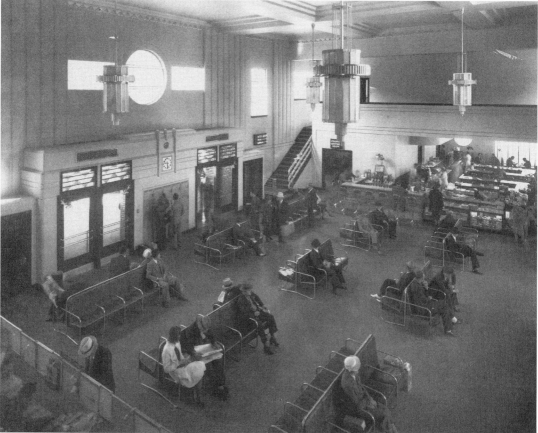

Top: 1937 Louisville Greyhound Terminal. *Bottom*: The interior of the Louisville Kentucky terminal was spacious and comfortable and provided services such as coin operated luggage check lockers and restaurant facilities for patrons.

verticality in the form of subtle vertical ribs, one pair flanking the main entrance, and another pair bracketing a large porthole window on the Fifth Street side.

There was no sidewalk canopy, but the word "Greyhound" spread across the front of the terminal just above the main entrance doorway achieved a similar visual function. A narrow scuff band of dark blue ringed the building at the sidewalk level, and a white band above the second floor windows acted as a counterpoint.

A newspaper reporter wrote about his impressions of the terminal in the *Louisville Courier Journal*, April 28, 1937:

> The building is of blue color throughout its entire and the Greyhound color scheme and carries a World's Fair atmosphere. Elaborate use of plate glass and glass blocks makes the building an outstanding one....
>
> Facing Broadway, the building is entered through two large chrome, wood, and plate glass doors to the floor of the main waiting room. A large neon sign, the first in the country to be constructed as part of the building, dominates this entrance. Large chrome letters over hundreds of tubes of neon lights spell the word "Greyhound" over the doors.
>
> The spacious waiting room is decorated in a sky-blue stipple finish, the floors are of dark blue composition over concrete, and the chairs and other fixtures are of dark blue leather, chrome metal, and aluminum. Seats are of the modernistic theater type while double lounges are artistically placed at various places of advantage.
>
> Waiting rooms, a restaurant with leather and chrome booths, luggage rooms, travel bureau, ticket and information counter, Postal Telegraph office, telephone booths and other accommodations are on the first floor.
>
> An innovation in passenger terminal facilities are the ladies' lounge rooms, separate wash rooms, dressing rooms and even full-size dressing and bath rooms containing tub and shower. There will be several maids available at all times for the comfort of women passengers who ... comprise sixty-five percent of Greyhound passengers. There is a large Men's washroom and lavatory with shower baths, wash basins and shoe shine stand. Large rounded plate glass windows admit light to all parts of the restrooms. All restrooms are on the mezzanine floor, with a spacious balcony overlooking the main white waiting room.
>
> Chrome and glazed glass chandeliers provide indirect lighting throughout the building. There is a special public address system that will be used to announce arrivals and departures of busses, paging and the making of announcements.
>
> Huge doors lead from the white waiting room to the loading concourse, which is staggered in what is known as a "sawtooth" arrangement. Busses will head into special concrete "tracks" for loading and unloading with accommodations for fifteen busses at a time. There are now one-hundred arrivals and departures daily from the temporary bus station.

The building ran one hundred seventy-five feet along Broadway and extended back fifty feet deep to the sawtooth loading docks at the rear of the terminal. The dock concourse was covered by a concrete canopy to protect passengers from the weather. The interior contained a waiting room that was sixty-six feet by forty feet, a restaurant, kitchen, colored waiting room, barber shop, baggage room, dispatcher's office, and large open counter ticket office. Twenty self-service luggage lockers were recessed in the waiting room wall between the doors leading to the buses. There were also twenty lockers on the loading concourse platform and twenty other lockers elsewhere in the terminal.

The restaurant had a large three-sided counter and stools of chrome and leather, with additional booths near the venetian blind covered windows; it had a separate sidewalk entrance. The mezzanine, with a wide balcony overlooking the waiting room, housed the general offices and restrooms. A Western Union office where passengers could send telegrams

was located adjacent to the main entrance in the waiting room. The terminal also had space for two retail stores with separate sidewalk entrances, like the restaurant, and display windows.

The cost for the building and associated facilities was one hundred fifty thousand dollars.[1]

1937 Bowling Green, Kentucky

Bowling Green, Kentucky, welcomed its new Greyhound Blue enamel-clad terminal May 26, 1937. Opened only a month after the Louisville terminal, it was much more modest in size. With a 75 foot frontage on Main Street, the terminal stood between College and Center Streets. Buses could load and unload on either side of the building along 18 foot driveways capable of handling five buses simultaneously under well lit marquees. The location was a definite improvement over the city's prior Greyhound depot, which had been on the ground floor of a local hotel.

The front elevation of the terminal featured fluting at the top and a wide dark blue band, just above the windows, that tied into the marquees at the side. A dark scuff strip ran below the windows at the sidewalk and the blue enamel cladding displayed two running greyhound dogs, one above each front window. Unlike the Louisville terminal, the Bowling Green Terminal, as built, bore no signage. Instead a C-shaped street sign mounted on a large pole in front of the terminal near the curb bore a running greyhound dog at the top, the words "Bus Depot" on the vertical leg of the sign and "Cafe" along the bottom. Although this was a Greyhound bus terminal, it served other lines as well and helped centralize bus traffic in Bowling Green.

The *Park City Daily News* of May 26, 1937, described the Bowling Green terminal as

> an imposing building utilizing the modernistic style of architecture radically different from ordinary transportation terminals.

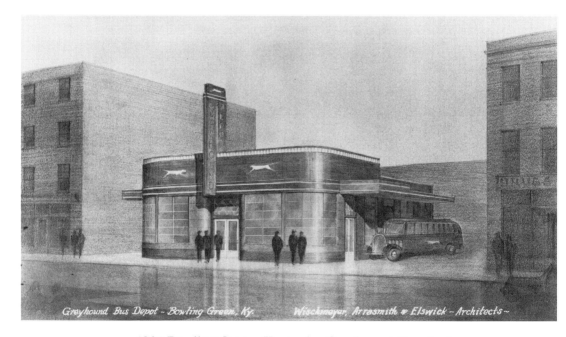

1937 Bowling Green, Kentucky, Greyhound Terminal

Plate glass, chrome and aluminum frame work and porcelain enamel steel make the front of the structure unusually attractive. All corners are rounded with double strength plate glass following the contour of the building, held in place by parallel chrome strips that have a ship-like appearance.

The waiting room is indirectly lighted by modernistic chrome fixtures. Deeply cushioned leather chairs trimmed in chrome, blue asbestos tile floors, and chrome metal trim make the white waiting room unusually attractive. A large restaurant operated by Mrs. Hilda Reynolds occupies half of the bus station. Elaborate use of deep blue leather booths trimmed in chrome metal, Bakelite-topped tables, two chrome and Bakelite "horseshoe" lunch counters and a modern kitchen utilizing monel metal and stainless steel make it one of the finest establishments in Warren County.

Rest rooms for both men and women are just off the main waiting room.... In the rear of the spacious waiting room is the colored waiting room which also has large rest rooms for both men and women.

Elaborate festivities highlighted the grand opening ceremonies which took place during the evening. Prominent transportation executives from throughout the area were in attendance as well as representatives of the Interstate Commerce Commission and the mayor of Bowling Green. The public was invited and all who came had a chance to win one of a dozen free tickets to various points on Greyhound Lines. Music was provided by the Red and Grey Orchestra of Western Teachers College. Flowers were passed out to the ladies and toy balloons to the children.[1]

1938 Jackson, Mississippi

Built during 1937 and 1938, this Greyhound Blue terminal, though smaller than the Louisville terminal, is similar in its general configuration. It is two stories tall and has

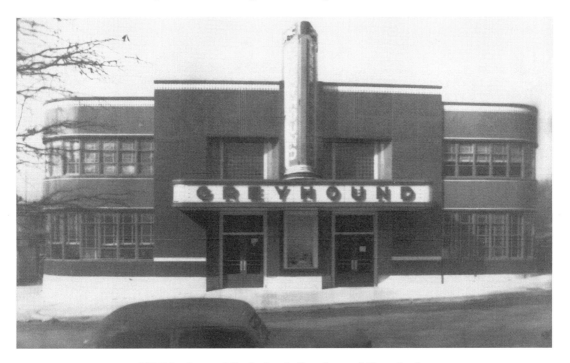

1938 Jackson, Mississippi, Greyhound Terminal

a glistening blue facade of architectural glass with gracefully rounded corners. This is the only terminal Arrasmith designed using architectural glass. A marquee and pylon sign are over the central entrance and feature a neon-lit running greyhound.

As passengers entered the terminal they stepped into the main waiting room which had ticket windows and a coffee shop with a horseshoe shaped counter. A mezzanine balcony with a curved aluminum and wood railing overlooked the waiting room and contained men's and women's rest rooms. The men's facility was provided with a shower, the women's with a bath tub. An attractive backlit circular window with a white greyhound on a cobalt blue background graced the wall opposite the balcony.

The terminal has been adaptively restored as an architect's office.[1]

1938 Fort Wayne, Indiana

Opened in September 1938, the Fort Wayne, Indiana, terminal was situated in the middle of a city block. The building was rectangular in shape and two stories tall. The front elevation had a gently curved bay centered between the sidewalk entrances to the building. The bay relieved what would otherwise have been a flat facade and lent a curvilinear form to what was a box-shaped building. One entrance was designated for the terminal and the other for the restaurant. The second floor windows on each end of the facade ran from the bay around the corners. A Greyhound sign pylon extended over fifteen feet above the top of the building and acted as the focal point of the front elevation.

A one-story-tall wing wall extended from the bus dock side of the building as a screen to conceal parked buses. The wall contained a display window and a row of glass blocks

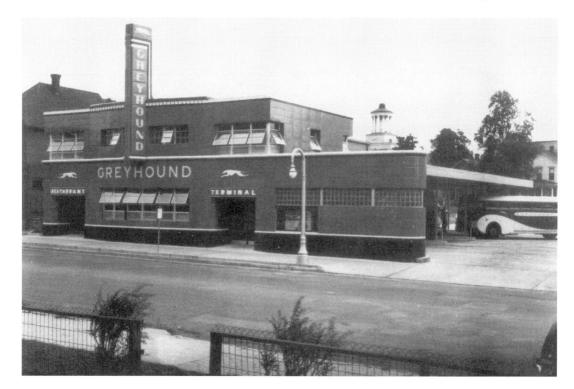

1938 Fort Wayne, Indiana, Greyhound Terminal

which wrapped around the tightly curved end of the wall. The terminal was clad in Greyhound Blue porcelain panels with a dark blue scuff strip at sidewalk level and three horizontal white accent lines—one at the top of the facade, one at the mid-point and the other at the top of the dark blue scuff strip. There was no canopy over the sidewalk entrances and the word "Greyhound" was emblazoned over the first-floor windows.

Facing on Jefferson Street the terminal was flanked on one side by a narrow alley, too narrow to be of use to buses. On the other side was an abutting property. The Greyhound lot extended through from Jefferson Street in front to Lewis Street in the rear. Buses entered from Lewis Street and pulled into sawtooth docks at the side and rear of the terminal. To depart, the buses backed out of the docks and then pulled through to the Jefferson Street exit at the front of the terminal.

The terminal was unusual in several respects. There were two separate entrances, one for the restaurant and the other for the terminal itself. The separation of entrances allowed the restaurant to be situated at the front of the building and a waiting room and other bus facilities to occupy the rear of the building. Up until the construction of this terminal it was the usual practice to have one main entrance for all functions contained within a terminal. This special arrangement may have been adopted to facilitate restaurant traffic and thereby restaurant revenue since it would be free of distracting pedestrian traffic to and from the waiting room.

Bus passengers in the waiting room had access to a separate lunch counter and fountain that was serviced from the restaurant kitchen. There was seating for thirty-four in the restaurant and sixty-eight in the waiting room. The ticketing counter was in the waiting room as was a newsstand. Passengers wanting to enter the restaurant had access from the terminal entrance foyer. The terminal was not air conditioned when it opened in September of 1938 and all windows throughout the building had transoms permitting them to be opened during the summer so that fresh air could circulate freely throughout the building. The waiting room ceiling was two stories high and had a balcony lounge, containing men's and women's restrooms, which occupied the area over the restaurant. Natural lighting for the balcony was furnished by the second floor bay windows which overlooked the street. A station manager's office and a driver's room were also on the balcony.[1]

1938 Binghamton, New York

The Binghamton, New York, terminal, which opened in November 1938, and was built at a cost of $53,000, represented a departure from the Greyhound Blue terminals, not only in the facing material and color of the building, but also in its style. The design was more conservative with traditional styling cues not present in the other terminals. As a result the building did not possess the appearance of mobility or detachment from its surroundings to the same extent as the Greyhound Blue terminals. It looked more attached to the site, substantial, and even heavy. If the signage were removed, one might think it was a bank building.

The large central tower and the use of imitation stone greatly affected the visual impact of the building. Unlike the Greyhound Blue terminals in Fort Wayne, Evansville and Louisville, Binghamton seemed anchored to the ground and the wide scuff strip did nothing to lighten its appearance. This impression was strengthened by the tower which seems to stake the terminal to the ground. Although the tower was off center on the building itself, the wing wall which concealed parked buses placed it visually in the center of the facade.

The terminal was situated between two streets, Prospect Avenue to the rear and Chenango Street to the front. Buses entered the depot from Prospect and pulled into one of five saw-toothed docks along the side of the terminal. Departing buses backed out of the docks and exited onto Chenango Street. The arrangement of this terminal was dubbed the parallel-type because the bus traffic flowed parallel to the building and the terminal was situated between and connected to two parallel streets.

As was typical with the other terminals, the foundation, walls, column footings, floor, roof slabs, and concourse platform were of reinforced concrete. Structural steel was used for the framing of columns and beams. The Binghamton terminal facade featured cast stone details including scalloped cornice window reveals, the block-lettered word "Greyhound," and a running greyhound, all of which formed an integral part of the building facade. Glass block was employed over the main street entrance and in a wing wall which concealed the bus docks from the street.

Similarities between the Binghamton and Fort Wayne terminals include the sign pylon, the slightly altered wing wall and the portion of the building containing the restaurant and second floor restrooms.

Exterior lighting of the building was supplied by a double globe street lamp located at the curb but centered on the building. Other night illumination was furnished by interior ambient light emitted through the windows and glass block, and from the pylon sign. Unlike Fort Wayne, Binghamton had bus garage facilities at the rear of the depot.

The waiting room was reached from the street by way of a foyer which took entering passengers past a restaurant offering counter service only. A newsstand kiosk occupied one

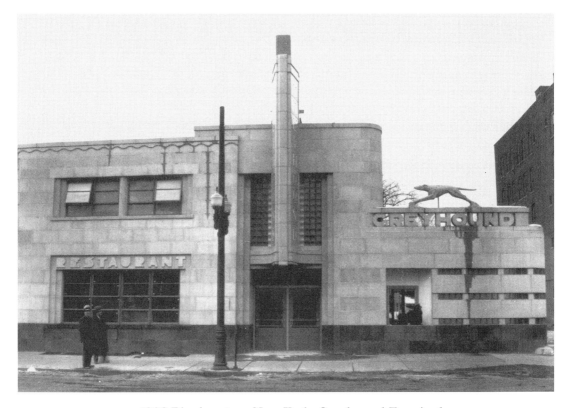

1938 Binghamton, New York, Greyhound Terminal

corner of the restaurant and served both restaurant and waiting room patrons. There were baggage lockers and a telegraph office in the waiting room as well as pay telephone booths. A baggage room was next to the ticket counter and a window behind the counter allowed dispatcher control of bus departures and arrivals. A second floor balcony which overlooked the waiting room, held restrooms, a driver's room and the manager's office. Storage space and building utilities were contained in the basement under the restaurant.

William Arrasmith was developing a basic pattern of terminal layout that would be used time and again as more buildings were designed for Greyhound. A restaurant would be found in every depot, would occupy a very significant portion of the available floor space, and be so situated as to be convenient to both off-the-street trade and bus patrons. The waiting room itself would take second place to the most advantageous arrangements for the restaurant so as to maximize the terminal's revenue potential. The waiting room would be large and well lighted with a high ceiling, and restrooms and lounges would be on a mezzanine or balcony to conserve ground floor space. A ticket counter and baggage room would be adjacent to one another at the opposite end of the waiting room from the entrance to assure good traffic flow and to free the entrance from congestion. In smaller terminals, the ticket counter area would often include bus dispatching facilities thus making it possible for employees to perform dual functions.

Several things might explain the shift away from blue porcelain for the Binghamton terminal. Local ordinances could have played a part although such restrictions were much less common in the 1930s than they are today. However, the country was still suffering from the effects of the Great Depression and any town or city would welcome new construction of almost any kind with open arms. If Greyhound had wished to construct another Greyhound Blue terminal, it most probably would have been well received. It is more likely that Greyhound made a company decision to employ a more conservative appearance while still retaining elements of its streamline architectural theme.

When compared to subsequent Streamline Moderne terminals such as Washington, D.C., the Binghamton terminal seems to be torn between the world of traditional architectural styles and the streamline world. During the 1950s the central tower block theme would reemerge as a more avant-garde style of Greyhound terminal developed.[1]

1939 Evansville, Indiana

The terminal, situated on a corner site in downtown Evansville, was of the island type, with structural systems made entirely of reinforced concrete. The main entrance was located at the base of a large cylindrical mass that dominated the corner of the building at the street intersection. Below a canopy bearing the legend "Greyhound" were two main entrance doors. Centered above the canopy a pylon sign extended over ten feet above the top of the building. The sign, visible from all approaching streets, bore the name Greyhound topped by the corporate mascot. The facade above the canopy was made of glass block which at night was illuminated by interior ambient light and the top of the cylinder received a scalloped treatment reminiscent of a Greek column.

A special traffic coordinator's booth, located between the two main entrance doors, was a short lived innovation unique to the Evansville terminal. Because of the terminal's location at a busy downtown intersection, Greyhound wished to assure that bus traffic would not interfere with street traffic in the vicinity of the terminal. Although there was a four-way traffic signal suspended above the intersection, there was concern that the increase in

congestion generated by the newly constructed terminal would add significantly to the already heavy automobile and pedestrian traffic. The traffic coordinator's task was to help the bus dock dispatcher time the release of buses to coincide with traffic light changes.

Greyhound built its Evansville, Indiana, terminal on the foundation of an abandoned theater. The property on which the terminal was built was purchased by Greyhound in November 1937 but work did not begin on the new terminal until mid–1938 with completion following in 1939. Although original plans and early publicity about this streamline terminal indicated that the facade would be faced in buff Indiana limestone, the finished building features the Louisville-style Greyhound Blue porcelain enamel panels. It is not surprising that local Indiana limestone was originally considered for the facing because of its international reputation as a building material. Postcards of the era incorrectly depict the station with buff or gray colored facing rather than the Greyhound Blue panels actually used.

The exterior walls of the terminal were of different lengths and punctuated by three evenly spaced vertical windows on the long wall and by one tall window and two shorter windows, one above the other, on the short wall. The tall windows rose from the wainscot to just below the level of the ceiling. The interior was separated into two wings. The wing on the longer wall contained a waiting room with separate information and ticket counters. The other wing served as the terminal's restaurant.

Although the initial intention was to use natural walnut benches in the waiting room, individual chairs of chrome tubing and dark blue leather were chosen. They were situated back to back in two rows down the center of the waiting room, between the main entrance and the ticket windows.

Flooring was of asphalt tile in dark and light colors, laid in a diamond pattern. Wainscot ran around the entire room and had two chrome rub strips spaced one and one-half

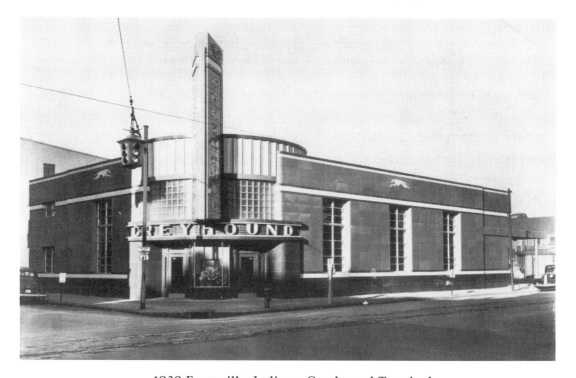

1939 Evansville, Indiana, Greyhound Terminal

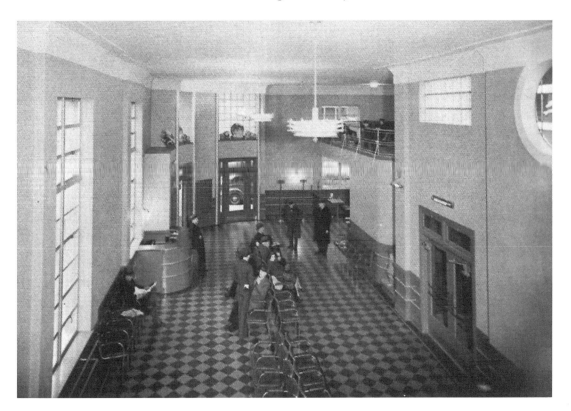

Evansville terminal waiting room

feet apart centered on the wainscot. An information counter near the entrance was cleverly incorporated into the interior wall profile by curving the wainscot outward into the waiting room, in order to flow around and visually envelop it. The interior of the terminal had an overall modern appearance. Fluorescent lighting was indirect and the burlap-covered walls and cream-colored plaster ceiling enhanced the lighting effect. A cobalt blue porthole window identical to that in the Jackson, Mississippi, terminal overlooked the waiting room.

The restaurant area contained a row of booths down the street side wall, and a counter with individual stools along the interior wall. The waiting room wainscot passed along a rounded corner into the restaurant, ending at the lunch counter. The ceiling of the restaurant was dropped to half the height of that in the waiting room and individual drum shaped lights ran down its center. The booths and stools had dark blue upholstery which matched that of the waiting room chairs. The women's room was situated at one end of a mezzanine balcony above the restaurant and the men's room was at the other end of the waiting room over the ticket counter and baggage area. Access to the buses was through two doorways leading directly from the waiting room to the concourse. A dispatcher's bay window looked out onto the concourse and docking area and was at the end of the ticket counter to allow both ticketing and dispatching functions to be performed by one employee.

The cylindrical focal point which dominated the exterior facade of the Evansville terminal was not an especially common theme on terminals during the streamline era, although the style was later employed by Greyhound at other locations including Spartanburg, South Carolina; Omaha, Nebraska; Billings, Montana; and Paducah, Kentucky. None of these terminals are known to have been designed by Wischmeyer, Arrasmith & Elswick. The

application of a cylindric mass is a valid solution to the problem of how best to utilize a corner location, while materials chosen, such as glass block, enhanced the corner's overall modernistic appearance. Another element of futuristic styling was the unusual scalloped top of the central cylinder. This may have been intended to mimic the fluted stainless steel panels found on the most modern passenger trains of the day, such as the Burlington Zephyr. Greyhound had never been averse to adapting the features of these handsome and popular streamlined trains for use on its buses, so employing this feature on a terminal was a logical application.

The restored Evansville, Indiana, terminal was entered on the National Register of Historic Places in 1979.[1]

1940 *Washington, D.C.*

The unusual trapezoidal shape of the Washington, D.C., terminal site called for a significant amount of creativity and ingenuity in order to make the most of the available space. One fortuitous result of this situation was the effect it had on enhancing the Streamline Moderne design of the terminal.

Portions of the building flanking the main entrance stepped back to accommodate the oblique site angles, which made the building look as if it were speeding forward on sweptback wings, an aeronautical concept that had yet to be discovered.

The terminal was faced in Indiana limestone and trimmed in black terra cotta with glass block used for accent. Black stone window sills on the second story flowed into the black stone coping of the flanking one story wings and helped to tie the building together. The pale color of the Washington, D.C., terminal was pleasing and lent a feeling of lightness, perhaps because of the building's overall configuration. This effect was emphasized by a narrow black terra cotta band that ran around the building at the sidewalk level, visually separating the building from the land.

The unusual configuration of the site provided a functional advantage in the design of the bus docks as well, as it permitted a closing-fan configuration to be used. This style of

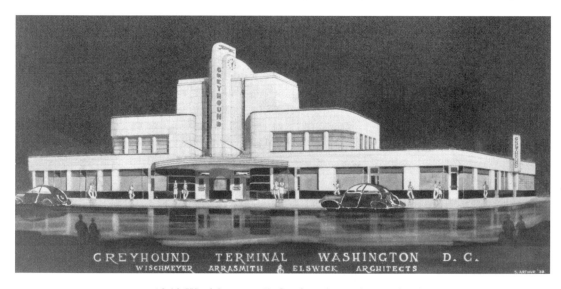

1940 Washington, D.C., Greyhound Terminal

bus docks is the most efficient possible arrangement as it allows for the greatest number of docks, while at the same time providing for a smooth flow of bus traffic.

The Washington terminal was the first one in which W.S. Arrasmith was able to fully articulate the maturing Streamline Moderne style. Predominant features were asymmetrical balance, a strong vertical accent, no more than three stories in height, smooth surfaces, uninterrupted window rows wrapping around corners, and rounded corners. It was also his first terminal in which the interior had received a thoroughly Streamline Moderne treatment. The building materials were contemporary as well, including an aluminum marquee, Formica wainscot, metal casement windows, a porcelain-faced enamel pylon sign, glass block, and burnished copper trim.

In remarking about the terminal on its opening day, one commentator summed it up succinctly, if somewhat grandly, when he wrote that it was "one of the most outstanding examples of motor transportation progress the world has yet witnessed ... and it marked the opening of a new era in the design and function of bus terminals in America."

Along with the 1937 Louisville terminal, Arrasmith's Washington, D.C., terminal was

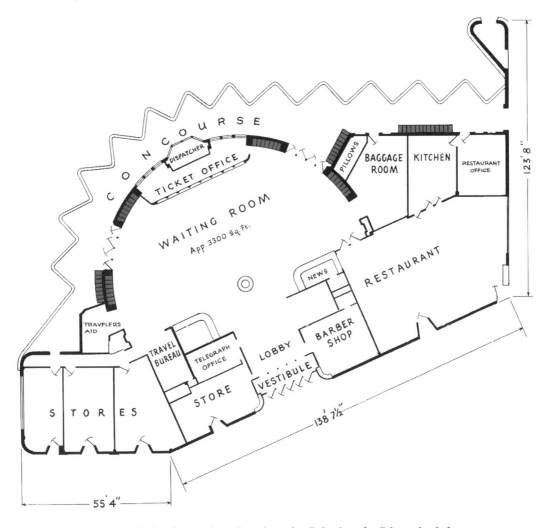

Washington, D.C., floor plan showing the "closing fan" bus dock layout

one of his most important Greyhound commissions, as well as his best expression of Streamline Moderne up to that time. Begun in 1939 and completed in March 1940 at a construction cost of $290,000, the Greyhound terminal in the nation's capitol was acclaimed by the press to be the Grand Central Station of the bus world. This Super Terminal, as it was described by one journalist, cost over $1 million including land acquisition and preparation costs by the time the doors opened to the public. Its structural system included a huge bus concourse canopy made entirely of reinforced concrete. The canopy itself was twenty-seven feet wide, two hundred feet long, four feet thick and cantilevered twenty feet beyond its support columns.

The terminal's location was very convenient to Capitol Hill and major governmental offices, including the Executive Office Building, the White House, the Federal Triangle, and a multitude of departments and agencies. Little wonder that the cost of the building itself was a relatively small portion of the total price of the terminal and land.

New York Avenue ran in front of the terminal's main entrance, diagonally intersecting 11th and 12th Streets which were parallel to each other and bracketed the building. Because the main entrance faced New York Avenue, the portions of the structure along the sidewalk had to accommodate oblique angles as the diagonal street met the intersecting streets. This gave the front elevation of the terminal a sweptback appearance which enhanced its streamline style.

Arrasmith also capitalized on the unusual arrangement of the streets in planning for the layout of the bus driveway and docking patterns. The terminal was on a diagonal in relation to the back portion of the parcel. As previously mentioned, this allowed Arrasmith to use a radial or closing fan style of sawtooth docking. Because of the high traffic flow that Greyhound experienced through the nation's capital, Arrasmith had to provide for the greatest number of bus docks possible while still assuring smooth flow of arriving and departing buses. If the streets adjacent to the terminal had met at right angles, the unique shape of the terminal and the efficient bus traffic patterns would probably not have been possible.

Passengers entered the fireproof, air conditioned terminal beneath a towering monitor style pylon sign which rose above an aluminum-trimmed marquee. The entrance doors were flanked with glass block which also ran across the entrance immediately above the doors. Passing through one of the five doors passengers entered a vestibule that led into the waiting room lobby. To the immediate left inside the entrance were four retail stores with both street and waiting room access. On the right was a barber shop and beyond the barber shop was the terminal's restaurant.

In the semicircular waiting room itself, coin operated lockers were located on the left, eight ticket windows ran across the far wall, and a large baggage room and pillow concession were to the right. Indirect lighting cascaded from the large domed ceiling. The semicircular shape with a dome above gave a very modern feel to the building's interior, reenforcing the Streamline Moderne theme of the exterior. The three-thousand-square-foot room had twelve wooden benches, enough to accommodate several hundred people. The walls of the waiting room were covered with walnut veneer paneling that matched the benches, and burnished copper accents were used for trim in the waiting room and in the domed ceiling above.

The use of wooden bench seating was a change for Greyhound. Waiting rooms had previously been furnished with individual chrome tube chairs with leather-covered seats. These had proven to be so comfortable that they began to attract people who had time on their hands rather than travel on their minds. To solve this problem

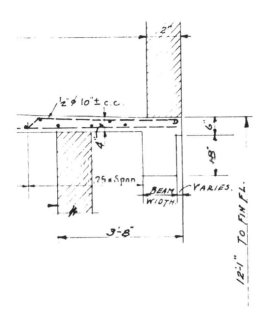

Truss and general details draft for Washington, D.C., terminal

Greyhound resorted to specially-designed wooden benches that were not nearly as comfortable. The benches were divided with wood armrests that made it impossible for an occupant to lie down.

The second floor contained all the terminal operating offices and had a small balcony overlooking the waiting room. Public restrooms were in the basement, along with storage rooms, building utilities, and the driver's lounge. In terms of size, quality of appointments, and the number of passenger amenities, the new terminal easily surpassed its predecessors.

The Washington, D.C., terminal has been adaptively incorporated in a new office complex and serves as the building's lobby.[1]

1940 Erie, Pennsylvania

Opened March of 1940, the Erie, Pennsylvania, terminal was situated on a narrow strip of land that ran between North Park Row and 5th Street in the heart of downtown Erie. In many ways this was W.S. Arrasmith's most remarkable Streamline Moderne building. The site was only eighty-three feet wide and the terminal building itself occupied less than one-half the width of the lot, with the balance being given over to the bus driveway and docking area. Nevertheless, the Erie terminal satisfied all of Greyhound's operational and streamline style requirements on a lot of the most modest proportions.

The Erie terminal confronted W.S. Arrasmith with many significant design problems. Streamline Moderne architecture is most effective when the building can be either isolated or situated on a corner. In the case of the Erie terminal, neither one of these preferred factors was available. The terminal was in the middle of a business block and abutted a three-story turn-of-the-century building. In addition, the extremely narrow lot prevented the terminal exterior from achieving the proportions typically required for a low horizontal appearance.

Because the lot was so small, a one-story building, which might have been easier to design in the streamline style, was not an option. In order to accommodate offices and other facilities while still allowing adequate space for passenger and bus traffic, the terminal had to be at least two stories tall.

The terminal as built was only thirty-six feet wide and was the smallest one designed by Arrasmith. Yet, by using only half of the lot width he was able to create the impression of an island location and to achieve an end product that retained a streamline appearance. Several elements of the design contributed to this.

Arrasmith held the terminal height to two stories, which is the most appropriate height for a Streamline Moderne building. He then interrupted the building's facade with the combination of a slight setback and step-down of the portion of the building that housed the

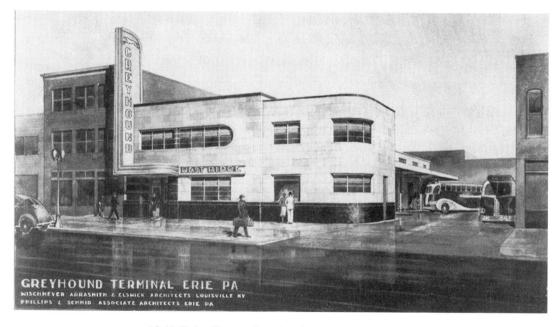

1940 Erie, Pennsylvania, Greyhound Terminal

terminal kitchen and offices and also served as a screen to conceal the docked buses from the street. He thereby effectively incorporated an asymmetrical element into the facade's overall appearance, one of the touchstones of Streamline Moderne design. This also had the effect of lengthening the overall appearance of the facade.

The most important design element was the placement of an L-shaped pylon sign and canopy marquee against the neighboring building. This served to separate the terminal from its incongruously styled mate and gave a visual reference point from which the viewer might mentally infer that the other half of the terminal was simply hidden behind the brick facing of the adjacent building.

The building's structural system was of the formulaic reinforced concrete and steel design. The exterior was done in Indiana limestone trimmed in light and dark shades of terra cotta with dark terra cotta covering the entire entrance recess. The pylon sign was faced in porcelain enamel and all exterior metal trim was of aluminum. The pylon sign and marquee over the terminal entrance were visually one unit, and the word Greyhound and the corporate mascot were done in neon. Four sawtooth bus docks served the concourse. A bus garage was attached to the rear of the terminal to allow for bus storage and minor maintenance.

Upon entering the terminal from North Park Row, passengers walked through a foyer leading past a twenty-three-seat lunch counter which was partitioned from the foyer by a gently curving wall. Upon reaching the waiting room, passengers found self-serve luggage lockers along the left wall, and ticket windows and a baggage room on the far wall. The waiting room contained wooden bench seating for sixty people and had two doorways leading to the bus concourse. The waiting room occupied the full height of the two story building. A window in the ticket office overlooking the bus concourse allowed the dispatcher to control bus arrivals and departures. The second floor level of the terminal was situated over the restaurant and contained restrooms and lounges, with a driver's room and an office over the kitchen.

Although many of the most important rules of Streamline Moderne design were, of necessity, violated in the Erie terminal, the effective manipulation of those elements that remained produced a highly successful result.[1]

1940 Columbus, Ohio

The Columbus, Ohio, Greyhound terminal, built during Wischmeyer, Arrasmith & Elswick's fifth year as architects for Greyhound, was a complete departure from the company's streamline theme. As was the custom on out-of-town work, the firm had a local architect as associate on the job. In this case it was Kyle W. Armstrong of Columbus. The terminal was of the most conventional style and was an anomaly among the Arrasmith and Greyhound terminals of the era.

When it opened in 1940 a casual observer viewing the white limestone and gray terra cotta trimmed building would have been hard pressed to tell that it was designed by William S. Arrasmith. If the pylon Greyhound sign were removed, the terminal would have looked more like a department store than a bus terminal. Because of the radical departure from the appearance of its preceding counterparts, and the fact that no other Arrasmith terminal looked anything like it, the Columbus terminal has to be considered to be a one-of-a-kind design that was out of step with Greyhound's overall stylistic plan.

The terminal faced East Town Street at the corner of South Third Street. Reinforced

concrete was used for the major structural framing elements. The cut stone facade was trimmed with terra cotta at the base and coping levels, and the main entrance detail also received terra cotta embellishment. Windows had aluminum mullions, and the canopy and pylon sign were trimmed in aluminum. The sign surface was of a light colored porcelain enamel. Unlike many other Greyhound buildings, the Columbus terminal bore the Greyhound name only on the sign pylon.

A wing wall, similar to those in Binghamton and Fort Wayne, concealed parked buses on the East Town Street side but there was no such visual amenity on South Third, due in part to the necessity of keeping bus turning radiuses clear.

Once inside the $125,000 terminal, it was easy to see from the layout that it was an Arrasmith terminal. When entering off East Town Street, passengers stepped across a terrazzo floor into a large open waiting room with plaster walls covered in burlap above wainscotting, and painted buff and pink. The floor was covered in asphalt tiles laid in a square pattern, and the ceiling was painted cream. The travel bureau, telegraph office, and public telephones were to the right and a ticket counter was situated at the opposite end of the waiting room. Walnut benches with individual arm rests provided seating in the center of the waiting room.

As passengers walked toward the ticket counter, they passed a restaurant on their left which was without any separating wall and occupied part of the open waiting room itself. The restaurant had dark blue leather upholstery, seating for sixty people, and was accessible from South Third Street. A newsstand was just beyond the restaurant next to the baggage room, and baggage check lockers ran the length of the wall opposite the restaurant. Two offices were located behind the ticket counter, and a bay-windowed dispatcher's booth off the ticket enclosure provided the dispatcher with a view of all eleven bus docks. On the second floor, situated over the travel bureau, was a mezzanine with restrooms, managers offices and a telephone room.

Notwithstanding the fact that the interior of the Columbus terminal was up to the standards of the classic Arrasmith design it must be said that this terminal is one of the least successful of all of Arrasmith's exterior designs. Perhaps this is due to the fact that city

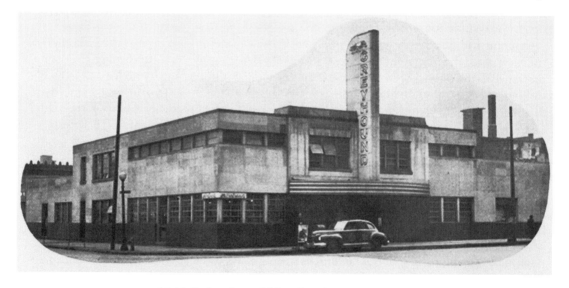

1940 Columbus, Ohio, Greyhound Terminal

planners were not enamored of the streamline styling of earlier Greyhound terminals and felt that such buildings were not appropriate for a major downtown location in the state's capital. It is also possible that Arrasmith's aforementioned accidental infractions of Ohio's reciprocity rules, which governed the practice of architecture by out-of-state architects, may have played some part in the end result. It has to be assumed that neither Arrasmith nor Greyhound were in complete control of the appearance of the terminal and that they had to struggle to keep as much of their design philosophy and visual architectural identity intact as possible.

However, it can be said in the terminal's behalf that it introduced the use of terra cotta as an accent around the main entrance and sign pylon, a treatment that would appear in terminals yet to come from the pencil of W.S. Arrasmith.[1]

1940 Dayton, Ohio

A second new Greyhound terminal opened in Ohio at the corner of Wilkinson and First Streets in Dayton, a mid-sized city with a population at the time of just over 200,000 people. The difference in appearance between the Dayton and Columbus terminals was striking. The streamline style of Dayton was in complete contrast to the square and boxy presentation of the Columbus terminal. Perhaps with the recently completed Columbus, Ohio, Greyhound terminal in mind, one commentator said that the Dayton terminal "avoided ugly angular lines to make the exterior appearance pleasing and chic."

The terminal cost $155,000 to complete and served 142 buses a day. It was built of reinforced concrete and structural steel. Steel bar joists were employed to support the second floor and the roof. The bus docks accommodated nine buses in a sawtooth pattern and the concourse was protected from the elements by a canopy. The portion of the property that was not occupied by the terminal and docking facilities was devoted to parking for additional buses.

The central part of the first floor of the terminal was given over to a waiting room with seating for one hundred people on wood benches featuring individual arms for each seating position. A large restaurant with capacity to serve sixty patrons occupied the street corner portion of the building and could be reached through a sidewalk entrance or directly from the waiting room. Differing from the waiting room in seating accommodations, the restaurant had plush blue leather upholstery. A newsstand, lunch counter and soda fountain separated the restaurant from the waiting room. As passengers passed through the main entrance to the waiting room from the street they found self-serve luggage lockers lining the wall on the opposite side of the waiting room together with three doors opening onto the bus concourse. To their left was the restaurant, and on their right were a baggage check counter and pay telephone booths. Between these facilities and the ticket windows ahead was a corridor that led to the concourse and bus docks. A travelers bureau office was located in the corridor. A dispatcher's booth had a commanding view of the entire dock and concourse area and was reached through the ticket office.

On the second floor were passenger restroom facilities and terminal offices. A balcony and mezzanine overlooked the waiting room. The basement held a porter's room, drivers lounge, mechanical room and overflow storage for the terminal.

All doors throughout the terminal were of wood and the windows were of the steel sash type. The flooring was done in a light rose and gray colored asphalt tile. Wainscoting was of burlap and the walls were done in buff and pink. Cream-hued ceilings and fluorescent lighting gave the interior a bright fresh appearance.

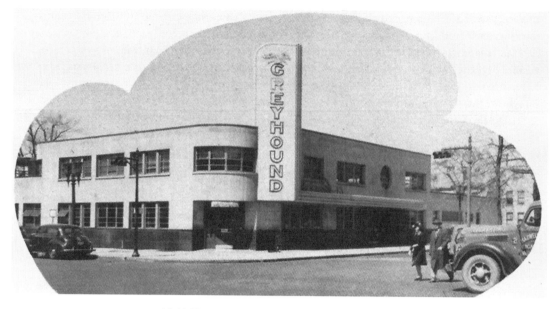

1940 Dayton, Ohio, Greyhound, Terminal

The terminal's window groupings and style broke up the smooth horizontal flow of the building's facade and the restaurant entrance with its deeply recessed and squared off vestibule added to this effect. An L-shaped pylon and canopy was situated over the main entrance of the terminal and a cobalt blue porthole window above the canopy overlooked the street. The unusually large size of the pylon and its offset location almost overpowered the building.[1]

1940 Atlanta, Georgia

Greyhound's terminal in Atlanta, Georgia, built at a cost of $300,000, was opened to the traveling public on August 26, 1940. The design of the Atlanta building echoed the Streamline Moderne style of the Washington terminal, and provided a blueprint for many of the features that were to appear on the 1948 Cleveland, Ohio, terminal which would be W.S. Arrasmith's ultimate Streamline Moderne building.

The asymmetrical wings on either side of the building's two story central block were reminiscent of the Washington, D.C., terminal, without the swept-back look.

Running greyhound mascots were centered over the porthole window and at the top of both sides of the pylon sign which rose above a canopy marquee trimmed in aluminum. The tall pylon sign had a shape similar to the monitor sign on the Washington, D.C., terminal, and was surfaced with porcelain enamel panels. The pylon sign was unique in that one of its faces was perpendicular to the building facade while the other face was at an angle of forty-five degrees to increase visibility from the nearby intersection. Unlike other terminals done by Arrasmith, this one did not have glass block.

A terra cotta facade over the main entrance reintroduced the use of Greyhound Blue. This treatment was a first for Arrasmith and the splash of color served to brighten the building. The hiatus on color usage had ended but it would not return to its former glory. This relatively small but prominent token of Greyhound Blue visually tied the Atlanta terminal

to the Super Coach and Silversides buses and to its counterpart Greyhound Blue terminals elsewhere.

All the corners on the first floor exterior were rounded, with window rows wrapping the ends of the building. Although the second floor section of the building had square corners, the window rows flowed uninterrupted around the corners in the streamline style, which helped to emphasize the building's horizontal theme.

As was Arrasmith's custom, this terminal was constructed of reinforced concrete. The exterior finish was a copy of the Washington, D.C., terminal, with Indiana limestone and dark terra cotta trim. All exterior metal work was of chrome and aluminum. The bus docks were laid out in the highly efficient radial sawtooth design, with parking for fifteen buses at the concourse.

Passengers entered Atlanta's new terminal through a bank of four doors centrally situated under a marquee and sign pylon. A large ninety-seat restaurant was on the immediate left just inside the entrance, and had both interior and street access. On the left was the colored waiting room with 41 seats and its own lunch counter and luggage lockers followed by an office and ticket counter.

Opposite these were a barber shop, a beauty parlor, the men's and women's restrooms and lounges, and a travel bureau with a telegraph room. This arcade brought the passengers to a two story main waiting room with indirect fluorescent lighting, luggage lockers, and walnut benches providing accommodation for 150 people.

The second floor, situated over the arcade, contained terminal offices and a telephone

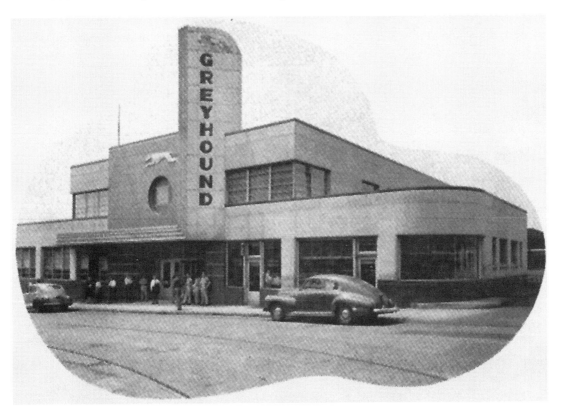

1940 Atlanta, Georgia, Greyhound Terminal

exchange. Instead of an open balcony overlooking the waiting room, there was a recessed bay window which helped reduce waiting room noise from reaching the terminal office area. A basement provided for storage, driver's lounge, and colored restrooms.

The building was fully air conditioned and had a forced air heating system which was thermostatically controlled for year-around comfort. The interior of the terminal was finished with acoustical plaster ceilings and wainscotting of burlap and plastic. The floors were terrazzo. A dispatcher's booth overlooked the bus docks and concourse from the far end of the waiting room and passenger access to the concourse was through two sets of doors on each side of the waiting room.[1]

1941 Syracuse, New York

Built at a cost of $250,000 and located in downtown Syracuse, this Greyhound terminal was a break from the streamline style of the previous Arrasmith Greyhound terminals.

With the exception of the main entrance pylon and canopy, and row of windows above it, this terminal possessed few of the curvilinear streamline features common to other Arrasmith terminals. In addition, the building was faced in gray Binghamton ceramic glazed brick rather than smooth Indiana limestone. The Syracuse terminal stands alone as the only prewar example of its type. This parallel or through style terminal had sawtooth docks for

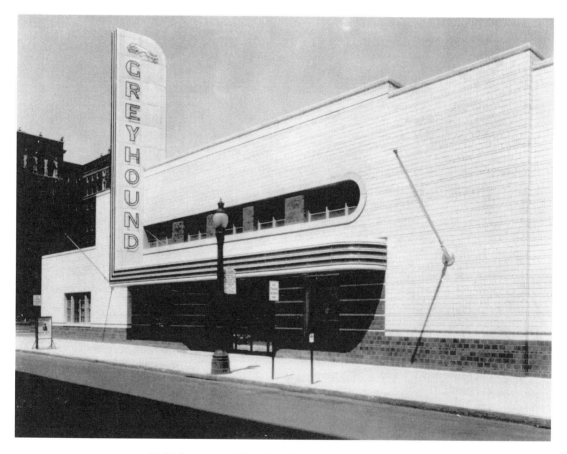

1941 Syracuse, New York, Greyhound Terminal

ten buses arranged along one side of the building. The terminal also had one of Greyhound's largest and most complete bus service and repair garages.

The main waiting room had terrazzo floors in light brown laid in a checkerboard pattern. Reddish brown terrazzo covered the lower wall areas while the upper walls were of plaster and painted buff color. A restaurant with three horseshoe shaped counters was off of the main lobby, along with a ticket office, information room, and Travel Bureau. Restrooms and offices were on the second floor.[1]

1941 Buffalo, New York

Buffalo, New York, was considered by Greyhound to be one of the most important points on the entire system because it served as the gateway to Canada and at the same time it was the transfer point for thousands of sightseers to Niagara Falls.

Construction began in October of 1940. Greyhound Lines had purchased the property for $185,000 and expected to spend another $145,000 on construction costs. At the time, Buffalo had a population of over 550,000 people and the old terminal was overtaxed. The cost for the new terminal, including the land, was $385,000 when it opened May 1, 1941.

The configuration of the Buffalo terminal was quite unusual when compared to other terminals designed by Arrasmith and presented several design problems for Arrasmith because of its width, length, and location. Abutting an adjacent building, it ran 226 feet back from Main Street and, with the exception of its street frontage, was only thirty-two feet wide for 180 feet of its rearmost length.

In many respects the Buffalo terminal was a replay of the Erie terminal, but on a different scale. One section of the front elevation was lower than the other, almost giving the building the appearance of being two separate buildings. It was not stepped back as the Erie terminal had been, but a similar effect was achieved, in part, thanks to the window arrangement.

The severe starkness of the interior decor was uncommon for an Arrasmith terminal. This may have been due to some extent by the disproportionately high cost of the property itself, which forced Greyhound to cut construction costs in order to remain within budget on the terminal.

Two flag poles were mounted along a line which was an imaginary extension of the marquee and had the visual effect of tying the two sections of the building together. The driveway end of the terminal had rounded corners and a large porthole window was centered above the first floor windows.

The structural system of the new terminal was of concrete and steel. There were eleven bus docks which almost doubled the number of docks at the old location, with additional parking for eleven more buses. The bus concourse was completely covered and a taxi stand was incorporated adjacent to the baggage room. The docks faced the waiting room and there were four double doorways leading directly from the waiting room onto the concourse. A dispatcher's booth was centered along the concourse wall of the terminal.

The facing of the terminal was of white limestone with terra cotta accents below the first floor windows, which rose to entirely cover the area under the marquee. Terra cotta also faced the coping at the top of the building and the uprights between the second floor windows. The marquee and pylon formed one continuous unit with highly polished stainless steel running along the canopy and up the edge of the sign giving the appearance of a

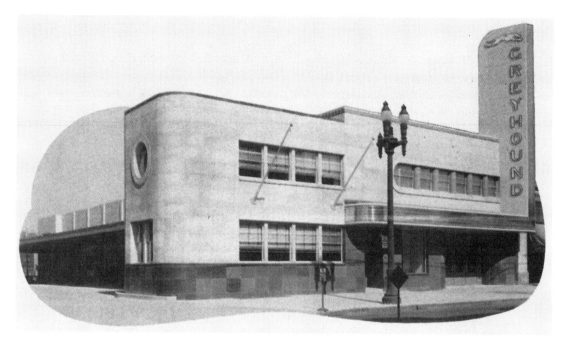

1941 Buffalo, New York, Greyhound Terminal

reversed letter "L." The word Greyhound ran vertically on the sign which was topped by a running greyhound.

The Main Street front of the terminal was seventy-eight feet wide and contained a restaurant. The restaurant provided soda fountain, counter and booth service, and also had a street entrance and an entrance off the main foyer. The waiting room had a newsstand, ticket counter, travel bureau, telegraph office and baggage room.

The floors throughout were patterned terrazzo and the walls and ceilings were buff colored painted plaster. Wooden benches provided seating. The ticket windows, office and travel bureau were behind a walnut veneer facade with open top. All available wall space was taken up with parcel check lockers. A row of windows just below the ceiling lined the concourse wall and a curvilinear cornice added a flowing accent. A mezzanine area housed restrooms, lounges, and executive offices. The overall effect of the terminal interior was one of stark simplicity.[1]

1942 Cincinnati, Ohio

Construction on the $325,000 Cincinnati, Ohio, Greyhound terminal began in September 1941 and the terminal was opened June 10, 1942. The island type building was faced with Indiana limestone and trimmed in black terra cotta. An aluminum marquee and companion pylon sign were centered over the main entrance. There were 16 sawtooth bus docks and a canopy covered the entire loading and unloading area.

Interior walls were of plaster with wainscot in pink-painted burlap. The ceilings were covered in a cream colored acoustical material and floor covering was of terrazzo laid in thirty inch squares. Lobby seating was provided by walnut benches with individual arms for each occupant. The restaurant, soda fountain, and ticket office faced onto the lobby.

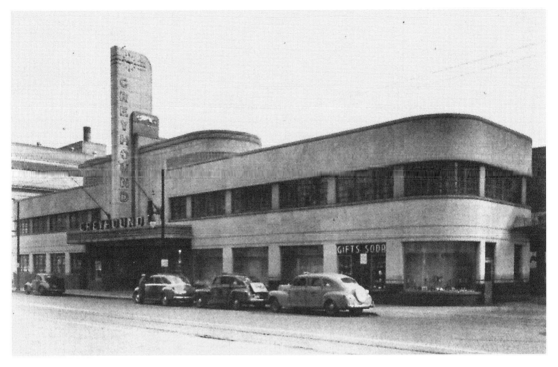

1942 Cincinnati, Ohio, Greyhound Terminal

Restaurant seating was done in chrome trimmed brown leather. There were also a barber shop, drug store, telegraph office, Travelers Aid Office, Travel Bureau, and newsstand. The terminal was designed to serve 5½ million people a year and over 380 buses a day.

Many of the terminal's streamline styling themes appeared on the 1948 Cleveland terminal, built just over 6 years later. Of particular note are the treatment of the pylon and the wedding cake arrangement of the building's mass.[1]

1942 Norfolk, Virginia

Opened for operation August 1, 1942, Greyhound's terminal at Granby Street and Brambleton Avenue was completed just in time to help fulfill the nation's wartime transportation needs. Despite construction delays due to wartime restrictions on materials, the terminal was completed as originally designed at a cost of $300,000. It contained a 100-seat restaurant, waiting room with a seating capacity of 150 people, nine bus loading docks, and additional parking for 15 buses. The terminal was the first in which the pylon was neither associated with the marquee nor positioned at the terminal's main entrance.

Local newspapers cautioned the public that military travel had precedence and civilians would be given seats on buses only after all men in uniform were boarded.[1]

1942 Baltimore, Maryland

Located on a major thoroughfare at the corner of Howard and Center Streets, the Baltimore, Maryland, terminal was completed November 30, 1942. It was the last new Greyhound terminal to be completed until after the war.

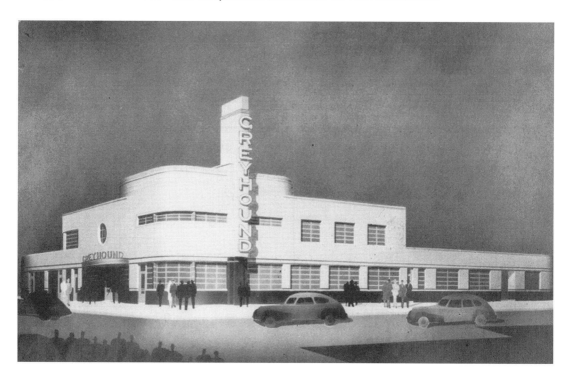

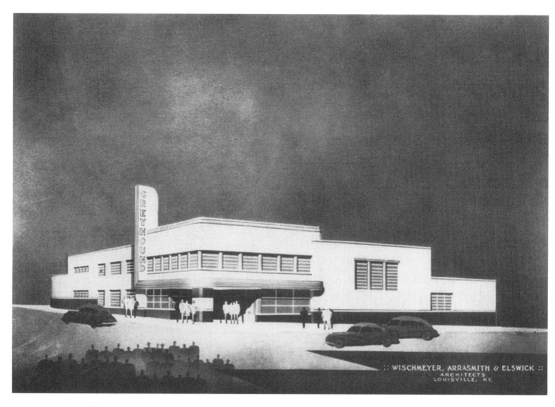

Top: 1942 Norfolk, Virginia, Greyhound Terminal. *Bottom*: 1942 Baltimore, Maryland, Greyhound Terminal.

This island type terminal was designed with an avant-garde treatment of the streamline theme and faced with white limestone. Dark brick, stone and terra cotta provided accents around window sills and coping. Together, the porcelain enamel-covered pylon and marquee presented a continuous unifying character line from the top of the pylon to the marquee's extreme end as it wrapped around the main entrance corner of the building. Wing walls hid the 12 bus docks from view at each end of the terminal.

Patterned terrazzo flooring covered the first floor of the terminal throughout. Plaster walls featured wainscot covered with pink-painted burlap which accented the cream-colored suspended ceiling. Walnut benches provided seating in the waiting room and most of the 72 self service parcel checking lockers lined the walls next to the bus concourse.

Rest rooms and executive offices were located on a second floor mezzanine. Also on the mezzanine was a central telephone switching office which handled the terminal's telephone service and the eight public pay telephones in the waiting room.

A large bus garage was at the rear of the property and featured a drive-through wash rack. The garage was refurbished as an exhibit facility by the Maryland Historical Society in 1997.[1]

1942 Chicago, Illinois (Proposed)

One of the last commissions W.S. Arrasmith was involved with before being called to active duty in 1942 was for Greyhound's intended new terminal in Chicago, Illinois. This massive undertaking was larger than any other terminal project the company had attempted and was designed to cover an entire city block on the western edge of downtown Chicago. Greyhound planned for the finished building to enclose over sixty thousand square feet of floor space on five levels. Its estimated cost approached ten million dollars and when finished this landmark building would have been the world's largest privately owned and operated bus terminal.

The most unusual feature of this proposed terminal was its location above Chicago's subterranean Wacker Drive roadway system which would allow buses to come and go without encountering congested street level traffic. Because of this, it was possible to locate the bulk of Greyhound's bus and passenger operations on the terminal's lower level. This meant that only a relatively small portion of the ground level space was dedicated to transportation activities, as the waiting room, ticket counters, and other related amenities were located at the inner central core of the first level. In addition, this arrangement left the entire street level frontage free for retail stores, which was its most desirable and profitable usage. There were up to fifteen retail spaces and a theater complex. Office space was to be contained in two tower blocks topped by roof gardens, and three levels in the core of the building were set aside for a public parking garage.

Another unusual feature of the building was its grand scale. The height would have exceeded that of any other streamline terminal designed by Arrasmith, and would have pressed the vertical limits of the style. However, the traditional horizontal proportions of the streamline style were preserved because of the building's great size . Thus, although it was twice as tall as the typical Greyhound streamline terminal, it was also more than twice as long and more than twice as deep.

The standard Streamline Moderne elements were present including smooth surfaces, strong horizontal lines, window rows wrapping around corners, combined pylon sign and marquee canopies, and the application of terra cotta accents in the sidewalk scuff strip. The blending of the tower blocks into the long horizontal masses was achieved by subtly mod-

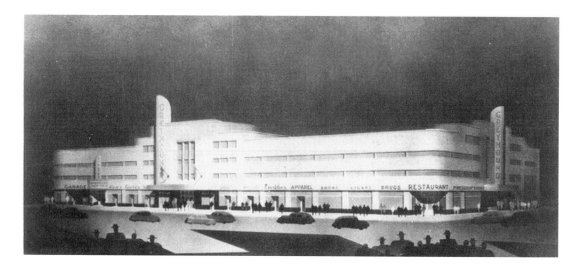

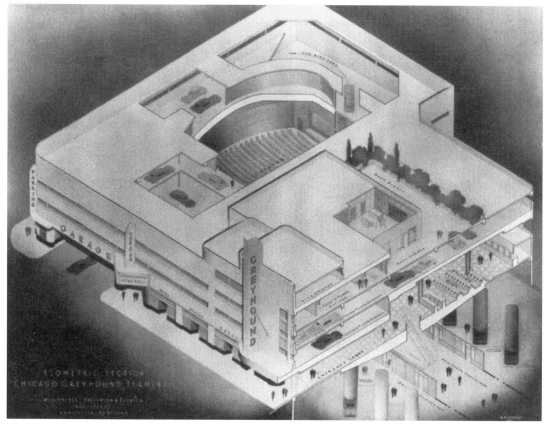

Top: 1942 Chicago, Illinois, Greyhound Terminal (Proposed). *Bottom*: W.S. Arrasmith's 1942 proposal for Greyhound's Chicago terminal showing interior details and the lower concourse, which was accessed from Wacker Drive.

ifying the vertical tower window theme at each level of elevation. Finally, because it was bordered on three sides by streets it was possible to design it as if it were an island type terminal.

The onset of World War II interrupted Greyhound's plans for the Chicago terminal and although it was never built, the proposal was the culmination of Arrasmith's prewar work.[1]

1946 Hagerstown, Maryland (Proposed)

One of Arrasmith's first postwar proposals for a Greyhound terminal was for Hagerstown, Maryland. It was also the first iteration of the avant-garde style architecture that Greyhound would be employing for most of its new terminal construction.

The new style architecture was devoid of streamline features that typified prewar terminal design. Nevertheless, many of the signature elements utilized in prewar terminal design were incorporated in this avant-garde building.

Among them were the L shaped pylon and canopy which was a focal point of the front elevation on the Hagerstown terminal. Also a wing wall was employed to hide the docked buses from view. Other features from prewar streamline terminals that were employed on the Hagerstown terminal proposal were the use of blue tiles which covered the central tower and wraparound corner windows.

Elements of Arrasmith's Hagerstown design proposal can be found on many of his terminals of the late avant-garde period.[1]

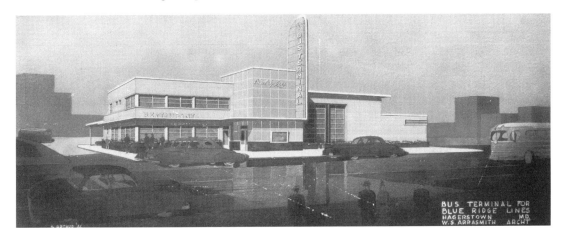

1946 Hagerstown, Maryland, Greyhound Terminal (Proposed).

1948 Cleveland, Ohio

"Greatest Bus Terminal in World to Open in City Tomorrow," proclaimed the headline of a March 30, 1948, *Cleveland News* eight-page special section devoted exclusively to a report on Cleveland's new Greyhound terminal designed by W.S. Arrasmith.

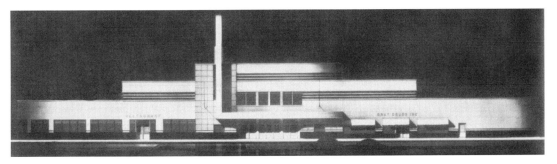

1948 Cleveland, Ohio, Greyhound Terminal.

Situated on more than 88,000 square feet of land on the eastern edge of downtown Cleveland, this million dollar terminal was built to handle a passenger load of more than 3 million people annually. It ran 250 feet along Chester Avenue, extended 150 feet back from the street and was ringed by 21 bus docks. The building was faced in Indiana limestone with dark and light blue terra cotta accents. All doors and windows were of aluminum framing. Windows on the second story flanking the entrance and third floor windows were accented with double horizontal strips of aluminum reminiscent of the leading edge of an airplane wing. This wing-edge accent was also applied to the entrance canopy and its pylon sign which rose sixty-six feet above the sidewalk. The pylon was faced with porcelain enameled metal panels finished in light rose-tan, and bore the word Greyhound with companion mascot and clock.

To enhance the appearance of the building as an island in its mid-block location, Arrasmith situated unusually wide bus driveways at opposite ends of the terminal effectively isolating the terminal from its neighbors. Isolation of the building is not only a critical element in a successful Streamline Moderne building, it is also a way to realize the full potential of the location and maximize its utility as a bus terminal.

Structurally, the central portion of the building was engineered to permit the erection of an additional four floors on top of the original three to accommodate more office space. From a visual standpoint it is fortunate that the expansion never took place.

The Cleveland terminal has remained in continuous service since the day of its opening in 1948 and stands as architecture's definitive statement of the Streamline Moderne genre. No other building expresses the essence of the Streamline Moderne style with comparable symmetry and grace. The terminal was placed on the National Register of Historic Places in 1999 and was restored by Greyhound in 2000 at a cost of $5 million.

The grand opening of the Cleveland terminal was a civic event of the highest order. Ohio governor Thomas J. Herbert and Cleveland mayor Thomas A. Burke officiated jointly at the event. Together they cut a blue and white ribbon spanning the main entrance, opening the terminal to the public as Greyhound executives welcomed visitors to the terminal. Guests toured the premises to the accompaniment of live music and everyone who attended received a brochure explaining the new terminal's many features, along with a travel map of the United States.

Not only did visitors get to see the new terminal, but they were also invited to examine Greyhound's newest bus-of-the-future, the Highway Traveler, which made its public debut that day, alongside examples of buses currently in use on the Greyhound lines. The new bus was fully air conditioned and rode on air cushions rather than steel springs, a veritable land yacht capable of carrying fifty passengers in double deck comfort, thirteen more people than the Silversides bus then in service could accommodate.

Greyhound buses as well as intracity and commuter buses entered the rear of the loading area from Walnut Avenue which ran along the northern edge of the property. Also located off Walnut Avenue was a large garage that contained facilities for washing and servicing two Greyhound buses at a time. A dispatcher's booth was situated at the northeast corner of the building from which the bus arrivals and departures could be monitored. Arriving buses would be berthed at one of the twenty-one docking slips which gave passengers direct access to the terminal lobby. Once unloading and loading had been completed, the buses would exit onto Chester Avenue to proceed on their way. The dispatcher announced departures and arrivals over a public address system of fifteen speakers located throughout the terminal.

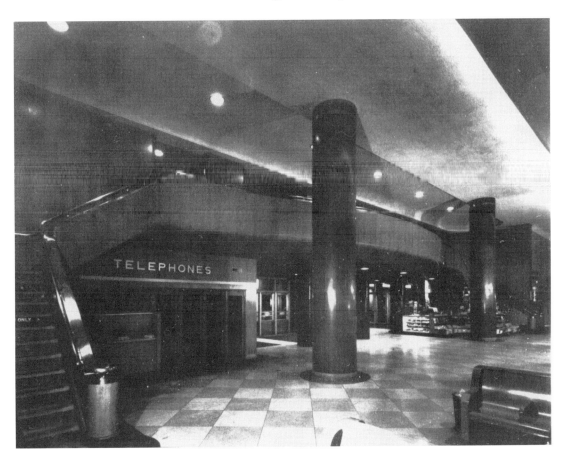

The focal point of the waiting room was a gently curved balcony, which was centered over the main entrance area and featured curved staircases at each end, which gave access to public facilities on the second floor. The waiting room and all other public areas of the terminal were in total harmony with the Streamline Moderne exterior. As a result, the Cleveland terminal was one of the most cohesively designed of Greyhound's streamline terminals.

The walls of the expansive waiting room were finished in a plain buff color, and seating for more than 300 people was provided in back-to-back blond oak benches. Passengers were assured of year-round comfort thanks to modern air conditioning and steam heating systems. Services available in the waiting room included nine ticket windows, a round information booth located in the center of the room, a Greyhound travel bureau, a Travelers Aid office, a first aid room, fourteen public telephone booths, and five hundred baggage check lockers. Above the ticket counter was a nine by thirty foot travel map mural of the United States by Cleveland artist Glenn Shaw who had painted murals for the luxury liner S.S. *America*.

Lighting throughout the terminal was by a combination of ceiling mounted spotlights and indirect lighting. Double stairways flanked the entrance area and led from the waiting room to a gracefully curved balcony faced in oak veneer. Terminal offices, barber shop, and restrooms were found off the balcony. The women's rest room had a lounge, and there were even special washroom facilities for children including a child-sized toilet.

The terminal's major retail businesses were a Gray's Drug Store in the east wing off

the waiting room and a Post House restaurant in the west wing. Customers could enter both, either from the street or from the waiting room. The drug store was arranged like a department store with island-type natural oak display cases and counters. Walls were done in light gray with panel mirror inserts. A forty-five-foot-long soda fountain with stainless steel food processing equipment and seating for 23 people was situated along the sidewalk wall of the store. There was an open-front prescription counter and a thermostatically controlled humidor room where a selection of tobacco products was available. Nearby was a lobby newsstand that served the traveling public. In the spirit of the grand opening Gray's Drug Store had gifts for all who attended, including helium-filled balloons for the children, a sample size package of Philip Morris cigarettes and, for the ladies, a cosmetic gift bag containing samples of nationally known toiletries, which was given along with any drug or cosmetic purchase.

Like the drug store, the restaurant was modern in appearance. The ceiling was painted in shades of rose and green and the walls were olive green. One hundred and eighty people could be seated in a combination of seventeen booths, eight tables, and three U-shaped counters. Food preparation equipment, both in the dining area and in the kitchen, was stainless steel. The dining room and kitchen were open 24 hours a day and staffed by one hundred people.

The Cleveland Greyhound bus terminal was Arrasmith's ultimate statement of Streamline Moderne design. It refined and distilled all of the elements that defined the genre as they had evolved since the very first streamline Greyhound terminal was constructed in the mid–1930s. Elements that had appeared on numerous earlier Arrasmith terminals came together in their most fully developed state in Cleveland.

From the Washington, D.C., and Cincinnati, Ohio, terminals Arrasmith took the wedding cake arrangement of the building's three story mass. The Greyhound Blue porcelain enameled panels like those that entirely covered his first terminal in Louisville appeared as a blue terra cotta accent that flanked the pylon sign, an arrangement first used by Arrasmith on the Atlanta terminal.

The L-shaped canopy and pylon sign owes its configuration to the pylon and canopy of Arra's Baltimore, Maryland, terminal, completed shortly before he departed for military duty. The pylon sign itself is almost identical to that which Arrasmith designed for the Cincinnati, Ohio, terminal. The combination of these features, and their placement on the front elevation of the Cleveland terminal, gave the purely symmetrical building mass Streamline Moderne's signature asymmetrical appearance. Double flag poles, used as a design element first seen on the Washington, D.C., terminal, were installed on the facade of the Cleveland terminal, flanking the main entrance canopy.

New to the design mix of these earlier themes was the strong horizontal emphasis created by smooth aluminum accents, simulating the leading edge of an airplane wing, which extended along the second and third story window rows. It may be that the origins of this unique feature lay somewhere in Arrasmith's war experiences and his familiarity with the fighters and bombers that helped win the war. The addition of this wing-edge trim added immensely to the flow of the streamline design. Also enhancing the horizontal strength of the design was the placement of the third story's lower window sill line at the top of the second story facade coping, a feature first seen on the Washington, D.C., terminal. This effectively and unobtrusively lowered the apparent height of the building and made it seem to be just two and one-half stories tall, rather than its actual height of three stories.

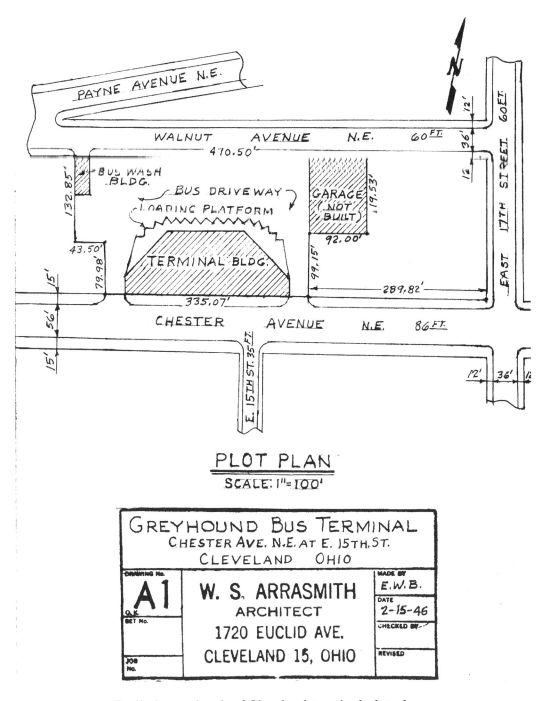

PLOT PLAN

SCALE: 1" = 100'

GREYHOUND BUS TERMINAL
CHESTER AVE. N.E. AT E. 15TH. ST.
CLEVELAND OHIO

DRAWING No.		MADE BY
A1	W. S. ARRASMITH ARCHITECT 1720 EUCLID AVE. CLEVELAND 15, OHIO	E.W.B.
O.K. SET No.		DATE 2-15-46
		CHECKED BY
JOB No.		REVISED

Preliminary sketch of Cleveland terminal plot plan.

Although it was not a new technique, Arrasmith used the juxtaposition of square and curved shapes to contrast and complement each other. The strongly rounded ends of the first floor are carried over to the east end of the second and third story levels, while a contrasting square corner treatment was applied to the west ends of these two levels. Thus the streamline emphasis is subtly muted as the viewer's eyes rise up the front elevation.

The second story was broken into two parts separated by the pylon sign and terra cotta facing which creates visual tension. The western half possesses a square corner which is wrapped by a window row and aluminum wing-edge accent that together give the square corner a smoothly flowing rhythm. The window line and aluminum wing-edge of the eastern half flow smoothly through a rounded corner. The third story continues the rounded corner theme with a long window line and aluminum wing-edge accent which wrap on its eastern end, while the window row and accent terminate abruptly in the terra cotta facing and pylon sign at its westerly end. This treatment is reminiscent of the Atlanta terminal.

Visual tension is achieved on the first floor portion of the terminal in a subtle way. Although both ends are rounded and present a balanced mass, the west end is lined with windows that wrap around it, while the eastern end wing wall is done in bare Indiana limestone with no windows or other accents. This treatment lends to the overall effectiveness of the building's asymmetrical appearance and helps tie the whole facade together.

With the exception of the Evansville, Indiana, terminal and the Washington, D.C., terminal, the interiors of Arrasmith's streamline Greyhound terminals had not always been in complete harmony with their streamline exterior. The interior of the Cleveland terminal, on the other hand, was a perfect reflection of the streamline motif. The imposing length of the building enabled the spacious waiting room to be broad rather than deep, and thus free of supporting structures. Columns at the perimeter of the central waiting room space were round and covered with a plastic Formica-like material. The oak benches were light in color and had low backs with curvilinear ends which consumed less visual space. The benches were situated in two groups, one on each side of the entrance area, leaving a large open space in front of the ticket counter which was on the wall directly opposite the main entrance. A circular information counter offered a visual reference point in the middle of this open area. The waiting room ceiling featured a suspended central panel which provided both indirect and spotlight illumination.[1]

1949 Akron, Ohio

When Greyhound's Akron terminal opened on February 15, 1949, it achieved two firsts: a transportation first and an architectural first.

It was the first and only location in which Greyhound incorporated direct access to long distance railroads in its terminal site. Here, national bus and rail systems were brought together under one roof, and Greyhound passengers could connect directly with the Pennsylvania and Baltimore & Ohio railroads, and also with the new Erie railroad station one block south. This arrangement facilitated purchasing rail and bus tickets, transferring baggage, and making connections protected from the weather.

The Akron terminal's second distinction was that it was also the first post–Streamline Moderne Arrasmith terminal to be built. Although the change was dramatic, the new avant-garde style retained substantial ties to the streamline style which had preceded it, so that the new terminal was still readily identifiable as a Greyhound terminal.

The overall appearance of the Akron terminal owed a majority of its character to Streamline Moderne. The underlying elements of streamline design that carried over included strong horizontal lines, asymmetry, continuous window rows including windows that wrapped around corners, the "wedding cake" arrangement of the building's upper tiers, the use of complementary color bands on the facade, and the vertical pylon.

Despite having similarities, the Akron terminal differed in many particulars from its

prewar era Streamline Moderne predecessors. Its surface was of extruded buff colored brick, rather than smooth neutral gray Indiana limestone used on previous terminals, and horizontal bands of brown brick replaced the blue and black terra cotta accents. There were no rounded corners anywhere on the building—not at end walls, not on window rows, not on the canopy or in any embellishments. All lines were straight lines and all angles were right angles. Windows, instead of being flush with the surface of the building, were recessed and framed in heavy protruding boxlike surrounds of stone or metal.

Where the streamline terminals gave an impression of lightness because of their neutral gray color, smooth surfaces, and black scuff band at the sidewalk level, the Akron terminal was emphatically a building anchored firmly to the spot. Where Streamline Moderne had evoked images of a transportation machine, the adaptation of streamlining to the new square cornered form of this bus terminal left no such impression. The new style made no attempt to visually identify with the buses. The terminal was no longer the bus, and the bus was no longer the terminal. And perhaps that is a more honest statement about the terminal's function in this case because it served not only as a bus terminal but also as a direct link between bus and rail service.

The *Akron Beacon Journal* covered the opening of the Greyhound terminal in its February 14, 1949, issue including photographs and information about the terminal and the event.

The grand opening began at 11:30 in the morning and continued until midnight. All visitors received gifts. A cake, baked in the shape of the new terminal, was shared with early visitors. Music was provided by a Seeburg Library of Records juke box which could play music continuously for fourteen straight hours. The opening ceremonies were broadcast over the radio and included speeches by Mayor Charles Slusser and Chairman Russell Bayer of the Chamber of Commerce. W.S. Arrasmith, on behalf of himself and the Navarro Corporation, general contractor on the terminal, presented Mayor Slusser with a token key to the terminal.

The Akron Greyhound terminal on South Broadway, built at a cost of $600,000, was 190 feet long and 73 feet deep. A canopy extended over a broad main entrance which gave access to a vestibule and the waiting room. A clock was mounted on the upper north corner of the second story and a tower rose from behind the north end of the canopy to just

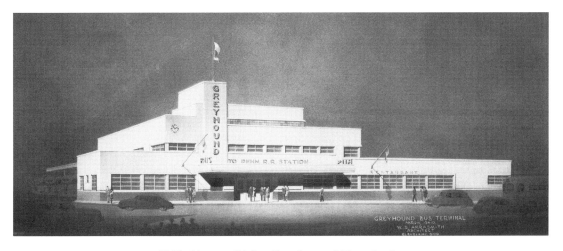

1949 Akron, Ohio, Greyhound Terminal

above the third story level. The word Greyhound was spelled out vertically on the tower face and a flag flew from a pole on top of the tower. Other flag poles were situated to the left and right of the canopy. All three levels of the building had long window rows with those on the second and third stories wrapping around their respective corners. Because the building faced west, the midday sun threw distinct shadows upon the facade from the boxed window surrounds and the tower. The sidewalk curb in front of the terminal was indented seven feet, allowing automobiles to pull out of the traffic flow to facilitate passenger arrivals and departures.

Passing through the main entrance and vestibule, passengers entered the waiting room which ran lengthwise across the building. It was reminiscent in appointments and design of the Cleveland terminal waiting room, though smaller. The floor was of brilliantly polished terrazzo with alternate squares in buff and brown. Seating was available for 112 people on wooden benches identical to those in Cleveland. There were 160 baggage lockers, ten pay telephone booths, a Travelers Aid office, a newsstand and a first aid room. Adjacent to the waiting room was a Post House cafeteria with a seating capacity of 120 people. The women's restroom and a children's restroom with child-sized fixtures was off a balcony at the north end of the building. The men's room was on the second floor and was reached by a separate staircase. A public address system with seven speakers assured passengers that they would hear all announcements of arrivals and departures throughout the building. The terminal was constructed to accommodate an air conditioning system in the future.

There were fourteen bus docks surrounding the back of the terminal, with a dispatcher's booth to manage traffic flow. The basement contained a bus driver's room where drivers could make reports and await scheduled runs.

The events surrounding the development of the Akron Greyhound terminal are of interest. Greyhound had been invited to join with three major railroads in a transportation complex to be located on the southeastern corner of downtown Akron. Arrasmith's initial rendering of the Greyhound portion of this enterprise showed a terminal that was identical to the streamline Cleveland terminal (*see* page 79).

The railroad structures on the other hand were conventional in style, with square corners and no embellishment. The only railroad-related structure depicted in Arra's rendering that showed rounded features was the stairway enclosure that gave access to the train platforms. Whether this was originally in the railroad renderings is unknown. Arrasmith may have included this as a tie-in to Greyhound's Streamline Moderne style terminal.

The architect in charge of the overall project was working for the railroads, and during negotiations between the railroads and Greyhound it was decided that the streamline style as planned by Arrasmith would be modified to be more in harmony with the buildings the railroads intended to construct. The avant-garde style adopted was also consistent with Greyhound's subsequent terminal designs.[1]

1949 Battle Creek, Michigan

Located on East Michigan Avenue just east of City Hall, Battle Creek's new Greyhound terminal was a big improvement over the company's previous facility which had been located in a retail arcade. Greyhound's move to its own terminal eliminated severe congestion problems caused by bus traffic in the city's downtown business district. The appearance of the new terminal echoed that of the 1949 Akron terminal and confirmed the direction Arrasmith would be taking during the decade of the 1950s. The terminal's square corners

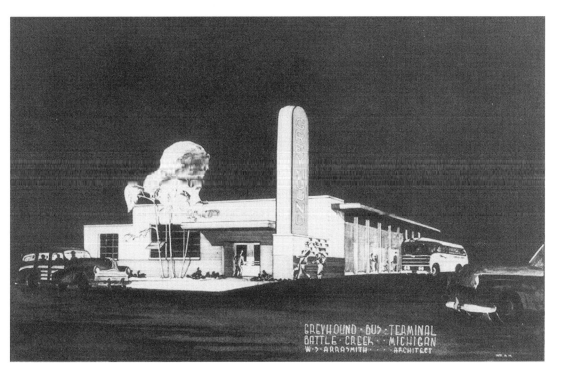

1949 Battle Creek, Michigan, Greyhound Terminal

confirmed the end of the streamline era and the facing materials of brick and building block only strengthened this impression. Relatively unique among Greyhound terminals, it would act as a union bus terminal by serving Indian Trails and Shortway Lines bus companies in addition to Greyhound. As was his custom, Arrasmith attended the grand opening ceremonies along with local dignitaries.

The Murray Construction Company began work on the terminal in November 1948 and completed it at a cost of $100,000. Local architect Leon Snyder, Jr., was the associate with Arrasmith on the project and it was Snyder who suggested and designed the neon lettered pylon sign in such a way as to bring the identification of the station nearer to the sidewalk while permitting the building itself to be set back from the street.

Restaurant facilities and a news and cigar stand were at the front of the building. The restaurant included a full kitchen, counters, steam tables, coffee urns, and refrigeration units. The lobby, located toward the rear of the terminal, was illuminated by flush-lens lights with day lighting being furnished through clerestory windows which could be opened during hot weather to enhance air circulation throughout the terminal. The lobby contained divided bench seats. Telephone booths were next to the ticket windows for the convenience of passengers. The front of the terminal was landscaped with small evergreens to soften its appearance. This was the only terminal to have landscaping.[1]

1949 Grand Rapids, Michigan

The Grand Rapids, Michigan, post-streamline avant-garde theme was drawn from Arrasmith's Akron terminal.

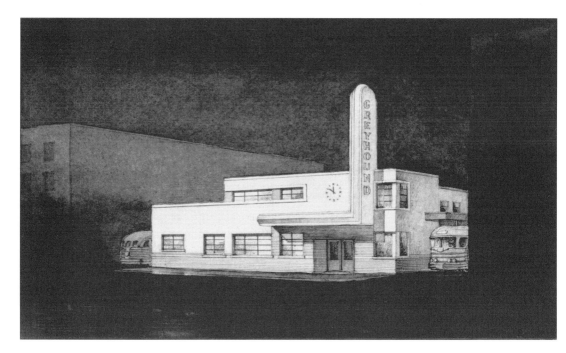

1949 Grand Rapids, Michigan, Greyhound Terminal

Placement of the clock on the face of the building rather than on the pylon originated with the Akron terminal and this design treatment, used on the Grand Rapids terminal, continued to be used whenever a clock was made part of a terminal's facade.

The Grand Rapids terminal reintroduced the L-shaped pylon and canopy style of the streamline era, a feature the Akron terminal had abandoned. Subsequent Arrasmith Greyhound terminals would utilize the pylon and canopy feature until the late 1950s.

The reappearance of the pylon and canopy signified its importance as a part of Greyhound's corporate identity and indicated that it was now an even more important element of that image than the presentation of building mass or arrangement of window rows.[1]

1949 Lima, Ohio

The Lima, Ohio, terminal was built at a cost of $318,000 and opened on August 18, 1949. It was another example of the post–Streamline Moderne style which had made its debut earlier in the same year.

Larger terminals often had a service and storage garage at the rear of the property. Despite the fact that the Lima terminal itself was relatively small, it boasted a very impressive maintenance facility which also housed driver's quarters, a division superintendent's office, and the garage foreman's office.

The extensive planning that was involved in every detail of Greyhound bus terminal design can be appreciated by considering the cabinets which were used by the ticket agents to organize and dispense tickets at the Lima terminal.

Similar in appearance to post office boxes, the cabinets contained preprinted tickets for route destinations. Because ticket sales patterns differed from terminal to terminal, cabinets were specially designed for each terminal with ticket cubbyholes arranged and sized

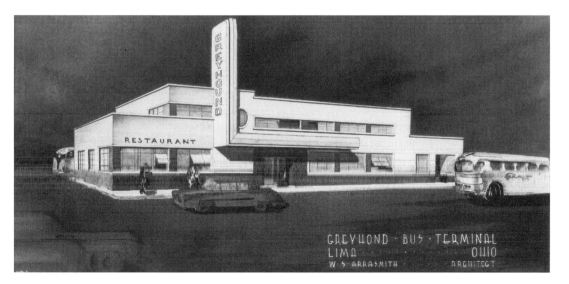

1949 Lima, Ohio, Greyhound Terminal

according to the demand for tickets to destinations originating from a particular terminal. Cubbyholes for frequently requested destinations were larger and closer to hand than for less popular routes. A well designed cabinet arrangement could add significantly to the efficiency of an agent's work.[1]

1950 Lansing, Michigan

More than a decade in planning, due in part to the interruption of World War II, this $300,000 terminal which opened December 21, 1950, held the distinction of containing

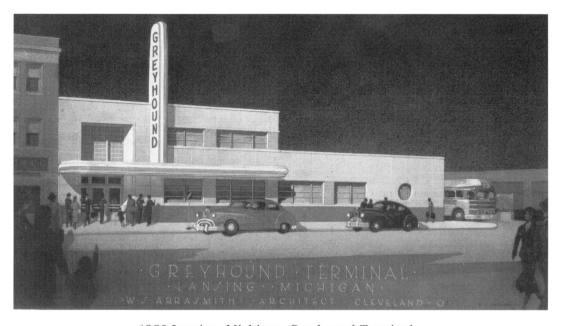

1950 Lansing, Michigan, Greyhound Terminal

the 125th Greyhound Post House restaurant facility. The front of the L-shaped terminal ran 143 feet along Washington Avenue, and its waiting room had four ticket windows and could comfortably seat 84 passengers. Also on the main floor were ticket windows, baggage storage space, and convenient access to eight bus docks. A cab stand next to the terminal, leased to the Michigan Cab Company, provided convenient local transportation for arriving and departing passengers.

The streamline design of the pylon and canopy of this terminal is in stark contrast to the avant-garde style of the building and lends visual tension to the terminal's facade. This was a function that had often been achieved during the streamline era by a visually asymmetrical arrangement of building mass and irregular window row treatment.[1]

1950 Boston, Massachusetts

Relatively unique among Arrasmith's designs, the Boston, Massachusetts, avant-garde terminal was a one-story structure. The only streamline era design elements present on this building were the pylon and canopy, sidewalk scuff strip, and porthole window adjacent to the main entrance. The windows and their arrangement in the facade were unremarkably conventional. No attempt was made to utilize window rows to emphasize the terminal's horizontal theme. The portion of the facade spanned by the canopy had a slight forward extension from the building and an equally slight elevation above the roof coping line. Horizontal character lines surround the building lending a pleasing dimension to its appearance.[1]

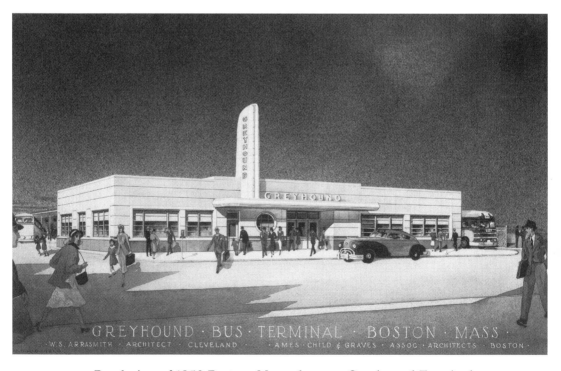

Rendering of 1950 Boston, Massachusetts, Greyhound Terminal.

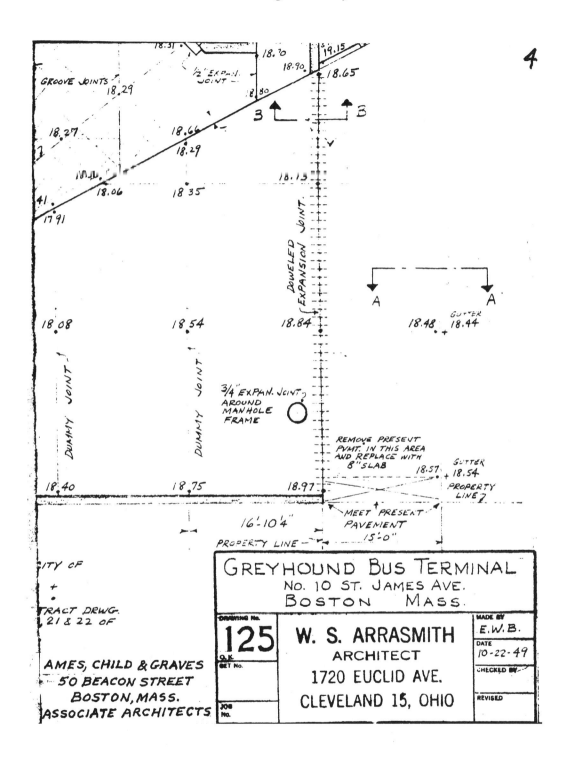

Engineering plan for the Boston terminal

1951 Birmingham, Alabama

Opened on February 1, 1951, the Birmingham Alabama Greyhound terminal was one of the largest to have been built since the completion of the Cleveland and Akron, Ohio, terminals. Built at a cost of $750,000 and designed to serve millions of passengers annually, it stretched 190 feet along North 19th Street and 300 feet along Seventh Avenue. Arrasmith's associate architects on this terminal were from the firm of Greer, Chambers & Holmquist.

Built of stone and brick the terminal could handle 16 buses in its covered loading zone which was overlooked by the dispatcher's office. A cab stand was located at the rear of the terminal.

Inside the terminal, floors were of terrazzo stone and ceilings were of acoustical plaster and tile. Solid oak benches could accommodate 156 people in the white waiting room and 44 persons in the colored lobby. Both sections had their own restaurant and newsstand. Other facilities in the open, bright, and airy main waiting room included a baggage room, barber shop, 20 public telephones, three Western Union phone connections, ticket and information offices, a travel bureau, and a Travelers Aid Society. The walls were covered with a variety of murals depicting different parts of the country. The basement provided 17 individual sleeping rooms for drivers and a large storage area.

As with earlier Arrasmith avant-garde terminals, the streamline era pylon and canopy, sidewalk scuff strip, and porthole window were retained as design elements.[1]

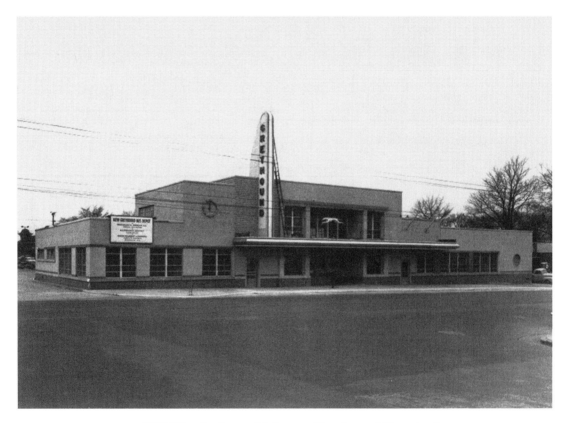

1951 Birmingham, Alabama, Greyhound Terminal

1954 St. Paul, Minnesota

By 1954 the avant-garde style that appeared immediately after World War II had given way to a more generic modern style. Although elements of the streamline era remained, they were overshadowed by the new style and had become mere tokens of what they had formerly been.

The building itself was indistinguishable from other neighboring buildings in the downtown retail district and had lost what been Greyhound's signature post-streamline avant-garde appearance.

The facade of the St. Paul, Minnesota, terminal was unique in its use of two tones of highly polished marble to cover the two story central portion of the building. It was Arrasmith's first use of this material on a Greyhound terminal.[1]

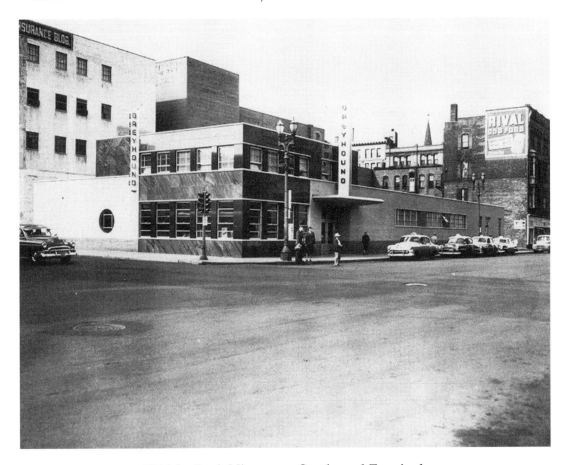

1954 St. Paul, Minnesota, Greyhound Terminal

1959 Pittsburgh, Pennsylvania

All traces of avant-garde's streamline heritage have vanished from this Greyhound terminal in downtown Pittsburgh, Pennsylvania. Built on the site of a prior Greyhound terminal, this 100,000 square foot site housed all of the company's Pittsburgh operations.

Although Arrasmith's first proposal for this terminal was made in 1946 construction

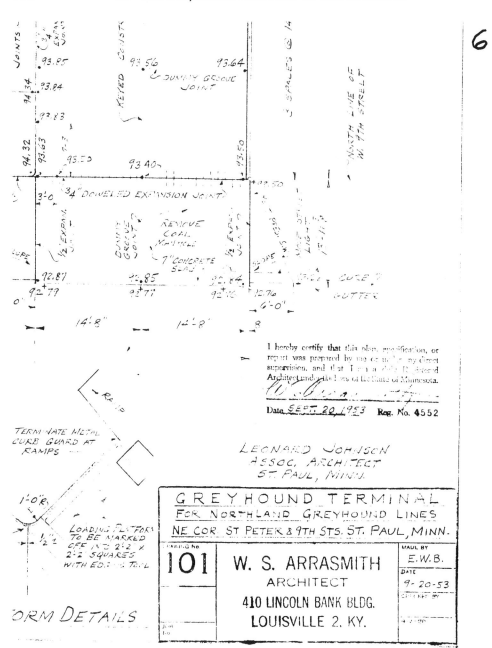

6

I hereby certify that this plan, specification, or report was prepared by me or under my direct supervision, and that I am a duly Registered Architect under the laws of the State of Minnesota.

Date SEPT 20, 1953 Reg. No. 4552

LEONARD JOHNSON ASSOC. ARCHITECT ST. PAUL, MINN.

GREYHOUND TERMINAL
FOR NORTHLAND GREYHOUND LINES
NE COR. ST PETER & 9TH STS. ST. PAUL, MINN.

DRAWING NO. 101

W. S. ARRASMITH
ARCHITECT
410 LINCOLN BANK BLDG.
LOUISVILLE 2, KY.

MADE BY E.W.B.
DATE 9-20-53
CHECKED BY

Plan for the St. Paul terminal

did not begin until April of 1958, after innumerable revisions. It served its first passenger on December 10, 1959.

The property occupied an entire city block—bordered by Eleventh and Twelfth Streets and Penn and Liberty Avenues—which facilitated the flow of bus traffic around the building. The site also incorporated a three-level parking garage to serve Greyhound's new but short lived rental car business.

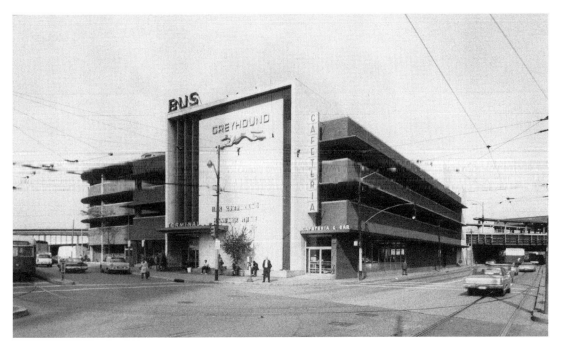

1959 Pittsburgh, Pennsylvania, Greyhound Terminal

This $3.5 million terminal was capable of providing for the loading and unloading of 21 buses simultaneously, and had complete accommodations for passengers including a large waiting room, ticket and information office, travel bureau, baggage and express offices, and a cafeteria and cocktail lounge.

Of special note is the fact that the terminal was situated across the street from the Pennsylvania Railroad station and at the intersection of many of Pittsburgh's busiest trolley and bus lines. With the addition of the new Greyhound terminal the location became a major transportation center for the city.[1]

Chronology of
W.S. Arrasmith Architectural
Firms and Commissions

W.S. Arrasmith Architectural Firms

1919–1921: T.C. Atwood, Chapel Hill, North Carolina (intern during summer months while attending University of Illinois)

1921: McKim Mead & White, New York, New York (designer, June 15 to December 31, 1921)

1922–1923: E.T. Hutchings, Louisville, Kentucky (staff architect, January 1, 1922 to April 1923)

1923–1926: Brinton B. Davis, Louisville, Kentucky (staff architect, April 1923 to July 1926)

1926: E.T. Hutchings, Louisville, Kentucky (staff architect, July 1926)

1926–1928: Clarence J. Stinson, Louisville, Kentucky (associate, August 1926 to March 1928)

1928–1931: Hermann Wischmeyer, Louisville, Kentucky (associate, March 1928 to 1931)

1931–1936: Wischmeyer & Arrasmith, 1303–4 Heyburn Building, Louisville, Kentucky

1936–1945: Wischmeyer, Arrasmith & Elswick, 1303–4 Heyburn Building, Louisville, Kentucky (established July 1936; Arrasmith absent from the firm 1942 to 1945, firm dissolved 1945)

1945–1946: William S. Arrasmith, 2341 Carnegie Avenue, Cleveland, Ohio (sole practitioner and Greyhound employee)

1946–1950: W.S. Arrasmith, 1720 Euclid Avenue, Cleveland, Ohio (sole practitioner; E.W. Baldwin, chief engineer)

1950–1953: W.S. Arrasmith, 410 Lincoln Bank Building, Louisville, Kentucky (W.S. Arrasmith sole practitioner; A.C. Dick and W.B. Durand, associates; E.W. Baldwin, engineer)

1953–1956: W.S. Arrasmith & W.C. Tyler, Jr., Architects—E.W. Baldwin, Engineer, 200 Madrid Building, Louisville, Kentucky

1956–1958: Arrasmith & Tyler, Architects, 200 Madrid Building, Louisville, Kentucky

1958–1960: Arrasmith & Tyler, Architects, 501 Park Avenue, Louisville, Kentucky

1960–1963: W.S. Arrasmith, 501 Park Avenue, Louisville, Kentucky (sole practitioner)

1963–1965: Arrasmith, Judd & Associates, 501 Park Avenue, Louisville, Kentucky (William Strudwick Arrasmith died 1965)

1965–1988: Arrasmith, Judd, & Rapp, 501 Park Avenue, Louisville, Kentucky

1988–2003: Arrasmith, Judd, Rapp, Inc., 607 West Main Street, Louisville, Kentucky

2003–present: Arrasmith, Judd, Rapp, Chovan, Inc., 607 West Main Street, Louisville, Kentucky.

Greyhound Terminals Designed by W.S. Arrasmith

Pre–World War II Greyhound Terminals, 1937–1942

Louisville, Kentucky (1937)
Bowling Green, Kentucky (1937)
Jackson, Mississippi (circa 1938)
Ft Wayne, Indiana (1938)
Binghamton, New York (1938)
Evansville, Indiana (1939)
Washington D.C. (1940)
Erie, Pennsylvania (1940)
Columbus, Ohio (1940)

Dayton, Ohio (1940)
Atlanta, Georgia (1940)
Syracuse, New York (1941)
Buffalo, New York (1941)
Cincinnati, Ohio (1942)
Norfolk, Virginia (1942)
Baltimore, Maryland (1942)
Chicago, Illinois (1942—proposal)
Cleveland, Ohio (1942—proposal, see below)

Sources: Modern Bus Terminals & Post Houses (1940); E.W. Baldwin List of Principal Works; J.B. Speed Museum Exhibit—Arrasmith; Kentucky Library, Western Kentucky University; National Register of Historic Places; Arrasmith, Judd, Rapp.

Post–World War II Greyhound Terminals 1946–1959

1. Greyhound terminals and garages designed by W.S. Arrasmith, Cleveland, Ohio, office, 1945 to 1950. Sources: E.W. Baldwin List of Principal Works; J.B. Speed Museum Exhibit—Arrasmith; Kentucky Library, Western Kentucky University.

Hagerstown, Maryland (1946—proposal)
Boston, Massachusetts (1946—proposal)
Pittsburgh, Pennsylvania—garage & terminal renovation (1946)
Pittsburgh, Pennsylvania (1946—proposal)
Toledo, Ohio—garage (1947)
Cleveland, Ohio (1948)
Youngstown, Ohio—garage (1948)

Akron, Ohio (1949)
Battle Creek, Michigan (1949)
Grand Rapids, Michigan (1949)
Lima, Ohio—terminal & garage (1949)
Flint, Michigan (circa 1950)
Athens, Ohio (circa 1950)
Lansing, Michigan (1950)
Boston, Massachusetts (1950)

2. Greyhound terminals, buildings and garages designed by W.S. Arrasmith, Louisville office, 1950 to 1960. Sources: E.W. Baldwin List of Principal Works; The Kentucky Library, Bowling Green, Kentucky; Hummel & George Engineers, brochure; Anne Arrasmith-Lewis.

Birmingham, Alabama (1951)
Montgomery, Alabama (1951)
Louisville, Kentucky—garage (1951)
Harrisburg, Pennsylvania—garage (1952)
New York, New York—remodeled (1952)
Pontiac, Michigan (1952)
St. Paul, Minnesota—terminal and parking garage (1954)
Cincinnati, Ohio—garage (1955)
Philadelphia, Pennsylvania—terminal and transportation center (1955)

Corbin, Kentucky (1956)
Richmond, Virginia (1956)
Detroit, Michigan—terminal and parking garage (1957)
Bowling Green, Kentucky (1957)
Indianapolis, Indiana (1958—proposal)
Pittsburgh, Pennsylvania (1959)
Knoxville, Kentucky—terminal & express building (1959)
New Orleans, Louisiana (1960)

Note: The number of Greyhound terminals designed by W.S. Arrasmith is quoted by various sources, including the architect himself (The *Courier Journal*, May 26, 1957) as being up to 65. Although this number may in fact be accurate, it could not be confirmed by the author.

Other Works and Commissions

1. Works and commissions (other than Greyhound) listed in Architecture and Design 11, No. 10 (November 1938), Architectural Catalog Company, New York:

Louisville Municipal Airport (Bowman Field), KY (1929)

Scottish Rite Temple, Louisville, KY (1932)
Duncan Memorial Chapel, Floydsburg KY (1937)

Kentucky State Prison and Hospital, Danville, KY (associate architects)
Farm Credit Administration Building (remodel of Kosair Shrine Temple and Hotel, Louisville, KY)
Byck Brothers interior remodeling and 1st floor façade
Steiden Store and Shopping Center, Louisville, KY
Douglas Boulevard Christian Church
Harmony Landing Country Club
Owensboro Country Club
Harry Livingston Store
residence: Shelton Walkins, Cherokee Gardens, Louisville, KY
residence: Walter H. Girdler, Shelbyville, KY
residence: V.V. Cooke, Hunting Creek, Indian Hills
residence: Robert F. Cate, Cherokee Gardens, Louisville, KY
residence: W.M. Smock, Cherokee Gardens, Louisville, KY
residence: Henrietta Bingham

residence: R.A. Robinson III
residence: Robert F. Vaughan, Cherokee Gardens, Louisville, KY
residence: John Schaefer
residence: Walter Hampton, Cherokee Gardens, Louisville, KY
residence: Silas Starr, Cherokee Gardens, Louisville, KY
residence: Harry Williams, Lexington Road west of Garden Drive
residence: Dan C. Byck
residence: McKee Greer
residence: Val Frank Kimbel, 231 S Galt, Louisville, KY
residence: H.H. Kiesler
residence: A.E. Loeffler, Jr.
residence: Hugh Russell, Ashland, KY
residence: David Geiger, Ashland, KY
residence: Lee Wright Browning, Ashland, KY
residence: J.C. Miller, Ashland, KY
residence: C.V.P. Pond, Ashland, KY
residence: Alex Josselson, Ashland, KY

2. *Works and Commissions listed in J.B. Speed Museum Exhibit of W.S. Arrasmith's work, Louisville, Kentucky:*

Ohio Theater, Louisville, KY
Woolworth's Dime Store, Louisville, KY
Kentucky State Reformatory, LaGrange, KY (1938)
Reelfoot Lake Hotel, Tiptonville, TN
Jenny Lind Shop
Sylvania Electric Plant, Winchester, KY (1952)
Ashland Oil Company office building, Ashland, KY
Owensboro Country Club, Owensboro, KY
Memorial, New Brunswick, Canada
Western Kentucky University Margie Helm Library and dormitories, Bowling Green, KY
University Alumni Tower, Moorhead, KY
University of Louisville Natural Science Building, Louisville, KY (1952)

University of Louisville Medical-Dental Apartments, Louisville, KY
Whiskey Barrel Pontoon Bridge, Louisville, KY
U.S. Army Camp Atterbury, Columbus, IN
Methodist Evangelical Hospital
Farm Credit Bank
John Knox Presbyterian Church
Immanuel United Church of Christ, Louisville, KY
Duvalle School
Kentucky State Police Headquarters
Kentucky State Highway Headquarters KY
"The 800 Building" apartments, Louisville, KY (1960)

3. *Other commissions not listed above. Source: E.W. Baldwin List of Principal Works unless otherwise specified:*

Kentucky Hotel, Louisville, KY: widely credited to W.S. Arrasmith while with Brinton B. Davis ("Architects of Louisville," *The Filson Club History Quarterly* 61, No. 4 (October 1987).
Women's State Prison, Pine Bluff, KY (Report on a Standard N.C.A.R.B. Senior Examination, September 21, 1937)
Kentucky State Hospital, Lake Herrington, KY
Euclid Avenue Bank, Cleveland, OH—remodeling (circa 1949)
Lincoln (Preston St.) Bank, Louisville, KY (1951)
South End Federal Bank, Louisville, KY (1951)

Girdler Corporation, Louisville, KY (1952)
Buehner Fertilizer Company, Danville, KY (1952)
University of Louisville fire safety improvements (*Courier Journal*, December 24, 1952)
Joseph S. Cotter School (1953) (*Courier Journal*, March 4, 1953)
Louisville Produce Market, Louisville, KY (1954)
Highland Baptist Church, Louisville, KY (1954)
Clarksville High School, Clarksville, IN (1955)
Kentucky Air National Guard, Corps of Engineers Building, Standford Field, Louisville, KY (1955/7)

Kentucky State Hospital, addition, Danville, KY (1955)

E-Town Time Corp., Elizabethtown, KY (1955)

Kentucky Youth Authority, Lydon, KY (1955)

Jefferson Federal Bank, Louisville, KY (1955)

Fort Knox Housing, Corps of Engineers, Ft. Knox, KY (1956)

Heth-Washington School, Central, IN (1956)

Tri-City Oldsmobile, Louisville, KY (1956)

I.B.M. Office Building, Louisville, KY (1957)

First Federal Bank, Elizabethtown, KY (1957)

Lincoln (3rd St.) Bank, Louisville, KY (1957)

Reynolds Metals Company, Louisville, KY (1957)

Colonial Federal Savings & Loan Association (1958)

Kentucky State Reformatory Gymnasium, LaGrange, KY

Air National Guard Hanger, Frankfort, KY (1958)

Lee Air Terminal, Standford Field, Louisville, KY (1957)

Shopping Center, Louisville, KY (1958)

Kentucky State Office Building, Louisville, KY (1959)

Walgreen Drug Store & parking garage, Louisville, KY (1959)

General Electric Company office and warehouse, Louisville, KY (1960)

Town Hall, Chatham, New Brunswick (*The Courier Journal*, June 14, 1964)

Skating Rink, St. Johns, Newfoundland (*The Courier Journal*, June 14, 1964)

4. *W.S. Arrasmith, et al., commissions not listed elsewhere. Source: Archives of William B. Scott, Jr.:*

 a. Wischmeyer & Arrasmith commissions:

Reliance Varnish Company, Louisville, KY (1928)

Hancock Store, Louisville, KY (1929)

residence: Mr. Ballard, Louisville, KY (1929)

residence: Mr. Almstedt, Louisville, KY (1929)

residence: Mr. & Mrs. Flexner, Louisville, KY (1929)

Kings Daughter Hospital addition, Louisville, KY (1930)

Bowman Field addition, Louisville, KY (1931)

residence: Mr. & Mrs. Humphry, Louisville, KY (1931)

Byck Building, Louisville, KY (1932)

residence: Mr. & Mrs. Tarrant, Louisville, KY (1933)

FGA Garage, Louisville, KY (1935)

residence: Mr. & Mrs. Armstrong, Louisville, KY (1935)

residence: Mr. & Mrs. Greer, Louisville, KY (1936)

 b. Wischmeyer, Arrasmith & Elswick commissions:

Bowman Field, addition, Louisville, KY (1936)

Brandeis Machine & Supply Co., Louisville, KY (1936)

Memorial, Robert Gast Bowman, Louisville, KY (1936)

residence: Mr. & Mrs. Embry, Louisville, KY (1936)

residence: Mr. & Mrs. Smith, Frankfort, KY (1936)

Reliance Varnish Company, Louisville, KY (1937)

Federal Land Bank, alterations, Louisville, KY (1937)

residence: Mr. & Mrs. Carrier, Jr., Harolds Creek, KY (1937)

residence: Dorsey Washington Brown, log cabin, Louisville, KY (1937)

Massachusetts Mutual Life Insurance Co., Louisville, KY (1938)

residence: Mr. & Mrs. Grooms, Louisville, KY (1938)

residence: Mr. & Mrs. Hamlett, Columbia, KY (1938)

residence: Mr. & Mrs. Smith, Louisville, KY (1938)

residence: Mr. & Mrs. Gerst, Louisville, KY (1938)

residence: Mr. & Mrs. Cornett, Louisville, KY (1938)

F.W. Woolworth store, Louisville, KY (1939)

Brick Plant building, Louisville, KY (1939)

Williams Property Development, Bowling Green, KY (1939)

Standard Foods Inc. building, Louisville, KY (1939)

residence: Mr. & Mrs. Egger, Anchorage, KY (1939)

residence: Mr. & Mrs. Wile, Lexington, KY (1939)

residence: Mr. & Mrs. Owen, Louisville, KY (1939)

residence: Mr. & Mrs. McCormick, Louisville, KY (1939)

residence: Mr. & Mrs. Bingham, Louisville, KY (1939)

residence: Helm Bruce, Cherokee Gardens, Louisville, KY (1939)

Aetan Oil service building, alterations, Louisville, KY (1940)

Aetan Oil service station, Louisville, KY (1940)

Capital Laundry building, Ft. Knox, KY (1940)

Reliance Varnish Company, addition, Louisville, KY (1940)

residence: Mr. & Mrs. Riker, Haroldsburg, KY (1940)

residence: Mr. & Mrs. Castleman, Louisville, KY (1940)

residence: Mr. & Mrs. Hundley, Louisville, KY (1940)

residence: Mr. & Mrs. Parsons, Ashland, KY (1940)

residence: Mr. & Mrs. Fahey, Louisville, KY (1940)

residence: Mr. & Mrs. Thompson, Louisville, KY (1940)

Frank Fehr Brewery, Louisville, KY (1941)

Blue Boar Cafeteria, Louisville, KY (1941)

River Bluff Farms Building, Oldham County, KY (1941)

Plainview Farms Dairy, addition (1941)

Eppley Hotel Night Club, Louisville, KY (1941)

Seelback Hotel, Louisville, KY (1941)

Capital Laundry, addition, Louisville, KY (1941)

residence: Carl Mock, Ashland, KY (1941)

residence: Mr. & Mrs. Herschedes, Mt. Washington, OH (1941)

residence: Mr. & Mrs. McLemore, Jr., Louisville, KY (1941)

residence: Mr. & Mrs. Humphrey, Louisville, KY (1941)

Reliance Varnish Company resin kettle building, Louisville, KY (1942)

Oldsmobile dealership, Louisville, KY (1945)

Byck Store, St. Matthews, KY (1946)

Chapter Notes

Part I—One.

1. Genealogical listings, Arrasmith Family Chart and History.
2. Author's interview with Mrs. Elizabeth Arrasmith and daughter, Anne Arrasmith-Lewis, Louisville, Kentucky, October 27, 1988.
3. Commonwealth of Kentucky State Board of Examiners and Registration of Architects, Application For Registration as Registered Architect, William Strudwick Arrasmith, September 17, 1930, and July 13, 1937.
4. Ibid.; Arrasmith, Arrasmith-Lewis interview.
5. Commonwealth of Kentucky State Board of Examiners and Registration of Architects.
6. Ibid.
7. Author's interview with Ed Baldwin and Stratton Hammon, Louisville, Kentucky, October 27, 1988.
8. Ibid.; *The Baseball Encyclopedia*, 8th ed. New York: Macmillan (1990); 1921 *Illio*, University of Illinois yearbook; 1922 *Illio*, University of Illinois yearbook; 1923 *Illio*, University of Illinois yearbook.
9. Ibid.
10. Baldwin, Hammon interview.
11. "Baseball," *Biographical Dictionary of American Sports*, ed. David L. Porter. Westport, CT: Greenwood Press (1987).
12. Baldwin, Hammon interview.
13. Arrasmith, Arrasmith-Lewis interview; Baldwin, Hammon interview.
14. Arrasmith, Arrasmith-Lewis interview; Commonwealth of Kentucky State Board of Examiners and Registration of Architects.
15. Arrasmith, Arrasmith-Lewis interview.
16. Baldwin, Hammon interview.
17. Arrasmith, Arrasmith-Lewis interview; Baldwin, Hammon interview; *Baseball Encyclopedia*.
18. Commonwealth of Kentucky State Board of Examiners and Registration of Architects.

Two.

1. Author's interview with Ed Baldwin and Stratton Hammon, Louisville, Kentucky, October 27, 1988; author's interview with Mrs. Elizabeth Arrasmith and daughter, Anne Arrasmith-Lewis, Louisville, Kentucky, October 27, 1988, and July 20, 1989.
2. Commonwealth of Kentucky State Board of Examiners and Registration of Architects, Application for Registration as Registered Architect, William Strudwick Arrasmith, September 17, 1930, and July 13, 1937.
3. Baldwin, Hammon interview; Arrasmith, Arrasmith-Lewis interview.
4. Baldwin, Hammon interview; Arrasmith, Arrasmith-Lewis interview.
5. Commonwealth of Kentucky State Board of Examiners and Registration of Architects, Application For Registration as Registered Architect, Brinton B. Davis, November 4, 1930.
6. Ibid.
7. Author's interview with Ed Baldwin, Louisville, Kentucky, October 27, 1988.
8. "Architecture," address by Brinton B. Davis at meeting of the Kentucky Chapter, American Institute of Architects, January 7, 1937.
9. Ibid.
10. Baldwin interview.
11. Baldwin, Hammon interview; Arrasmith, Arrasmith-Lewis interview.
12. Arrasmith, Arrasmith-Lewis interview, October 27, 1988.
13. Commonwealth of Kentucky State Board of Examiners and Registration of Architects, Arrasmith application.
14. Ibid.; Arrasmith, Arrasmith-Lewis interview, October 27, 1988.
15. Arrasmith, Arrasmith-Lewis interview, October 27, 1988.
16. State Board of Examiners and Registration of Architects of Kentucky, Application For Registration as Registered Architect, Hermann Wischmeyer September 17, 1930.
17. Commonwealth of Kentucky State Board of Examiners and Registration of Architects, Arrasmith application; State Board of Examiners and Registration of Architects of Kentucky, Wischmeyer application.
18. Baldwin interview.
19. Baldwin, Hammon interview; Arrasmith, Arrasmith-Lewis interview; Baldwin interview.

Three.

1. Commonwealth of Kentucky, State Board of Examiners and Registration of Architects, Application for Registration as Registered Architect, William Strud-

wick Arrasmith, September 17, 1930; Commonwealth of Kentucky, State Board of Examiners and Registration of Architects, Application For Registration as Registered Architect, Hermann Wischmeyer, September 17, 1930.

2. Ibid.

3. Author's interview with Stratton Hammon, Louisville, Kentucky, October 27, 1988.

4. Ibid.

5. Ibid.; Commonwealth of Kentucky, State Board of Examiners and Registration of Architects, Application for Registration as Registered Architect, William Strudwick Arrasmith, September 17, 1930 and July 13, 1937.

6. Hammon interview.

7. Ibid.

8. Letter from C. Julian Oberwarth to W.S. Arrasmith, October 4, 1930, commending him on his design for the Certificate of Registration for the State Board of Examiners and Registration of Architects of Kentucky.

9. Letters from W.S. Arrasmith to C. Julian Oberwarth regarding delinquent dues: May 12, 1933, January 18, 1935, January 19, 1935, January 25, 1935.

10. Ibid.

11. Letters from C. Julian Oberwarth to W.S. Arrasmith relative to annual renewal fee arrearage for Kentucky Architectural Registration: November 11, 1931; December 15, 1931; September 3, 1932; September 19, 1932; September 23, 1932; March 28, 1933; May 4, 1933, November 13, 1933; January 15, 1935, January 21, 1935; January 26, 1935.

12. Hammon interview.

Four.

1. Author's interview with Stratton Hammon, Louisville, Kentucky, October 27, 1988.

2. Commonwealth of Kentucky, State Board of Examiners and Registration of Architects, Application For Registration as Registered Architect, Frederick Hoyt Elswick, September 17, 1930.

3. Hammon interview.

4. Ibid.; author's interview with Ed Baldwin and Stratton Hammon, Louisville, Kentucky, October 27, 1988.

5. Baldwin, Hammon interview.

6. Ibid.; author's interview with Ed Baldwin, Louisville, Kentucky, October 27, 1988.

7. Ibid.

8. Author's interview with Cornelius Hubbuch, Louisville, Kentucky, October 27, 1988.

9. Ibid.; Baldwin, Hammon interview; Baldwin interview.

10. Hammon interview; Baldwin interview.

Five.

1. Author's interview with Ed Baldwin and Stratton Hammon, October 27, 1988.

2. Railroad and Bus Terminal and Station Layout, American Locker Company (1945).

3. Ibid.

4. Author's interview with Ed Baldwin, Louisville, Kentucky, October 27, 1988.

5. Author's interview with Cornelius Hubbuch, Louisville, Kentucky, October 27, 1988.

6. National Council of Architectural Registration Boards, Experience and Record in Professional Practice, Senior Classification, William Strudwick Arrasmith, September 29, 1937.

7. Ibid.

8. Ibid.

9. Author's interview with Stratton Hammon, Louisville, Kentucky, October 27, 1988.

10. State of Ohio, State Board of Examiners of Architects, letter to W.S. Arrasmith, August 11, 1937.

11. Ossian P. Ward, secretary, Kentucky Chapter A.I.A., letter to Wischmeyer, Arrasmith & Elswick, December 30, 1937.

12. Baldwin, Hammon interview.

13. Ibid.

14. Ibid.; National Council of Architectural Registration Boards, Experience and Record in Professional Practice; Harry S. Pack and W.S. Arrasmith, "Bus Terminal Design," *Architectural Record*, October 1941. Harry S. Pack was born in 1904. He was employed by Henry Dryfus in 1936 and subsequently, after having worked for one year in the General Motors styling department, he formed his own industrial design firm in 1939. Among his firm's clients were Trailways Bus Company, Penn Central Airlines, and American Airlines. He is currently retired and living in Florida.

Six.

1. *Courier Journal* (Louisville, Kentucky), January 19, 1937.

2. Author's interview with Stratton Hammon, Louisville, Kentucky, October 27, 1988; author's interview with Ed Baldwin, Louisville, Kentucky, October 27, 1988; author's interview with Mrs. Elizabeth Arrasmith and daughter, Anne Arrasmith-Lewis, Louisville, Kentucky, October 27, 1988.

3. Arrasmith, Arrasmith-Lewis interview.

4. Ibid.

5. Ibid.

6. Ibid.

Seven.

1. Author's interview with Ed Baldwin, Louisville, Kentucky, October 27, 1988; author's interview with Mrs. Elizabeth Arrasmith and daughter, Anne Arrasmith-Lewis, Louisville, Kentucky, October 27, 1988.

2. Obituary of Hermann Wischmeyer, *Courier Journal* (Louisville, Kentucky), May 27, 1945; Baldwin interview; Arrasmith, Arrasmith-Lewis interview.

3. Baldwin interview.

4. Letterhead stationary, 2341 Carnegie Avenue, Cleveland, Ohio.

5. Letterhead stationary, 1720 Euclid Avenue, Cleveland, Ohio.

6. Baldwin interview.

7. Ed Baldwin Letters—File #3: 1st installment March 25, 1998; 2nd installment May 8, 1998; 3rd installment, June 3, 1998.

8. Ibid.

9. Baldwin interview.
10. Baldwin letters.
11. Ibid.
12. Baldwin interview.
13. Ibid.
14. Ibid.
15. Author's interview with William B. Morris, Cleveland, Ohio, 1989.

Eight.

1. Author's interview with Ed Baldwin, Louisville, Kentucky, October 27, 1988.
2. Ibid.; "Greyhound Terminal To Be Dedicated Tuesday," *Akron* (Ohio) *Beacon Journal*, February 14, 1949.
3. Baldwin interview.
4. Ed Baldwin letters—File #3: 1st installment, March 25, 1998; 2nd installment, May 8, 1998; 3rd installment, June 3, 1998.
5. Baldwin interview.
6. Greyhound Terminals and garages designed by W.S. Arrasmith Cleveland Office 1945 to 1950, Ed Baldwin List of Principal Works.

Nine.

1. Ed Baldwin Letters—File #3: 1st installment, March 25, 1998; 2nd installment, May 8, 1998; 3rd installment, June 3, 1998.
2. Author's interview with Ed Baldwin, Louisville, Kentucky, October 27, 1988.
3. Ibid.
4. Baldwin letters.
5. Baldwin interview.
6. Baldwin letters; Baldwin interview.
7. Oscar Schisgall, *The Greyhound Story: From Hibbing to Everywhere* (New York: Doubleday, 1985).
8. Baldwin letters; Baldwin interview.
9. Baldwin letters; Baldwin interview.
10. Baldwin interview.

Ten.

1. Ed Baldwin Letters—File #3: 1st installment, March 25, 1998; 2nd installment May 8, 1998; 3rd installment June 3, 1998
2. Author's interview with Ed Baldwin, Louisville, Kentucky, October 27, 1988
3. Baldwin letters; Baldwin interview.
4. Baldwin letters; Baldwin interview.
5. Baldwin letters; Baldwin interview.
6. Ed Baldwin curriculum vitae.
7. Author's interview with Arnold Judd, October 27, 1988.
8. Ibid.
9. Obituary, W.S. Arrasmith, Courier *Journal* (Louisville, Kentucky), December 1, 1965.
10. Author's interview with Graham Rapp, Louisville, Kentucky, October 27, 1988.

Part II—Eleven.

1. Oscar Schisgall, *The Greyhound Story: From Hibbing to Everywhere* (New York: Doubleday, 1985).

Twelve.

1. Oscar Schisgall, *The Greyhound Story: From Hibbing to Everywhere* (New York: Doubleday, 1985).
2. "Plans Being Drafted For New Bus Depot At 8th And Robert," *St. Paul Dispatch*, October 7, 1948.
3. Motor Transport Terminals—Busses, Trucks and Architecture, John S. Worley (1941)
4. Harry S. Pack and W.S. Arrasmith, "Bus Terminal Design," *Architectural Record*, October 1941.

Thirteen.

1. Raymond Loewy, *Industrial Design* (Woodstock, NY: Overlook Press, 1979).
2. Jeffrey Meikle, *Twentieth Century Limited: Industrial Design in America 1925–1939* (Philadelphia: Temple University Press, 1979).
3. Angel Schonberger, *Raymond Loewy: Pioneer of American Industrial Design* (Munich: Prestel-Verlag, 1990).

Fourteen.

1. Rendering, Greyhound terminal, Cleveland, Ohio, W.S. Arrasmith (1946); rendering, Greyhound terminal, Akron, Ohio, W.S. Arrasmith (1947); rendering, Greyhound terminal, Hagerstown Maryland (proposed), S. Arthur (1946)

Fifteen.

1. "Greatest Bus Terminal in World to Open in City Tomorrow," *Cleveland News*, March 30, 1948, Special Greyhound Section.
2. Ibid.
3. "Ceremonies to Open New $300,000 Greyhound Bus Terminal, Dec 20th," *Lansing* (Michigan) *Star Journal*, December 19, 1950.
4. "Bus Station Opened in Formal Ceremony," *The Enquirer & News*, (Battle Creek, Michigan), June 14, 1949.

Part III

1937 Louisville, Kentucky

"Greyhound Terminal's Gala Opening Set for Wednesday," *Courier Journal*, (Louisville, Kentucky), April 28, 1937; Railroad and Bus Terminal and Station Layout, "Louisville, Kentucky," American Locker Company (1945); "Greyhound Says No Decision Yet for New Site or Any Construction," *Courier Journal*, August 1, 1959; "Greyhound Will Remain at Same Site," *Courier Journal*, September 22, 1959; "Greyhound,

Urban Renewal Study New Bus Station Site on Walnut," *Courier Journal*, August 10, 1967.

1937 Bowling Green, Kentucky

"Bus Terminal to be Erected Here," *Park City Daily News*, Bowling Green, Kentucky, September 10, 1936; "Bus Station to be Opened on Wednesday," *Park City Daily News*, March 23, 1937; "To Dedicate Bus Station Here Tonight," *Park City Daily News*, (1937); Kentucky State Firemen's Association "Welcome" flier, Bowling Green, Kentucky, September 11, 1948; "Proposed Bus Station," *Park City Daily News*, Bowling Green, Kentucky, March 31, 1957.

1938 Jackson, Mississippi

"Greyhound Wants to Relocate its City Station," *Clarion-Ledger*, (Jackson, Mississippi), July 26, 1982; "Old Bus Station May Soon Retire," *Clarion-Ledger*, April 29, 1986; "Greyhound May Leave Downtown," *Clarion-Ledger*, August 28, 1986; "Bus Station: Eyesore or Landmark?" *Clarion-Ledger*, November 4, 1986; "Bank Official Unsure of Bus Station Future," *Clarion-Ledger*, February 5, 1987; "Irish Eyes are Hoping to Save Old Bus Station with Parade," *Clarion-Ledger*, February 21, 1987; "Merger Means New Bus Station Will Go Unused," *Clarion-Ledger*, August 6, 1987; "An Old Dog Gets New Life," *Clarion-Ledger*, December 28, 1988; "Wall-to-wall Flashback," *Clarion-Ledger*, August 8, 1989; "Adaptive Reuse of Older Buildings an Office Space Trend," *Clarion-Ledger*, February 7, 1994; notes of author's interview of Robert Park Adams, architect, owner, Greyhound station, Jackson, Mississippi, August 2002; "Interiors & Exteriors, The Greyhound Bus Terminal," *The New Southern View*, Spring 2002.

1938 Fort Wayne, Indiana

"Site is Leased for $65,000 Bus Terminal," *Fort Wayne News Sentinel*, February 1, 1938; "Commission Seeks Future Possibilities for Redevelopment," *Fort Wayne News Sentinel*, January 20, 1992; "Bus Station Razing Comes as Surprise," *Fort Wayne News Sentinel*, May 9, 1992; "Lack of Interest Prompted Razing of Depot," *Fort Wayne News Sentinel*, May 12, 1992; "With No Plans for Use, Depot's Fate Was Sealed," *Fort Wayne News Sentinel*, May 12, 1992; "All Was Not Lost When Greyhound Was Razed," *Fort Wayne News Sentinel*, May 14, 1992; "Historic Buildings Link a City to its Past," *Fort Wayne News Sentinel*, May 26, 1992; "We're Demolishing Art," *Fort Wayne News Sentinel*, May 26, 1992; "ARCH Lists Structures it Wants Saved," *Fort Wayne News Sentinel*, June 9, 1992; "Save Special Buildings," *Fort Wayne News Sentinel*, September 9, 1992.

1938 Binghamton, New York

"Greyhound Bus Station, Chenango St.," L.L. Cole Collection, Broome County Historical Society, Binghamton, New York.

1939 Evansville, Indiana

"Bus Terminal," *Evansville* (Indiana) *Press*, November 18 and September 2, 1937; "Work on Bus Terminal to Begin in June," *Evansville Press*, November 4, 1937; What Cadick Corner Will Look Like Soon," *Evansville Press*, November 7, 1937; "Workmen Busy at Bus Station Site," *Evansville Press*, May, 25, 1938; "Cadick Walls Come Tumbling Down," *Evansville Press*, May 27, 1938; "George L. Mesker & Co. Steel Work in Greyhound Terminal," *Evansville* (Indiana) *Courier*, January 16, 1939; Railroad and Bus Terminal and Station Layout, "Evansville, Indiana," American Locker Company (1945); "Deco Depot isn't Going to Dogs," *Evansville Press*, August 9, 1978; National Register of Historic Places, Greyhound Bus Terminal, Evansville, Indiana, October 1, 1979; "Greyhound May Franchise its Terminal in Evansville," *Evansville Courier Journal*, October 30, 1985; "This Depot is Worth the Trip," *Evansville Courier Journal*, November 16, 1985; "Going ... Once Bustling Bus Depot," *Evansville Press*, February 20, 1986; "Greyhound Ready to Rededicate Depot," *Evansville Press*, March 19, 1988.

1940 Washington, D.C.

Railroad and Bus Terminal and Station Layout, "Washington, D.C.," American Locker Company (1945); Joint Committee on Landmarks of the National Capitol, Application Form Historic Landmark, Washington, D.C., Greyhound Terminal, February 21, 1984; "Great Greyhound at Bay," *Society for Commercial Archeology News Journal*, April 1985; "D.C. Designates 'Slip-covered' Bus Station a Landmark," *Preservation News*, March 1987; "Preservationists OK New Greyhound Scheme," *Preservation News*, September 1987; "Greyhound Plan Gets Final Okay," *Preservation News*, October 1988; "Manufacturers Uncovers Historic Greyhound Bus Terminal," Manufacturers Life Insurance Company, January 31, 1989; Letter from Keyes Condon Florance, Architects, January 31, 1989; "Praised by Preservationists—Manufacturers Goes Deco," *Site Lines*, Manufacturers Real Estate, circa 1990; "The Dignified Depot," *Washington Post*, September 14, 1991; "What a Swell Ride it Was," *Newsweek*, October 14, 1991; "A Rare and Successful Alliance," *Historic Preservation News*, November 1991; 1100 New York Avenue, Washington, D.C., Keyes Condon Florance, Architects, circa 1991.

1940 Erie, Pennsylvania

"Officials Open Modern Erie Greyhound," *Erie* (Pennsylvania) *Daily Times*, March 22, 1940.

1940 Columbus, Ohio

"Bus Terminal Contract is Let," *Ohio State Journal*, (Columbus), August 9, 1939; Railroad and Bus Terminal and Station Layout, "Columbus, Ohio," American Locker Company (1945).

1940 Dayton, Ohio

Railroad and Bus Terminal and Station Layout, "Dayton, Ohio," American Locker Company (1945).

1940 Atlanta, Georgia

"World's Safest Record is Held by Greyhound," *Atlanta Constitution*, August 29, 1940; Railroad and Bus

Terminal and Station Layout, "Atlanta Greyhound Bus Terminal," American Locker Company (1945).

1941 Syracuse, New York

"Work Starts Oct. 1 on New Bus Terminal," *Syracuse* (New York) *Herald American*, August 25, 1940; "Bus Station Contract Let," *Syracuse Herald American*, October 22, 1940. "Bus Terminal Plans Receive ICC Approval," *Syracuse Herald American*, December 8, 1940; "New $250,000 Bus Terminal Set to Open," *Syracuse Herald Journal*, May 20, 1941, Railroad and Bus Terminal and Station Layout, "Syracuse, New York," American Locker Company, (1945); "City Offers Adams St. Site for New Greyhound Depot," *Syracuse Post Standard*, February 23, 1964.

1941 Buffalo, New York

"New Terminal to be Erected By Greyhound," *Buffalo* (New York) *Courier-Express*, August 18, 1940; "Greyhound Bus Terminal Will Open Tuesday," *Buffalo Courier-Express*, April 27, 1941; Railroad and Bus Terminal and Station Layout, "Buffalo, New York," American Locker Company (1945); Sanborn Atlas, Vol. 1, Buffalo, New York (New York: Sanborn Map Company, 1963).

1942 Cincinnati, Ohio

"Plans for New Bus Terminal Near Completion," *Cincinnati* (Ohio) *Times Star*, circa 1941; "New Greyhound Terminal is on Historic Transportation Site," *Cincinnati Times Star*, June 1942; "Queen City's New Bus Terminal," *Cincinnati Enquirer*, June 10, 1942; Railroad and Bus Terminal and Station Layout, "Cincinnati, Ohio," American Locker Company (1945).

1942 Norfolk, Virginia

"Greyhound Bus Terminal Will Open August 1," *Ledger Star* (Norfolk, Virginia), July 21, 1942; "Public Invited to Greyhound Station Today," *Ledger Star*, July 31, 1942.

1942 Baltimore, Maryland

"Bus Terminal is Open," *Baltimore* (Maryland) *Evening Sun*, November 30, 1942; "Greyhound Lines Begins Schedules at New Terminal," *Baltimore Sun*, December 1, 1942; "Baltimore Greyhound Bus Terminal," *Pencil Points*, July 1945; Railroad and Bus Terminals and Station Layout, "Baltimore Greyhound Terminal," American Locker Company (1945); "Regional Council Moves to Old Greyhound Station," *Baltimore Sun*, July 17, 1991; "Greyhound Site Awaits Art's Arrival," *Baltimore Sun*, October 13, 1994; "Historical Society Plans Annex," *Baltimore Sun*, June 22, 1995.

1942 Chicago, Illinois (Proposed)

Renderings by Wischmeyer, Arrasmith & Elswick (1942).

1946 Hagerstown, Maryland (Proposed)

Rendering by W.S. Arrasmith, Architect.

1948 Cleveland, Ohio

Architectural drawings, W.S. Arrasmith, Greyhound Terminal, Cleveland, Ohio, Arrasmith, Judd, Rapp (1946); City of Cleveland Division of Buildings files, Greyhound Application for Permit, New Structure, July 1, 1946; City of Cleveland Division of Buildings files, Greyhound, Miscellaneous; "Greyhound Depot to Open in March," *Cleveland* (Ohio) *Plain Dealer*, February 14, 1948; "Greatest Bus Terminal in World to Open in City Tomorrow," Special Greyhound Section, *Cleveland News*, March 30, 1948; "Greyhound Bus Terminal faces 'dangerous moment,'" *Habitat*, May 29-June 4, 1987; "The Forgotten Forties," Wilma Salisbury, *Cleveland Plain Dealer Magazine*, May 8, 1988; "The Million Dollar Futuristic Streamline Baby," Cleveland Edition, *Cleveland Plain Dealer*, February 1–7, 1990; "New Script for Bus Terminal," *Crain's Cleveland Business*, June 25, 1990; National Register of Historic Places, Cleveland, Ohio, Greyhound Terminal, December 2, 1990; "Greyhound Station Recycling Ideas Running Wild," *Cleveland Plain Dealer*, May 19, 1991; "Bus Station Sale Likely to Kill Apartment Project," *Crain's Cleveland Business*, November 4, 1991; National Register of Historic Places, Greyhound Bus Station, Cleveland, Ohio, File Name NRO319.bap (1991); "Bus Station Gets Face Lift," *Cleveland Plain Dealer*, March 2, 2000; "Greyhound Restores Cleveland Bus Terminal to its Former Architectural Glory," *Properties Magazine*, May 2000.

1949 Akron, Ohio

"Greyhound Terminal To Be Dedicated Tuesday," *Akron* (Ohio) *Beacon Journal*, February 14, 1949; "Revisiting History," *Akron Beacon Journal*, October 9, 2000.

1949 Battle Creek, Michigan

"New Inter-City Bus Station Will Open for Operation Tuesday," *The Enquirer & News*, (Battle Creek, Michigan), June 13, 1949; "Bus Station Opened In Formal Ceremony," *The Enquirer & News*, June 14, 1949.

1949 Grand Rapids, Michigan

"New Bus Station to Open in 30 Days," *Grand Rapids* (Michigan) *Press*, August 17, 1949.

1949 Lima, Ohio

"Greyhound to Move to its New Terminal on N. West St. in Ceremonies Today," *Lima News*, August 14, 1949; "Bus Terminal Move Delayed Until Friday," *Lima News*, August 15, 1949; "Greyhound Depot to Open Thursday," *Lima News*, August 17, 1949, pages 8 through 11.

1950 Lansing, Michigan

"Ceremonies to Open New $300,000 Greyhound Bus Terminal, Dec. 20," *Lansing* (Michigan) *State Journal*, December 19, 1950.

1950 Boston, Massachusetts

Rendering by W.S. Arrasmith, Architect (1949)

1951 Birmingham, Alabama

"Greyhound Bus Lines Open One of Nation's Finest Depots Here," *Birmingham* (Alabama) *News*, January 31, 1951.

1954 St. Paul, Minnesota

"Plans Being Drafted For New Bus Depot At 8th And Robert," October 7, 1948; "Bus Line, City Officials Work on Plan," *St. Paul Dispatch*, November 3, 1948; "Lund Favors New Bus Depot Site," *St. Paul Dispatch*, May 21, 1949; "New Bus Depot To Open April 1," *St. Paul Pioneer Press*, 2nd News Section, March 14, 1954.

1959 Pittsburgh, Pennsylvania

"Greyhound's New Look," *Pittsburgh* (Pennsylvania) *Sun-Telegraph*, June 26, 1959; "Greyhound Opens New Depot Here," *Pittsburgh Sun-Telegraph*, December 10, 1959.

Sources

This bibliography of research sources is arranged by topic.

William Strudwick Arrasmith

Personal information regarding his life, education, family, military career, and similar matters:

Arrasmith Family Chart and History.

Arrasmith, Elizabeth, and Anne Arrasmith-Lewis. Interview with author, Louisville, Kentucky, October 27, 1988, and July 20, 1989.

Arrasmith, W. S. World War II Diary. Transcribed by Anne Arrasmith-Lewis.

Baldwin, Ed. Interview with author, Louisville, Kentucky, October 27, 1988.

_____. Letters. File #1—November 6, 1988; June 2, 1991; November 6, 1991. File #2—July 17, 1997; October 15, 1997; December 7 to 14, 1997; February 5, 1998. File #3—1st, 2nd, 3rd Installments, March 25, 1998; May 8, 1998; June 3, 1998. File #4—June 29, 1998; August 30, 1998; April 8, 1999. File #5—February 7, 2001; June 22, 2002.

_____. Letter, November 20, 1988.

Hammon, Stratton. Interview with author, Louisville, Kentucky, October 27, 1988.

"A History of the Department of General Engineering." Urbana: University of Illinois, 1968.

Hubbuch, Cornelius. Interview with author, Louisville, Kentucky, October 27, 1988.

The Illio (Yearbook of the University of Illinois), 1922. Urbana: University of Illinois, 1922. Pages 66, 200, 514, 515.

Johnson, Henry C. *Teachers for the Prairie: The University of Illinois, 1869–1945*. Urbana: University of Illinois Press, 1972.

Judd, Arnold. Interview with author, Louisville, Kentucky, October 27, 1988.

Morris, William B. Interview with author, Cleveland, Ohio, 1989.

Obituary of W.S. Arrasmith. *Courier Journal* (Louisville), December 1, 1965.

Professional information regarding his curriculum vitae, professional qualifications, architectural career, associates and staff:

Arrasmith, W.S. "Time Saver Standards," *Architectural Record*, October 1941.

_____. Letters to C. Julian Oberwarth, May 12, 1933; January 18, 1935; January 19, 1935; January 25, 1935. Archives of William B. Scott, Jr.

_____. Letter to L.K. Frankel, August 10, 1945. Archives of William B. Scott, Jr.

_____. Letters to J.T. Gilligan, Kentucky State Board of Examiners and Registration of Architects, September 19, 1950; October 9, 1950. Archives of William B. Scott, Jr.

Baldwin, Ed. Letter, June 2, 1991.

_____. Letter, July 17, 1997, Inclusion #5, "Speech Given by E.W. Baldwin at the Kaden Tower, Louisville, Kentucky, October 23, 1992."

_____. Letter, July 17, 1997, Inclusion #6, "Let's Get Down and Really Talk About Architecture in Louisville," *Courier Journal* (Louisville), July 30, 1992.

_____. Letters, December 7 to 14, 1997.

_____. Letter, February 5, 1998.

_____. List of Principal Works from the Office of Arrasmith & Tyler, Architects & Engineers, Louisville, Kentucky

Burleigh, Manfred, and Charles M. Adams, eds. *Modern Bus Terminals & Post Houses.* Ypsilanti, MI: University Lithoprinters, 1941.

"Bus Terminal Design and Construction," *Architectural Record*, October 1941.

Collector's Pictorial History, Bowman Field (1994).

Commonwealth of Kentucky State Board of Examiners and Registration of Architects. Application For Registration as Registered Architect, William Strudwick Arrasmith, September 17, 1930, and July 13, 1937. Archives of William B. Scott, Jr.

_____. Application For Registration as Registered Architect, Hermann Wischmeyer, September 17, 1930. Archives of William B. Scott, Jr.

_____. Letters to W.S. Arrasmith, June 13, 1933; August 12, 1933; and, October 8, 1933; July 11, 1934. Archives of William B. Scott, Jr.

_____. Letter to W.S. Arrasmith, September 9, 1937. Archives of William B. Scott, Jr.

_____. Letter to William S. Arrasmith, September 21, 1937. Report on Standard N.C.A.R.B. Senior Examination. Archives of William B. Scott, Jr.

_____. Letter to W.S. Arrasmith, September 30, 1937. Archives of William B. Scott, Jr.

_____. Certification of Registration of W.S. Arrasmith, October 1, 1937. Archives of William B. Scott, Jr.

_____. Letters from L.K. Frankel to W.S. Arrasmith: July 17, 1945; August 9,1945; August 13, 1945. Archives of William B. Scott, Jr.

Courier Journal (Louisville), May 26, 1957.

_____. October 2, 1959.

Hammon, Stratton. Letter, October 29, 1991.

Judd, Arnold. Interview with author, October 27, 1988.

"Large Terminal With Paying Concessions—Washington, D.C.," *Architectural Record*, October 1941.

"Motor Transport Terminals, Buses, Trucks and Architecture," *Architectural Record*, October 1941.

National Council of Architectural Registration Boards. Experience and Record in Professional Practice, Senior Classification, William Strudwick Arrasmith, September 29, 1937. Archives of William B. Scott, Jr.

_____. Letter to L.K. Frankel, Kentucky State Board of Examiners, regarding W.S. Arrasmith, September 3, 1946. Archives of William B. Scott, Jr.

National Register of Historic Places. Bowman Field, Louisville, Kentucky (1988).

Oberwarth, C. Julian. Letter to R.C. Kempton, August 31, 1937. Archives of William B. Scott, Jr.

_____. Letter, October 30, 1937. Archives of William B. Scott, Jr.

_____. Letter to W.S. Arrasmith, October 4, 1930. Archives of William B. Scott, Jr.

_____. Letter to W.S. Arrasmith, October 16, 1930. Archives of William B. Scott, Jr.

_____. Letters to W.S. Arrasmith, November 11, 1931; December 15, 1931; September 3, 1932; September 19, 1932; September 23, 1932; March 28, 1933; and, May 4, 1933; November 13, 1933; January 15, 1935; January 21, 1935; January 26, 1935. Archives of William B. Scott, Jr.

_____, and William B. Scott, Jr. *A History of the Profession of Architecture in Kentucky*. Louisville, KY: Gateway Press, 1987.

Rapp, Graham. Interview with author, October 27, 1988.

State of Ohio, State Board of Examiners of Architects. Letter to W.S. Arrasmith, August 11, 1937. Archives of William B. Scott, Jr.

_____. Letter to C. Julian Oberwarth, August 18, 1937. Archives of William B. Scott, Jr.

_____. Letter to R.C. Kempton, August 20, 1937. Archives of William B. Scott, Jr.

_____. Letter to W.S. Arrasmith, August 30, 1937. Archives of William B. Scott, Jr.

_____. Letter to C. Julian Oberwarth, September 2, 1937. Archives of William B. Scott, Jr.

_____. Letter, November 15, 1937. Archives of William B. Scott, Jr.

Ward, Ossian P., secretary, Kentucky Chapter A.I.A. Letter to Wischmeyer, Arrasmith & Elswick, December 30, 1937. Archives of William B. Scott, Jr.

Hermann Wischmeyer

Commonwealth of Kentucky, State Board of Examiners and Registration of Architects of Kentucky. Letter, October 17, 1930. Archives of William B. Scott, Jr.

"Hermann Wischmeyer," *History of Kentucky*, vol. IV (Chicago: S.J. Clark & Co., 1928) page 783.

Obituary of Hermann Wischmeyer. *Courier Journal* (Louisville), May 27, 1945.

_____. Unattributed and undated

Frederick Hoyt Elswick

Commonwealth of Kentucky, State Board of Examiners and Registration of Architects, Application for Registration as Registered Architect, Frederick Hoyt Elswick, September 17, 1930. Archives of William B. Scott, Jr.

Newspaper article file (author's collection). Fred H. Elswick: articles dated November 8, 1949; October 25, 1956; May 5, 1957; September 2, 1956; November 6, 1958; November 7, 1958; November 7, 1958; and 1950.

Kentucky State Fair History booklet, pages 10 to 18.

"Tradition in the Making: A Brief History of Construction at the Kentucky Fair & Exposition Center," circa 1997.

Brinton B. Davis

"Brinton B. Davis, Architect of Some of Bowling Green's Most Stately Buildings." Undated and unattributed article. Archives of William B. Scott, Jr.

Commonwealth of Kentucky State Board of Examiners and Registration of Architects, Application for Registration as Registered Architect, Brinton B. Davis, November 4, 1930. Archives of William B. Scott, Jr.

Davis, Brinton B. "Architecture." Address at meeting of the Kentucky Chapter, American Institute of Architects, January 7, 1937. Archives of William B. Scott, Jr.

Greyhound Terminals

Akron, Ohio

"Greyhound Terminal To Be Dedicated Tuesday." *Akron (Ohio) Beacon Journal,* February 14, 1949.
"Revisiting History." *Akron Beacon Journal,* October 9, 2000.

Atlanta, Georgia

Railroad and Bus Terminal and Station Layout, "Atlanta Greyhound Bus Terminal." American Locker Company (1945).
"World's Safest Record is Held by Greyhound," *Atlanta Constitution,* August 29, 1940.

Baltimore, Maryland

"Baltimore Greyhound Bus Terminal." *Pencil Points,* July 1945.
"Bus Terminal is Open." *Baltimore* (Maryland) *Evening Sun,* November 30, 1942.
"Greyhound Lines Begins Schedules at New Terminal." *Baltimore Sun,* December 1, 1942.
"Greyhound Site Awaits Art's Arrival." *Baltimore Sun,* October 13, 1994.
"Historical Society Plans Annex." *Baltimore Sun,* June 22, 1995.
Railroad and Bus Terminals and Station Layout, "Baltimore Greyhound Terminal." American Locker Company (1945).
"Regional Council Moves to Old Greyhound Station." *Baltimore Sun,* July 17, 1991.

Battle Creek, Michigan

"Bus Station Opened In Formal Ceremony." *The Enquirer & News,* June 14, 1949.
"New Inter-City Bus Station Will Open for Operation Tuesday." *The Enquirer & News* (Battle Creek, Michigan), June 13, 1949.

Binghamton, New York

"Greyhound Bus Station, Chenango St." L.L. Cole Collection, Broome County Historical Society, Binghamton, New York.

Birmingham, Alabama

"Greyhound Bus Lines Open One of Nation's Finest Depots Here." *Birmingham* (Alabama) *News,* January 31, 1951.

Bowling Green, Kentucky

"Bus Station to be Opened on Wednesday." *Park City Daily News,* Bowling Green, Kentucky, March 23, 1937.
"Bus Terminal to be Erected Here." *Park City Daily News,* Bowling Green, Kentucky, September 10, 1936.
Kentucky State Firemen's Association "Welcome" flier, Bowling Green, Kentucky, September 11, 1948.
"Proposed Bus Station." *Park City Daily News,* Bowling Green, Kentucky, March 31, 1957.
"To Dedicate Bus Station Here Tonight." *Park City Daily News,* Bowling Green, Kentucky (1937).

Buffalo, New York

"Greyhound Bus Terminal Will Open Tuesday." *Buffalo Courier-Express,* April 27, 1941.
"New Terminal to be Erected By Greyhound." *Buffalo* (New York) *Courier-Express,* August 18, 1940.
Railroad and Bus Terminal and Station Layout, "Buffalo, New York." American Locker Company (1945).
Sanborn Atlas, Vol. 1, Buffalo, New York (New York: Sanborn Map Company, 1963).

Cincinnati, Ohio

"New Greyhound Terminal is on Historic Transportation Site." *Cincinnati Times Star,* June 1942.
"Plans for New Bus Terminal Near Completion." *Cincinnati* (Ohio) *Times Star,* circa 1941.
"Queen City's New Bus Terminal." *Cincinnati Enquirer,* June 10, 1942.
Railroad and Bus Terminal and Station Layout, "Cincinnati, Ohio." American Locker Company (1945).

Cleveland, Ohio

Arrasmith, W.S. Architectural drawings, Greyhound Terminal, Cleveland, Ohio. Arrasmith, Judd, Rapp (1946).
"Bus Station Gets Face Lift." *Cleveland Plain Dealer,* March 2, 2000.
"Bus Station Sale Likely to Kill Apartment Project." *Crain's Cleveland Business,* November 4, 1991.
City of Cleveland Division of Buildings. Greyhound Application for Permit, New Structure, July 1, 1946.
_____. Greyhound, Miscellaneous.
"The Forgotten Forties." Wilma Salisbury, *Cleveland Plain Dealer Magazine,* May 8, 1988.
"Greatest Bus Terminal in World to Open in City Tomorrow." Special Greyhound Section, *Cleveland News,* March 30, 1948.
"Greyhound Bus Terminal faces 'dangerous moment.'" *Habitat,* May 29–June 4, 1987.

"Greyhound Depot to Open in March." *Cleveland* (Ohio) *Plain Dealer*, February 14, 1948.

"Greyhound Restores Cleveland Bus Terminal to its Former Architectural Glory." *Properties Magazine*, May 2000.

"Greyhound Station Recycling Ideas Running Wild." *Cleveland Plain Dealer*, May 19, 1991.

"The Million Dollar Futuristic Streamline Baby." Cleveland Edition, *Cleveland Plain Dealer*, February 1–7, 1990.

National Register of Historic Places. Greyhound Bus Station, Cleveland, Ohio, File Name NRO319.bap (1991).

_____. Cleveland, Ohio, Greyhound Terminal, December 2, 1990.

"New Script for Bus Terminal." *Crain's Cleveland Business*, June 25, 1990.

Columbus, Ohio

"Bus Terminal Contract Is Let." *Ohio State Journal*, (Columbus), August 9, 1939.

Railroad and Bus Terminal and Station Layout, "Columbus, Ohio," American Locker Company (1945).

Dayton, Ohio

Railroad and Bus Terminal and Station Layout, "Dayton, Ohio." American Locker Company (1945).

Erie, Pennsylvania

"Officials Open Modern Erie Greyhound." *Erie* (Pennsylvania) *Daily Times*, March 22, 1940.

Evansville, Indiana

"Bus Terminal." *Evansville* (Indiana) *Press*, November 18, September 2, 1937.

"Cadick Walls Come Tumbling Down." *Evansville Press*, May 27, 1938.

"Deco Depot Isn't Going to Dogs." *Evansville Press*, August 9, 1978.

"George L. Mesker & Co. Steel Work in Greyhound Terminal." *Evansville* (Indiana) *Courier*, January 16, 1939.

"Going ... Once Bustling Bus Depot." *Evansville Press*, February 20, 1986.

"Greyhound May Franchise its Terminal in Evansville." *Evansville Courier Journal*, October 30, 1985.

"Greyhound Ready to Rededicate Depot." *Evansville Press*, March 19, 1988.

National Register of Historic Places. Greyhound Bus Terminal, Evansville, Indiana, October 1, 1979.

Railroad and Bus Terminal and Station Layout, "Evansville, Indiana." American Locker Company (1945).

"This Depot is Worth the Trip." *Evansville Courier Journal*, November 16, 1985.

"What Cadick Corner Will Look Like Soon," *Evansville Press*, November 7, 1937.

"Work on Bus Terminal to Begin in June." *Evansville Press*, November 4, 1937.

"Workmen Busy at Bus Station Site," *Evansville Press*, May, 25, 1938.

Fort Wayne, Indiana

"All Was Not Lost When Greyhound Was Razed." *Fort Wayne* (Indiana) *News Sentinel*, May 14, 1992.

"ARCH Lists Structures it Wants Saved." *Fort Wayne News Sentinel*, June 9, 1992.

"Bus Station Razing Comes as Surprise." *Fort Wayne News Sentinel*, May 9, 1992.

"Commission Seeks Future Possibilities for Redevelopment." *Fort Wayne News Sentinel*, January 20, 1992.

"Historic Buildings Link a City to its Past." *Fort Wayne News Sentinel*, May 26, 1992.

"Lack of Interest Prompted Razing of Depot." *Fort Wayne News Sentinel*, May 12, 1992.

"Save Special Buildings." *Fort Wayne News Sentinel*, September 9, 1992.

"Site is Leased for $65,000 Bus Terminal." *Fort Wayne News Sentinel*, February 1, 1938.

"We're Demolishing Art." *Fort Wayne News Sentinel*, May 26, 1992.

"With No Plans for Use, Depot's Fate Was Sealed." *Fort Wayne News Sentinel*, May 12, 1992.

Jackson, Mississippi

Adams, Robert Park. Interview with author. Jackson, Mississippi, August 2002.

"Adaptive Reuse of Older Buildings an Office Space Trend." *Clarion-Ledger* (Jackson, Mississippi), February 7, 1994.

"An Old Dog Gets New Life." *Clarion-Ledger*, December 28, 1988.

"Bank Official Unsure of Bus Station Future." *Clarion-Ledger*, February 5, 1987.

"Bus Station: Eyesore or Landmark?" *Clarion-Ledger*, November 4, 1986.

"Greyhound May Leave Downtown." *Clarion-Ledger*, August 28, 1986.

"Greyhound Wants to Relocate its City Station." *Clarion-Ledger*, July 26, 1982.

"Interiors & Exteriors, The Greyhound Bus Terminal." *The New Southern View*, Spring 2002.

"Irish Eyes are Hoping to Save Old Bus Station with Parade." *Clarion-Ledger*, February 21, 1987.

"Merger Means New Bus Station Will Go Unused." *Clarion-Ledger*, August 6, 1987.

"Old Bus Station May Soon Retire." *Clarion-Ledger*, April 29, 1986.

"Wall-to-wall Flashback." *Clarion-Ledger*, August 8, 1989.

Knoxville, Tennessee

"Greyhound, City Tangle Over Terminal." *Knoxville (Tennessee) News Sentinel*, February 7, 1957.

"Greyhound Closes Deal on Terminal Site." *Knoxville News Sentinel*, June 6, 1957.

"Greyhound Pays $200,000 for Site." *Knoxville News Sentinel*, August 8, 1957.

"New Greyhound Bus Terminal Opens Tomorrow." *Knoxville News Sentinel*, October 2, 1959.

"Work Still Awaited On New Bus Terminal." *Knoxville News Sentinel*, August 5, 1958.

Lansing, Michigan

"Ceremonies to Open New $300,000 Greyhound Bus Terminal Dec. 20." *Lansing (Michigan) State Journal*, December 19, 1950.

Lima, Ohio

"Bus Terminal Move Delayed Until Friday." *Lima (Ohio) News*, August 15, 1949.

"Greyhound Depot to Open Thursday." *Lima News*, August 17, 1949.

"Greyhound to Move to its New Terminal on N. West St. in Ceremonies Today." *Lima News*, August 14, 1949.

Louisville, Kentucky (1937 Terminal)

"Greyhound Says No Decision Yet for New Site or Any Construction," *Courier Journal*, (Louisville, Kentucky), August 1, 1959.

"Greyhound Terminal's Gala Opening Set for Wednesday," *Courier Journal*, April 28, 1937.

"Greyhound, Urban Renewal Study New Bus Station Site on Walnut," *Courier Journal*, August 10, 1967.

"Greyhound Will Remain at Same Site," *Courier Journal*, September 22, 1959.

Railroad and Bus Terminal and Station Layout, "Louisville, Kentucky." American Locker Company (1945).

Louisville, Kentucky (1970 Terminal)

"Bus Station Coming Along on Time." *Louisville (Kentucky) Times*, February 28, 1970.

"New Bus Station Proposal." Series of articles in *Courier Journal* and *Louisville Times*: August 11, 1967; August 21, 1967; August 22, 1967; September 12, 1967; January 11, 1968; February 23, 1968; January 24, 1969; February 24, 1968; March 6, 1969; April 2, 1969; April 16, 1969; April 23, 1969; April 26, 1969.

"New Greyhound Station Gets First Customers." *Louisville Times*, December 9, 1970.

"New End for The Line." *Louisville Times*, December 10, 1970.

"$1.75 Million Greyhound Terminal to Open on Walnut Street Dec. 10." *Louisville Times*, November 6, 1970.

"Union Bus Station Was on Broadway." *Louisville Times*, June 25, 1970.

Montgomery, Alabama

"Division Manager to Attend Opening." *Montgomery (Alabama) Advertiser*, August 16, 1951.

"New Bus Terminal Here to Hold Formal Opening on Thursday." *Montgomery Advertiser*, August 16, 1951.

"Teche Greyhound President is Active Community Worker." *Montgomery Advertiser*, August 16, 1951.

Norfolk, Virginia

"Greyhound Bus Terminal Will Open August 1." *Ledger Star* (Norfolk, Virginia), July 21, 1942.

"Public Invited to Greyhound Station Today," *Ledger Star*, July 31, 1942.

Pittsburgh, Pennsylvania

"Greyhound's New Look." *Pittsburgh (Pennsylvania) Sun-Telegraph*, June 26, 1959.

"Greyhound Opens New Depot Here." *Pittsburgh Sun-Telegraph*, December 10, 1959.

Pontiac, Michigan

"Built for Comfort." *Pontiac (Michigan) Press*, October 30, 1952.

"Push Work on Bus Station." *Pontiac Press*, September 24, 1952.

"Ready for Business." *Pontiac Press*, October 30, 1952.

Syracuse, New York

"Bus Station Contract Let." *Syracuse (New York) Herald American*, October 22, 1940.

"Bus Terminal Plans Receive ICC Approval." *Syracuse Herald American*, December 8, 1940.

"City Offers Adams St. Site for New Greyhound Depot." *Syracuse Post Standard*, February 23, 1964.

"New $250,000 Bus Terminal Set to Open." *Syracuse Herald Journal*, May 20, 1941.

Railroad and Bus Terminal and Station Layout, "Syracuse, New York," American Locker Company, (1945).

"Work Starts Oct. 1 on New Bus Terminal." *Syracuse Herald American*, August 25, 1940.

Washington, D.C.

"A Rare and Successful Alliance." *Historic Preservation News*, November 1991.

"D.C. Designates 'Slipcovered' Bus Station a Landmark." *Preservation News*, March 1987.

"The Dignified Depot." *Washington Post*, September 14, 1991.

"Great Greyhound at Bay." *Society for Commercial Archeology News Journal*, April 1985.

"Greyhound Plan Gets Final Okay." *Preservation News*, October 1988.

Joint Committee on Landmarks of the National Capitol. Application Form Historic Landmark, Washington, D.C., Greyhound Terminal, February 21, 1984.

Keyes Condon Florance, Architects. Letter. January 31, 1989.

_____. 1100 New York Avenue, Washington, D.C., circa 1991.

"Manufacturers Uncovers Historic Greyhound Bus Terminal." Manufacturers Life Insurance Company, January 31, 1989.

"Praised by Preservationists—Manufacturers Goes Deco." *Site Lines*, Manufacturers Real Estate, circa 1990.

"Preservationists OK New Greyhound Scheme." *Preservation News*, September 1987.

Railroad and Bus Terminal and Station Layout, "Washington, D.C." American Locker Company (1945).

"What a Swell Ride it Was." *Newsweek*, October 14, 1991.

General Reference Sources

Bishir, Catherine W. *Architects and Builders in North Carolina*. Chapel Hill: University of North Carolina Press (1990).

_____. Interview with author, 2002.

Bush, Donald J. *The Streamlined Decade*. New York: George Braziller, 1975.

"Great Lakes Greyhound Lines," Motor Coach Age, July-August 1990.

Loewy, Raymond. *Industrial Design*. Woodstock, NY: Overlook Press, 1979.

Meikle, Jeffrey L. *The Twentieth Century Limited: Industrial Design in America 1925-1935*. Philadelphia: Temple University Press, 1979.

"The 1931 Mack Bus." Greyhound Lines, Inc., brochure (undated).

"The 1937 Super Coach," Greyhound Lines, Inc., brochure (undated).

Scenicruiser Greyhound brochure (undated).

Schisgall, Oscar. *The Greyhound Story: From Hibbing to Everywhere*. New York: Doubleday, 1985.

Schonberger, Angel. *Raymond Loewy: Pioneer of American Industrial Design*. Munich: Prestal-Verlag, 1990.

Silversides Greyhound brochure (undated).

"Top Dog: Tracing the Pedigree of Greyhound Lines, Inc." Greyhound Lines, Inc. (undated).

Weber, Kem. "The Moderne in Southern California 1920 through 1941." Exhibition, University of California at Santa Barbara, 1969.

"Yellow Coach and GM Busses, 1923–1937." *Motor Coach Age*, September-October 1990.

Zimny, Michael F. "Robert Vincent Derrah and the Nautical Moderne." B.F.A. thesis, University of Illinois, 1978.

Photograph and Image Credits

The photographs, renderings, and images contained in this book are listed below in the order of their appearance with type of image, source, and page number. The author wishes to thank Greyhound Lines, Inc., for granting permission to use images, pictures or likeness of Greyhound trademarks, service marks, trade names, and/or copyrights in this book. The author is not in any way affiliated with Greyhound Lines, Inc.

Index